PATTERNS

MOTIFS I MUSTER I PATRONEN

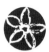

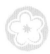

© 2009 **booQs** publishers bvba
Godefriduskaai 22
2000 Antwerp
Belgium
Tel: +32 3 226 66 73
Fax: +32 3 226 53 65
www.booqs.be
info@booqs.be

ISBN: 978-94-60650-00-0
WD: D/2009/11978/001
(Q001)

Editor & texts: Macarena San Martín
Art direction: Mireia Casanovas Soley
Design and layout coordination:
Emma Termes Parera
Translation: Cillero & De Motta Traducción

Editorial project:

maomao publications
Via Laietana, 32, 4.º, of. 104
08003 Barcelona, Spain
Tel.: +34 932 688 088
Fax: +34 933 174 208
maomao@maomaopublications.com
www.maomaopublications.com

Printed in China

PATTERNS

MOTIFS | MUSTER | PATRONEN

CONTENTS

A graphic pattern consists of a single motif placed within several repetitions of itself to create a consistent and scalable design that varies depending on the number of repetitions. This technique can be used to create graphic compositions that freely play with color, image size, rhythm, the figure and background, and proportion. For example, a designer may choose to cover a small area using only large details, although this approach risks losing the overall logic of the composition.

These repetitions have been present in different cultures for centuries, featured in Moroccan mosques, Celtic art, etc. Yet, apart from the basic characteristics of these compositions, what do they have that makes them so very appealing? For some, it is the magic and excitement of discovering what motif or motifs are repeated, and where they begin and end. For others, what strikes them most is the structure and symmetry, because this simulates the mathematical part of the brain.

Some say that what truly amazes them is the ability of a graphic pattern — or rather, of its creator — to play with the laws of

shapes by using, for example, geometric details to achieve totally organic results, which modify the view of the original motif. There are also those who find it tempting to lose themselves in an infinite sea of shapes, drawn in by the endless possible interpretations. Or, is it simply the hypnosis caused by these compositions as they transport onlookers to another reality?

Whatever the reason, what is clear is that these patterns attract our attention and inspire different reactions and sensations in each of us. This is what we know as sensuality: provoking delight or the pleasure perceived by the senses through a stimulus. In this case, the stimulus is visual.

The following pages invite you to experience more than four hundred and fifty sensations through original, innovative compositions, created from graphic patterns with a sensual power that emanates from each of their elements.

Un motif est un élément graphique qui, se trouvant intégré parmi plusieurs copies de lui-même, crée un design cohérent pouvant être agrandi en fonction du nombre de reproductions. On peut ainsi créer des compositions graphiques qui jouent aisément avec les couleurs, les dimensions, l'image et le fond, le rythme et la proportion. Par exemple, pour de petites surfaces on peut opter expressément pour des détails de grande taille au risque de perdre le sens de la composition dans sa totalité.

Ces créations sont présentes dans différentes cultures depuis des siècles : dans les mosquées marocaines, dans l'art celte, etc. Mais au-delà des caractéristiques basiques de ces compositions, qu'ont-elles véritablement pour plaire autant ? Pour certains il peut s'agir de la magie et de l'émotion en découvrant le ou les éléments qui se répètent, où commencent et finissent les motifs sur toute la superficie. Pour d'autres, l'attention est attirée par la symétrie et la structure schématique parce qu'elle satisfait la partie mathématique du cerveau.

Certains diront que ce qui est vraiment hallucinant c'est la capacité du motif, ou plutôt de celui qui le crée, à jouer avec les lois

de la forme, par exemple, en utilisant des détails géométriques afin d'obtenir des résultats totalement organiques, ce qui modifie la perception de l'élément original. De la même façon, d'autres se sentiront attirés et pourront se perdre dans un océan infini d'images, notamment en raison des innombrables interprétations que l'on peut y trouver. À moins qu'il ne s'agisse que de l'hypnose que provoquent ces compositions en transportant l'observateur dans une autre réalité ?

Quoi qu'il en soit, ce qui est évident c'est que ces représentations attirent l'attention de ceux qui les regardent et suscitent en chacun de nous des réactions et des impressions différentes. Et c'est précisément ce que nous appelons la sensualité : un stimulus qui va provoquer la satisfaction ou le plaisir des sens. Ici, le stimulus est visuel.

Les pages suivantes nous invitent à éprouver plus de quatre cent cinquante sensations par le biais de compositions originales et innovantes, créées à partir de motifs dont le pouvoir sensuel émane de chacun de leurs éléments.

Ein graphisches Muster ist ein Element, das, mehrmals kopiert, ein von der Zahl der Wiederholungen abhängiges, kohärentes und erweiterbares Design ergibt. Auf diese Weise werden graphische Kompositionen geschaffen, die mühelos mit Farben, Bildgröße, Figur und Hintergrund, mit dem Rhythmus oder mit der Proportion spielen. Zum Beispiel kann man sich bei kleinen Flächen ausdrücklich für große Details entscheiden, selbst wenn man dabei riskiert, den Sinn der Komposition in ihrer Gesamtheit zu verlieren.

Diese Erweiterungen sind seit Jahrhunderten in verschiedenen Kulturen präsent: in den marokkanischen Moscheen, in der keltischen Kunst usw. Aber abgesehen von den grundlegenden Merkmalen dieser Kompositionen... Was genau haben sie, was uns so sehr gefällt? Für einige können es der Zauber und die Spannung sein, herauszufinden, welches Element oder welche Elemente sich wiederholen, wo diese in der Weite der Fläche anfangen und wo sie aufhören. Für andere sind die Symmetrie und die schematische Struktur am auffälligsten, weil diese den mathematischen Teil des Gehirns befriedigen.

Manche werden sagen, dass das eigentlich Verblüffende daran die Fähigkeit einer graphischen Struktur ist, oder vielmehr die

Fähigkeit desjenigen, der sie geschaffen hat, mit den Gesetzen der Form zu spielen, zum Beispiel unter Verwendung von geometrischen Details, um vollkommen organische Ergebnisse zu erhalten, mit denen sich die Sicht auf das Ursprungselement verändert. Ebenso wird es diejenigen geben, die sich gern in einem unendlichen Meer von Figuren verlieren, vor allen Dingen wegen der unendlichen Interpretationsmöglichkeiten, die dies mit sich bringen kann. Oder ist es einfach der hypnotische Zustand, den diese Kompositionen hervorrufen, wenn sie den Betrachter in eine andere Realität entführen?

Wie dem auch sei, es ist klar, dass diese Darstellungen die Aufmerksamkeit der Betrachter auf sich ziehen und bei jedem einzelnen verschiedene Reaktionen und Gefühle auslösen. Das ist genau das, was wir unter Sinnlichkeit verstehen: das Auslösen von Vergnügen oder Sinnesfreude durch einen Reiz. In diesem Fall handelt es sich um einen visuellen Reiz.

Die folgenden Seiten laden uns ein, über vierhundert Gefühlszustände zu erleben, durch originelle und neue Kompositionen, die von graphischen Mustern ausgehend geschaffen wurden, deren sinnliche Macht aus jedem einzelnen ihrer Elemente hervorgeht.

Een grafisch patroon is een element dat, afhankelijk van het aantal herhalingen, een samenhangend en vergrootbaar ontwerp vormt wanneer het tussen verscheidene kopieën van zichzelf wordt geplaatst. Op deze manier ontstaan grafische composities die gemakkelijk te combineren zijn met verschillende kleuren, de grootte van de afbeeldingen, de figuur en de achtergrond, het ritme en de verhouding. Op kleine oppervlakken kan men bijvoorbeeld opzettelijk kiezen voor grote details, hoewel men hiermee het risico loopt dat de strekking van de compositie in zijn geheel verloren gaat.

Deze vergrotingen zijn reeds eeuwenlang in verschillende culturen aanwezig: in de Marokkaanse moskees, in de Keltische kunst, enz. Maar wat zorgt er nu, afgezien van de basiskenmerken van deze composities, voor dat ze zo populair zijn? Voor sommigen kan het de magie en de emotie zijn van het ontdekken welk element of welke elementen zich herhalen, en waar ze beginnen en eindigen in de extensie van het oppervlak. Wat anderen vooral opvalt is de symmetrie en de schematische opbouw, omdat dit het wiskundige deel van de hersenen bevredigt.

Sommige mensen vinden het vooral ongelooflijk dat een grafisch patroon, of liever gezegd, degene die het heeft ontworpen,

in staat is met de wetten van de vorm te spelen en zo bijvoorbeeld gebruik maakt van geometrische details teneinde geheel organische resultaten te krijgen, waardoor het beeld van het oorspronkelijke element gewijzigd wordt. En dan zijn er ook nog diegenen die graag verdwalen in een oneindige zee van figuren, vooral vanwege het oneindig aantal interpretaties dat deze figuren kunnen teweegbrengen. Of is het simpelweg de hypnose die deze composities veroorzaken wanneer ze de toeschouwer naar een andere werkelijkheid vervoeren?

Wat de reden ook mag zijn, het is duidelijk dat deze voorstellingen de aandacht trekken van alle kijkers en bij iedereen weer andere reacties en gevoelens opwekken. Dit is nu precies wat we kennen als zinnelijkheid: de uitlokking van de smaak of het zintuiglijk genot door middel van een stimulans. In dit geval is de stimulans visueel.

De volgende bladzijden nodigen ons uit om meer dan vierhonderdvijftig indrukken op te doen door middel van originele en nieuwe composities, die gecreëerd zijn op basis van grafische patronen waarvan elk onderdeel sensuele kracht uitstraalt.

Inspired by nature

Inspiré par la nature

Von der Natur inspiriert

Geïnspireerd op de natuur

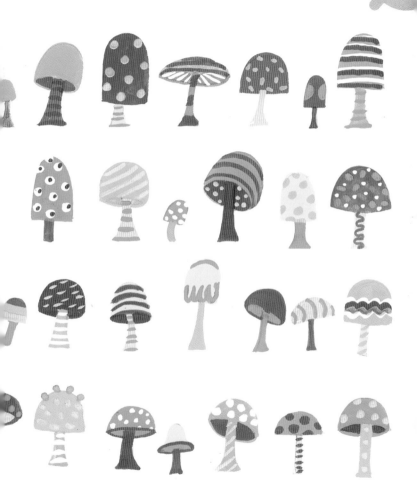

Nature has always been a source of inspiration for different forms of artistic expression, such as painting, sculpture and architecture. Look no further than the art of the Mayans, Monet's impressionist landscapes, or the Modernist works of Gaudí. In nature we find an infinite range of colors, a vast diversity of shapes, and countless stories. These ingredients easily make the imagination run wild.

Die Natur war immer eine Quelle der Inspiration für die verschiedenen Formen des künstlerischen Ausdrucks wie die Malerei, die Bildhauerkunst oder die Architektur; es genügt ein Blick auf die Darstellungen der Mayas, die impressionistischen Landschaften von Monet oder das Werk des katalanischen Jugendstils von Gaudí. In der Natur kann man eine unendliche Vielfalt von Farben, eine enorme Mannigfaltigkeit von Formen und eine Unmenge von Geschichten finden... Faktoren, die mühelos die Phantasie beflügeln.

La nature a toujours été une source d'inspiration pour les différentes formes d'expression artistique comme la peinture, la sculpture ou l'architecture, il suffit de voir les représentations des Mayas, les paysages impressionnistes de Monet ou l'œuvre moderniste de Gaudí. Dans la nature, on peut trouver une variété infinie de couleurs, une grande diversité de formes et une myriade d'histoires, de facteurs qui font facilement décoller l'imagination.

De natuur is altijd een inspiratiebron geweest voor de verschillende vormen van artistieke expressie, zoals de schilderkunst, de beeldhouwkunst of de architectuur. U hoeft alleen maar te kijken naar de voorstellingen van de Maya's, de impressionistische landschappen van Monet of het modernistische werk van Gaudí. In de natuur is het mogelijk om oneindig veel verschillende kleuren, een grote verscheidenheid aan vormen en een schat aan verhalen te vinden, allemaal factoren die gemakkelijk tot de verbeelding spreken.

RACHAEL TAYLOR, surface pattern designer www.rachaeltaylordesigns.co.uk

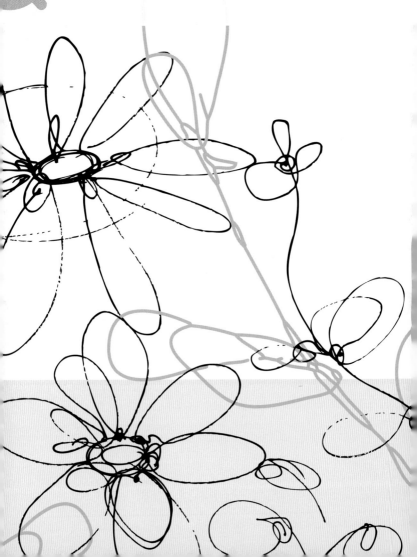

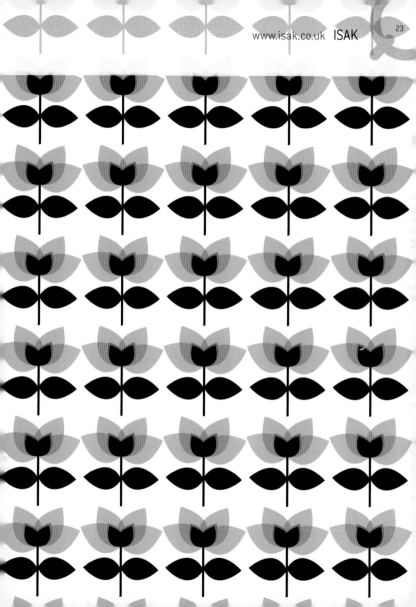

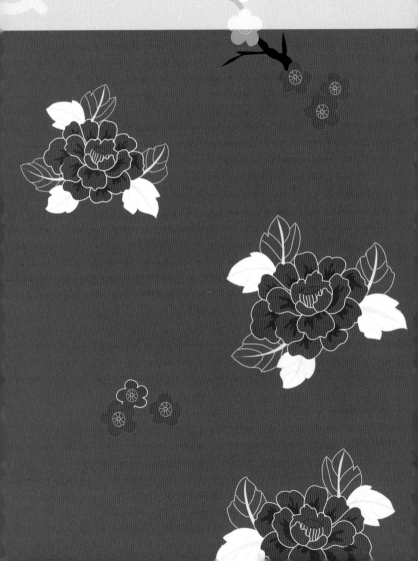

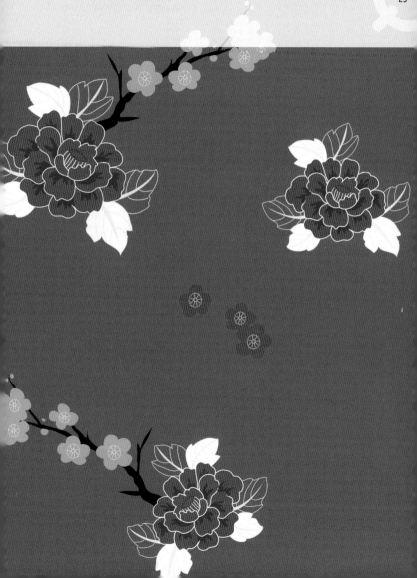

DELPHINE DOREAU/DEL4YO del4yo.squarespace.com

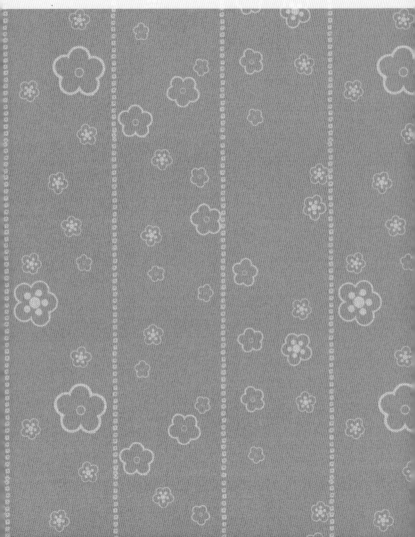

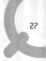

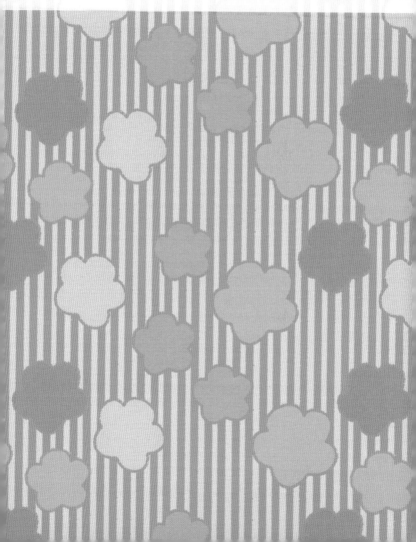

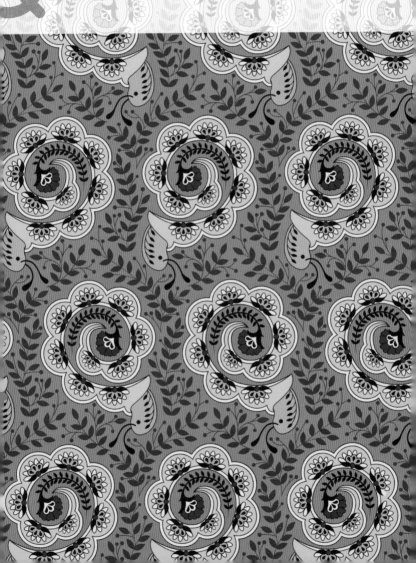

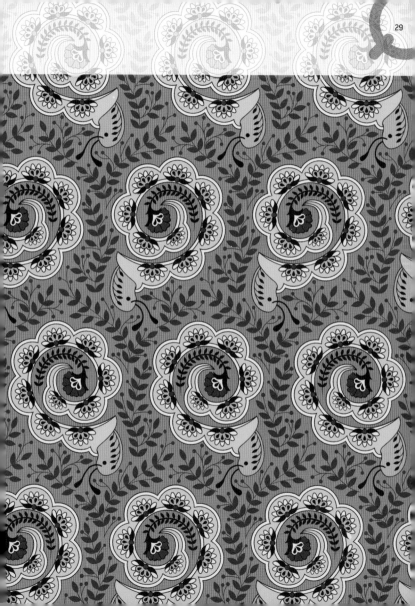

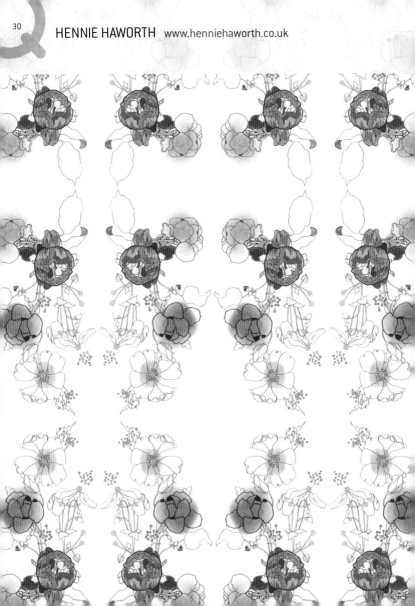

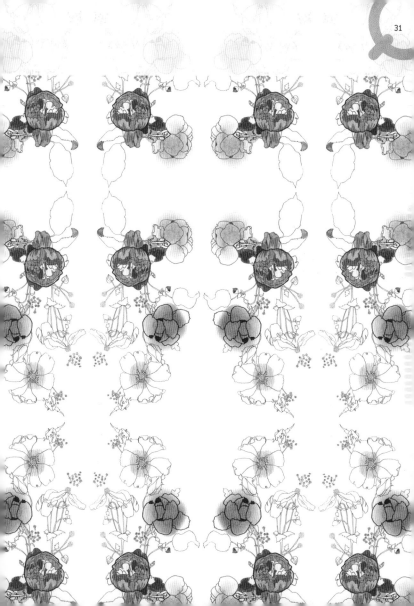

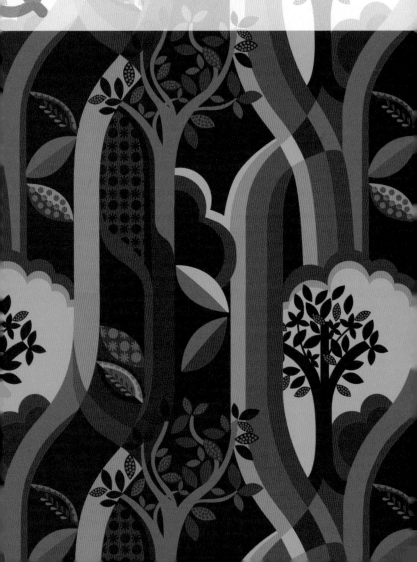

tashconnell@hotmail.com NATASHA CONNELL

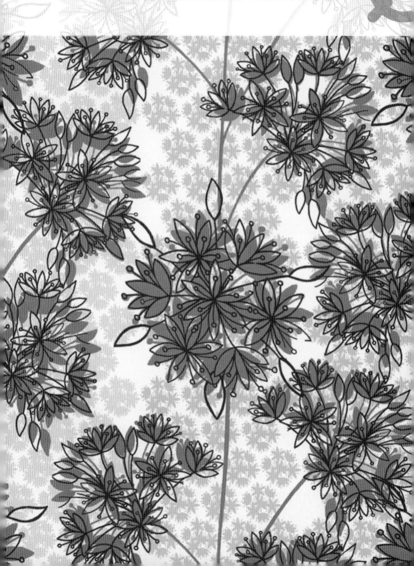

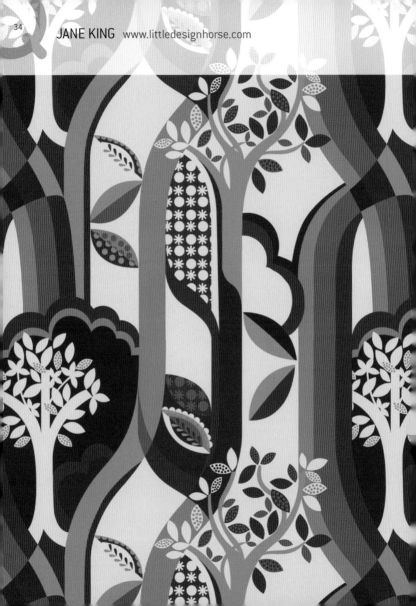

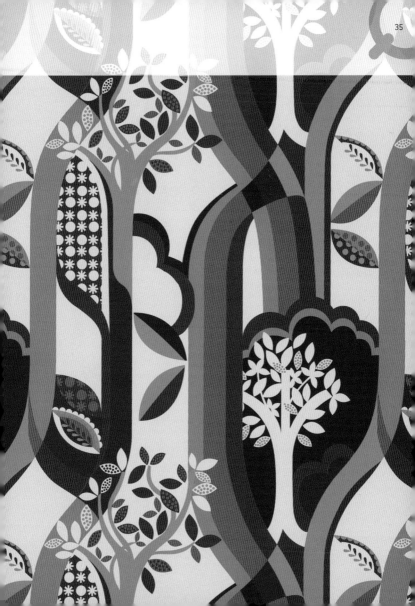

SABINE CORNIC, LONDON www.sabinecornic.com

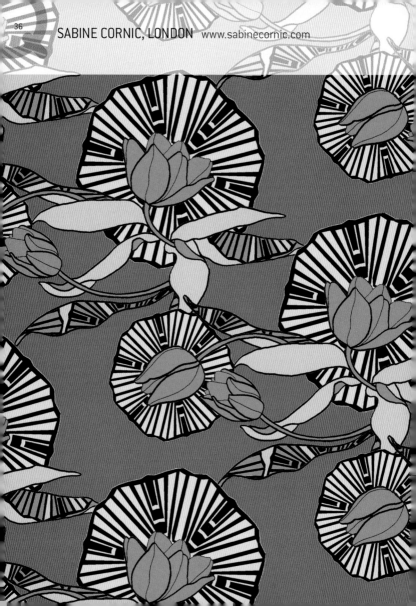

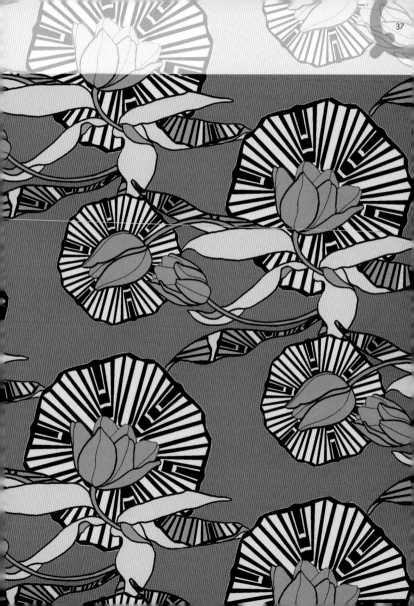

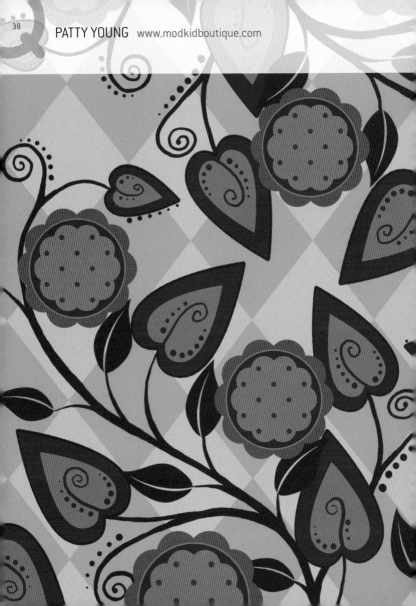

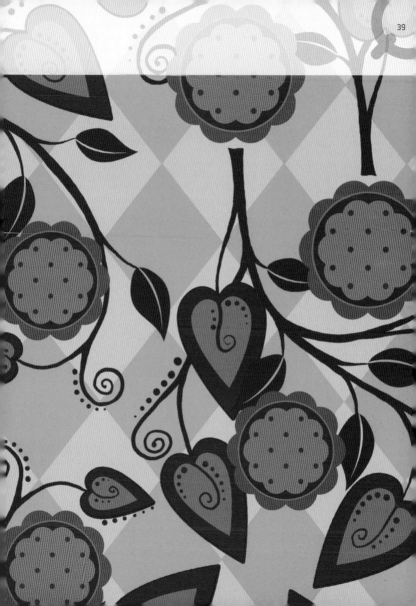

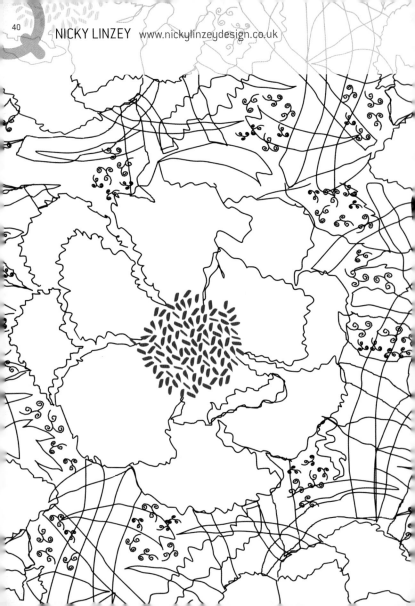

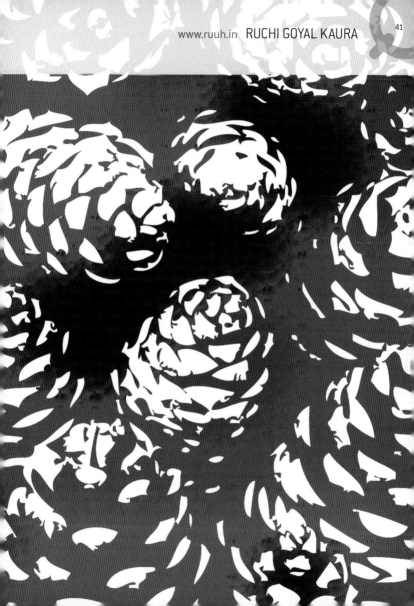

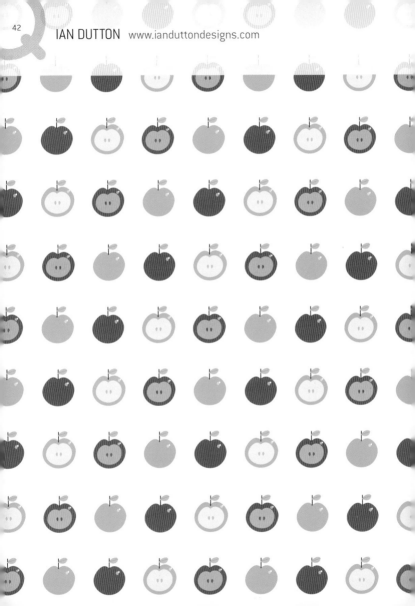

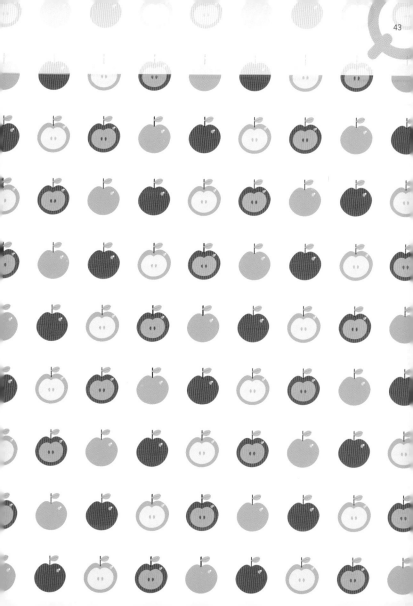

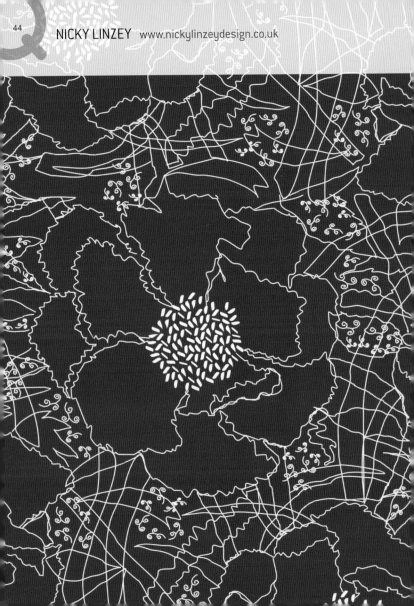

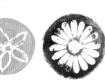

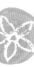

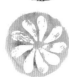
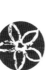
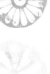
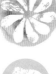
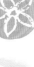

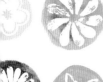

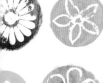
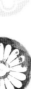
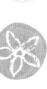

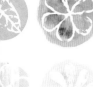

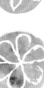

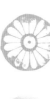

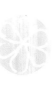
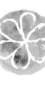

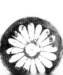

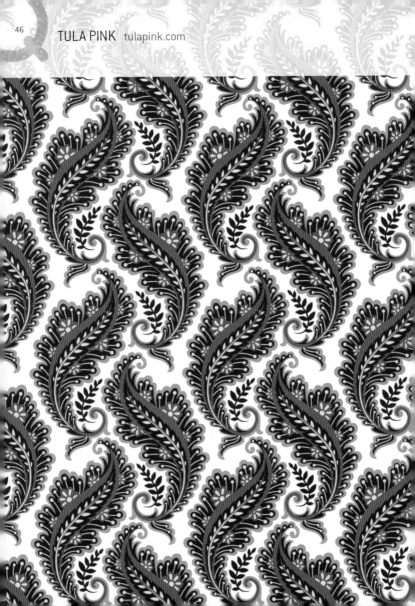

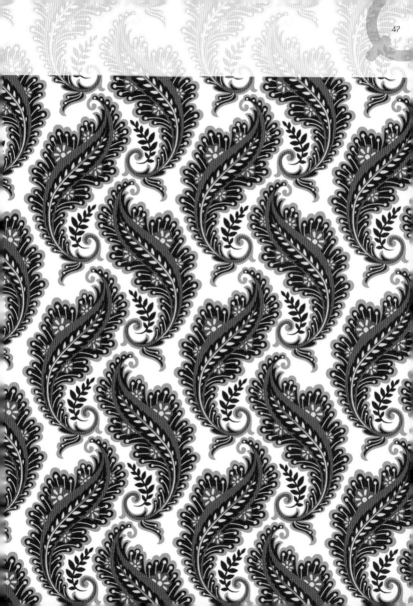

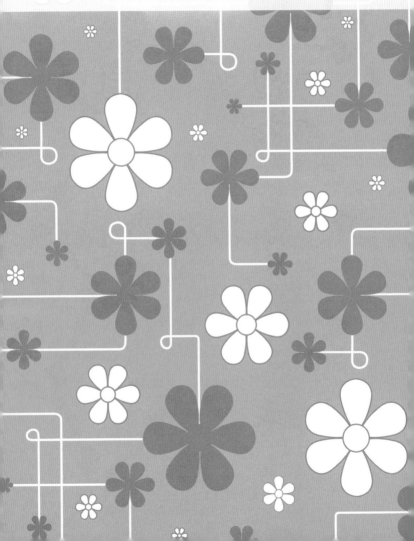

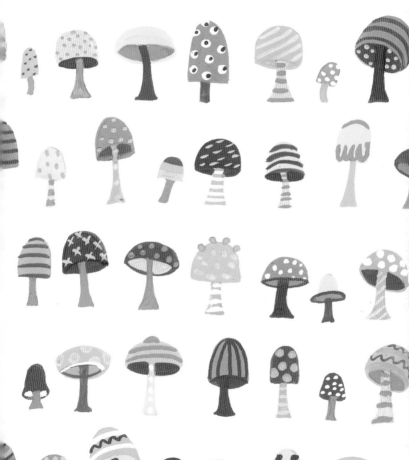

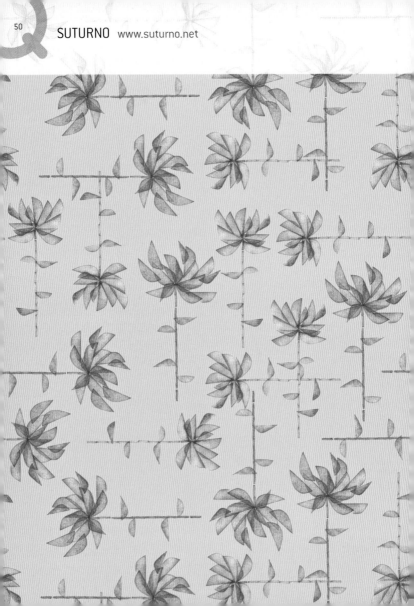

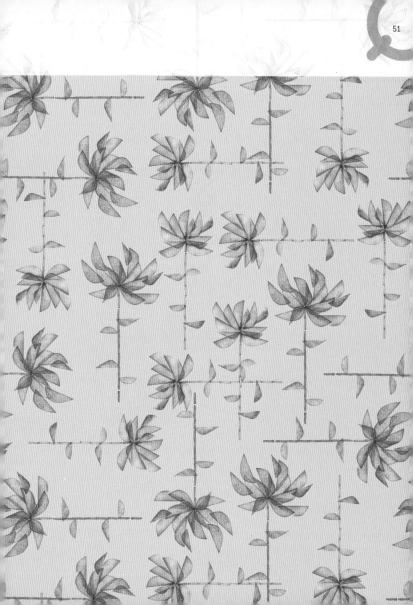

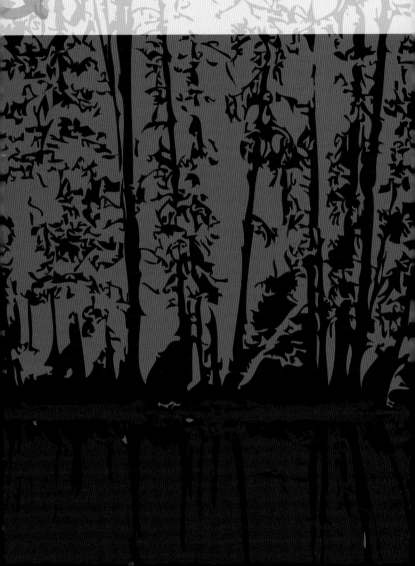

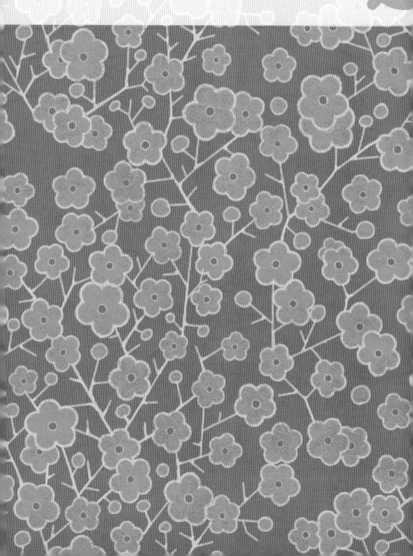

PATAPRI BY YUKO UEMURA www.patapri.com

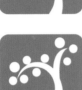

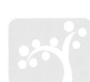

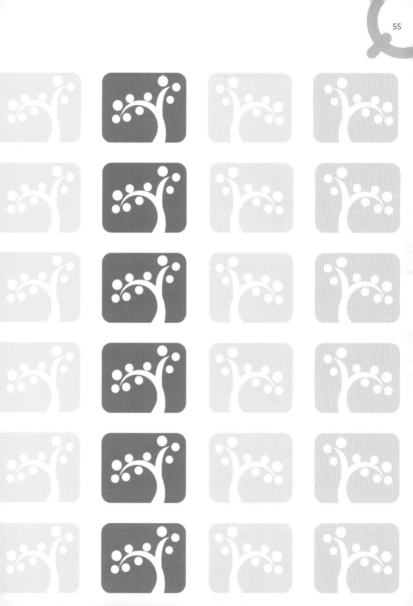

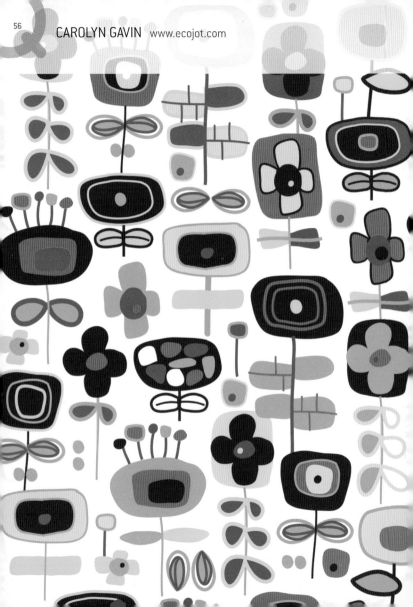

CAROLYN GAVIN www.ecojot.com

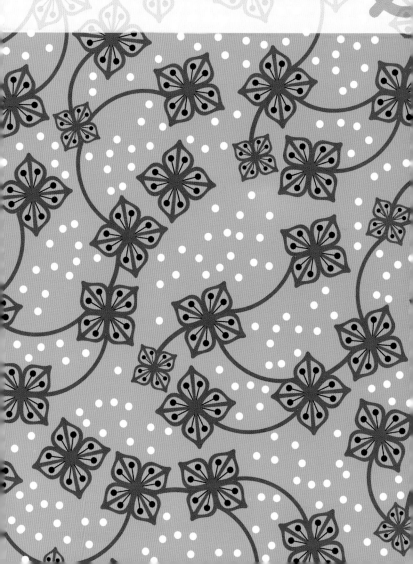

PATAPRI BY YUKO UEMURA www.patapri.com

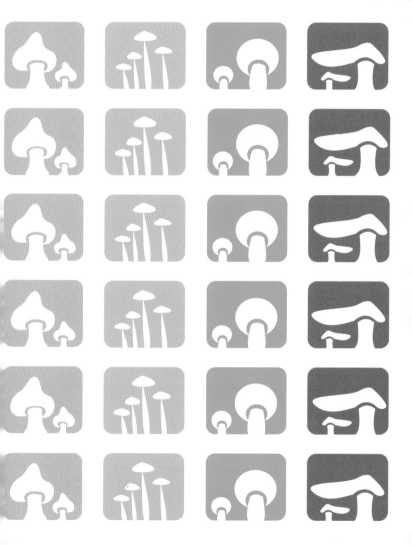

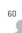

MARCIA COPELAND www.swizzlestix.net

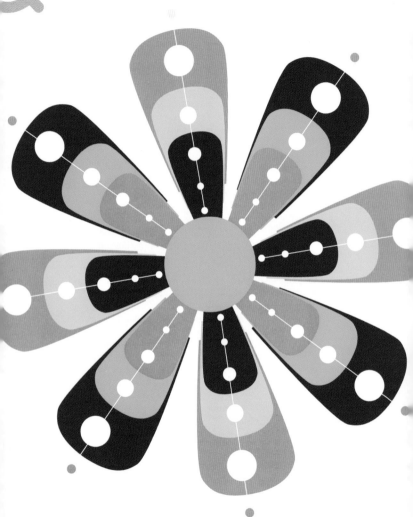

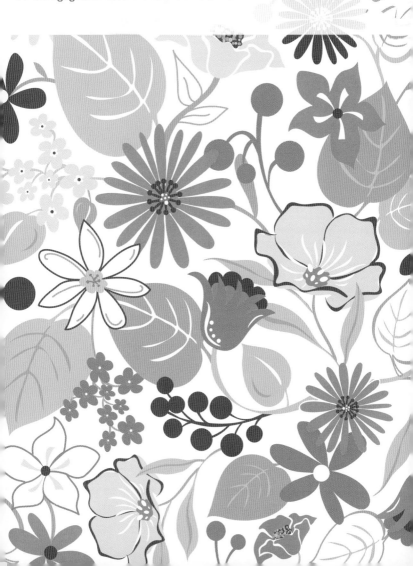

LABOLAULULINTU labolaululintu@gmail.com

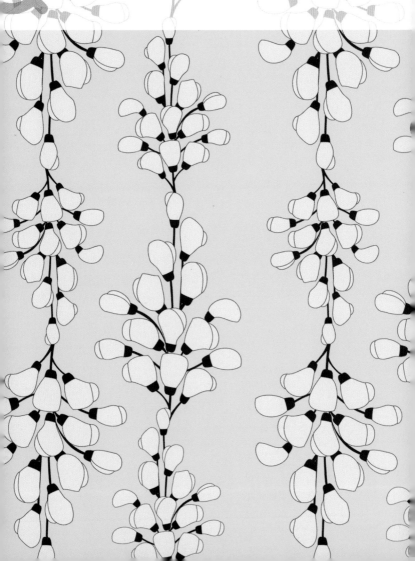

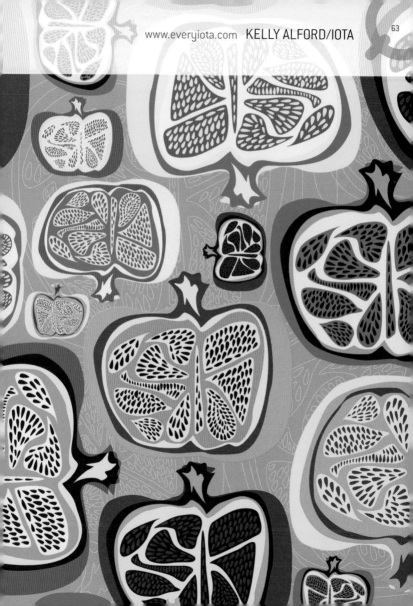

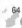

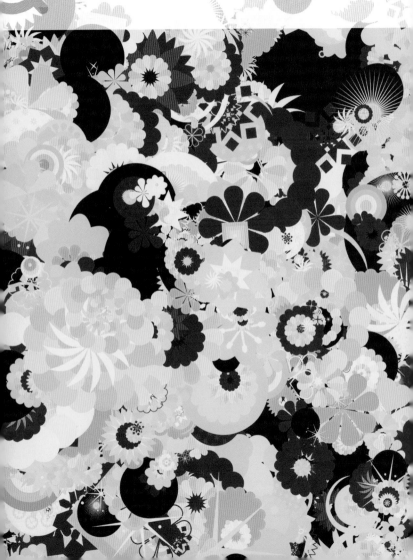

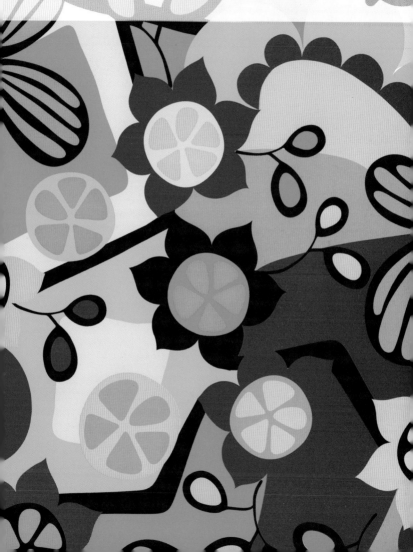

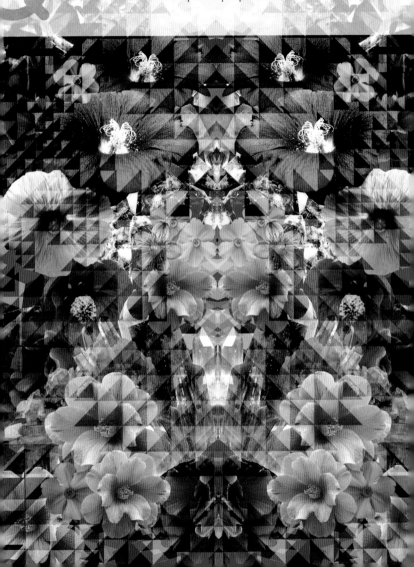

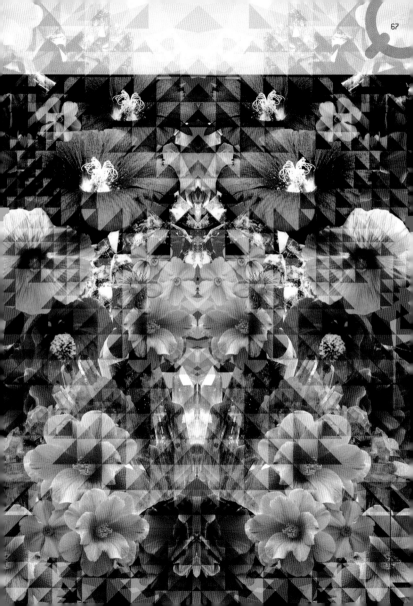

JOSEFINA CERIMEDO/BÁBYLON www.babylonlab.blogspot.com

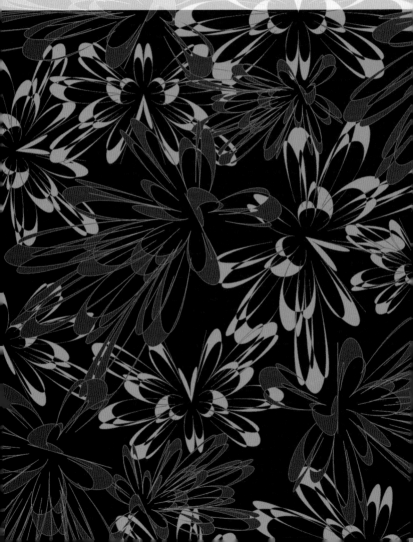

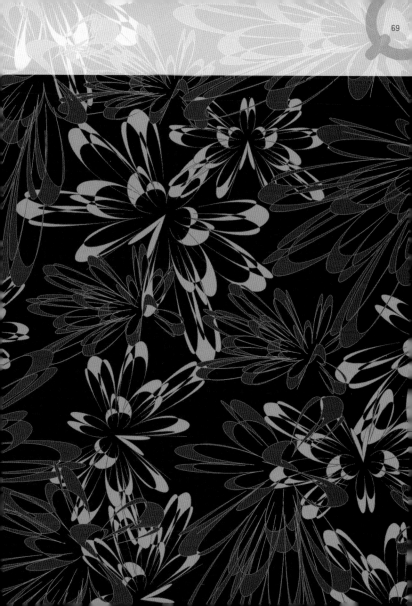

AIMEE WILDER DESIGNS www.aimeewilder.com

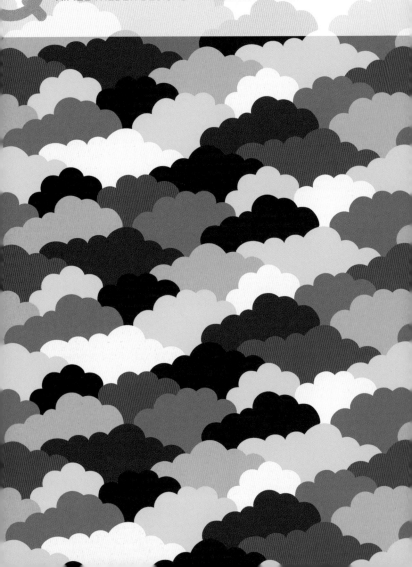

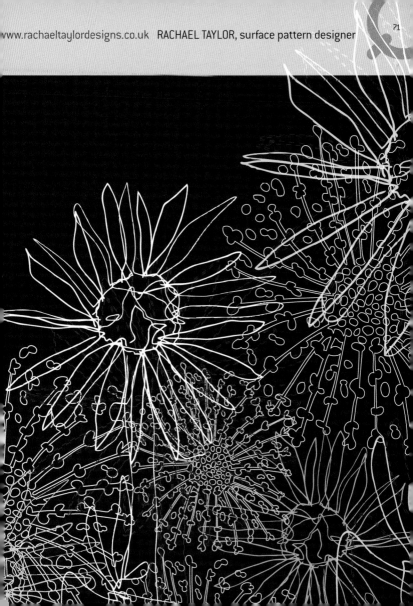

CAROLINE BOURLÈS mytextiledesign.com

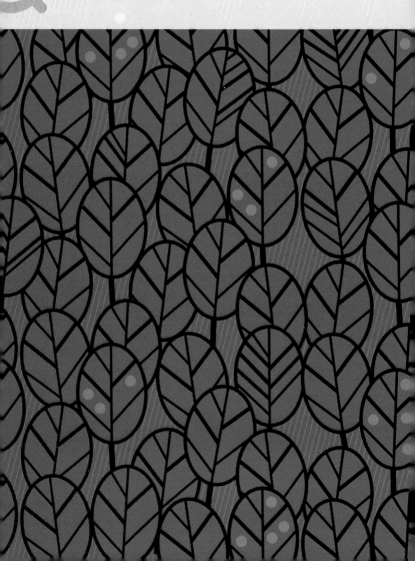

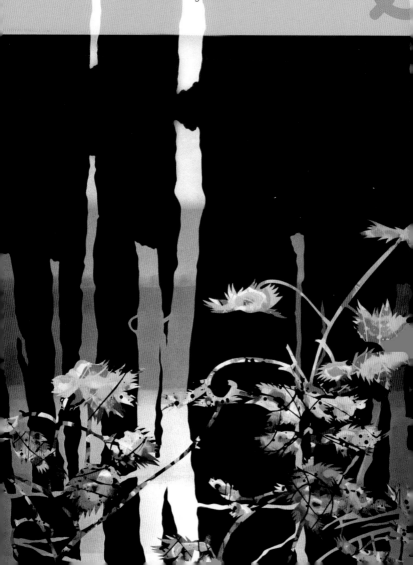

CAROLINE BOURLÈS mytextiledesign.com

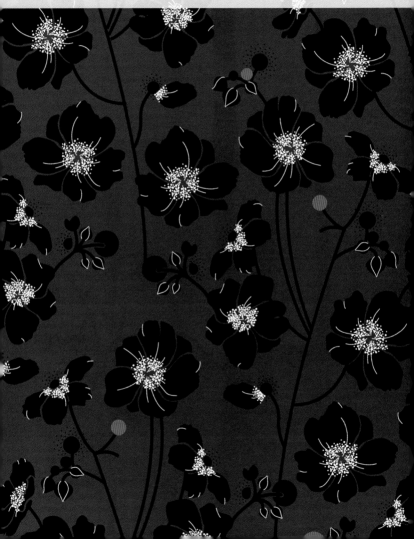

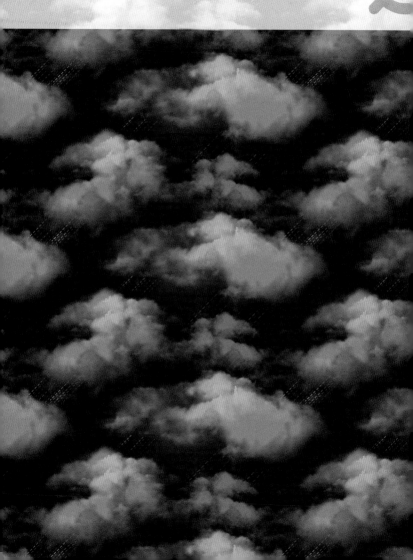

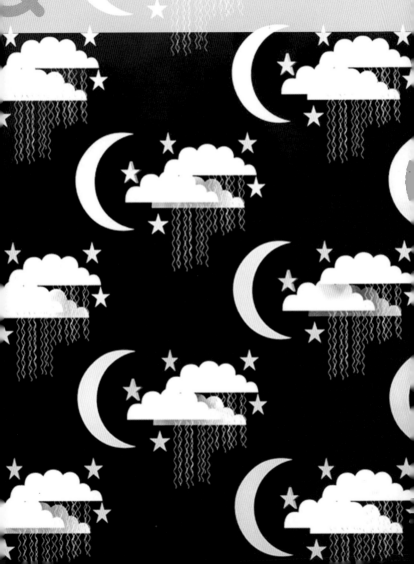

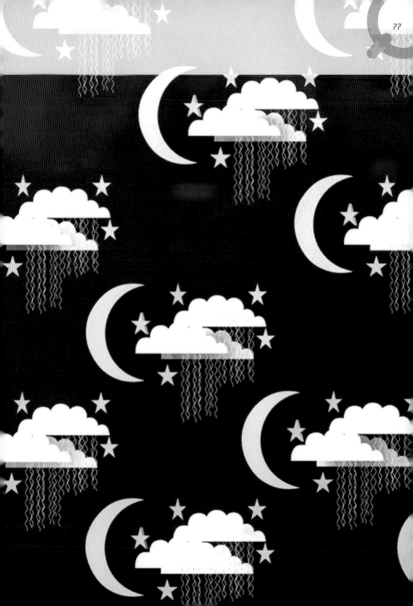

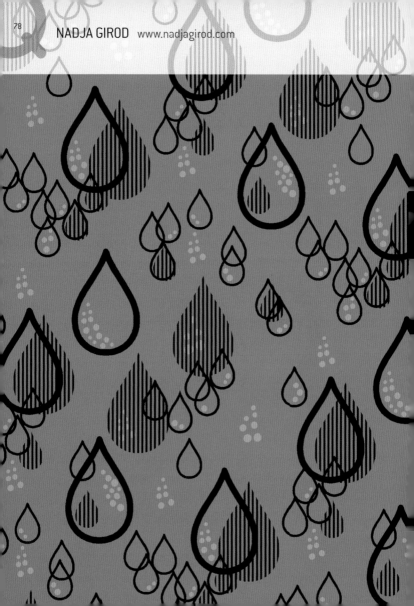

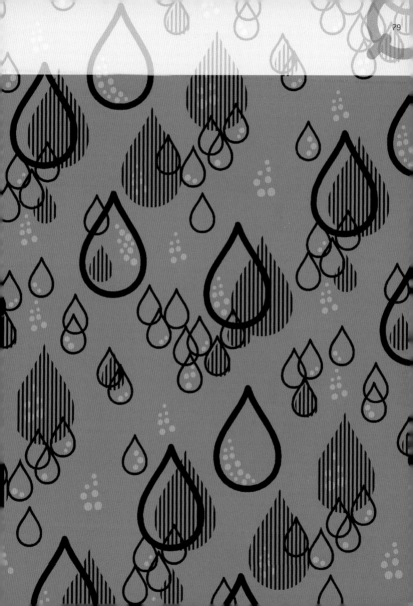

INKJET DESIGNS www.inkjet-designs.com

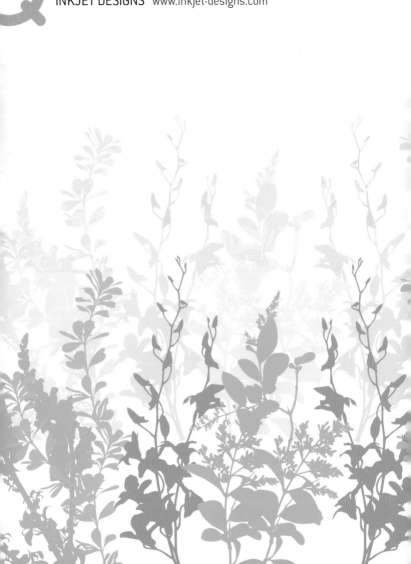

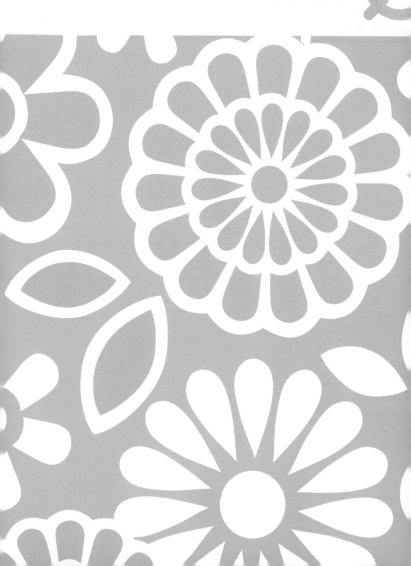

PATAPRI BY YUKO UEMURA www.patapri.com

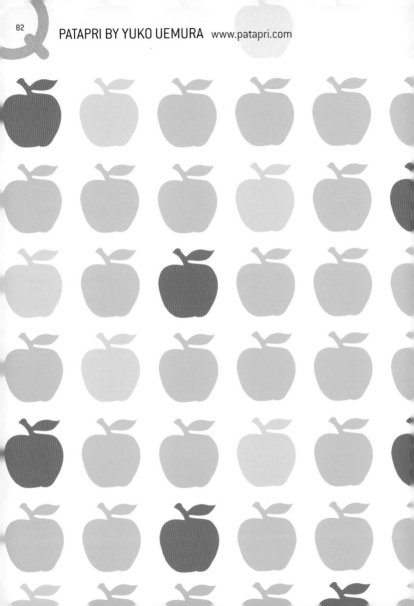

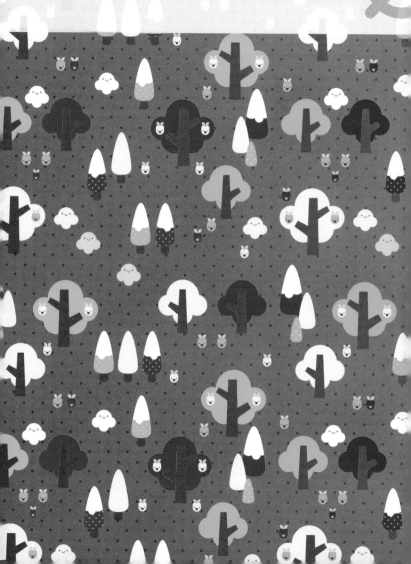

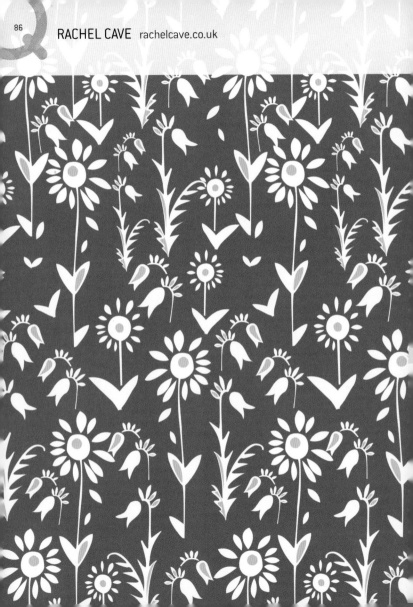

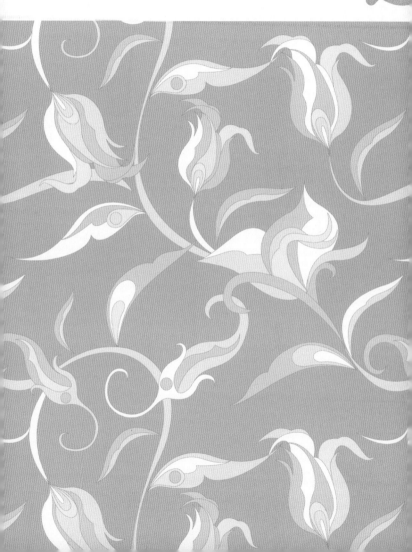

ANNA-LISA BACKLUND www.anna-lisa.com

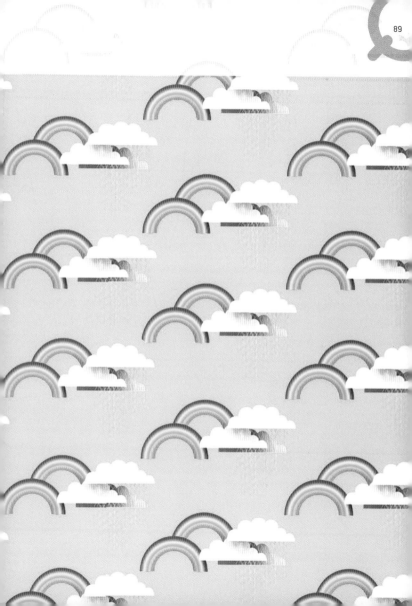

TULA PINK tulapink.com

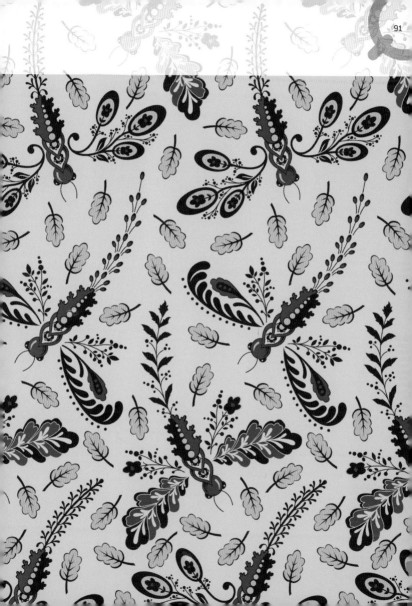

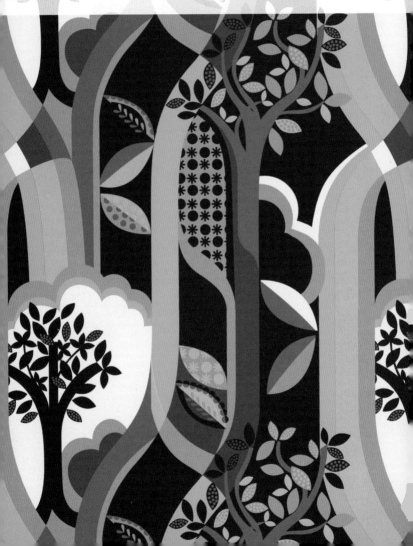

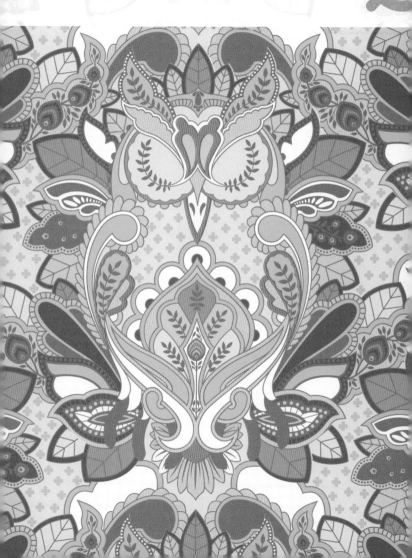

NATASHA CONNELL tashconnell@hotmail.com

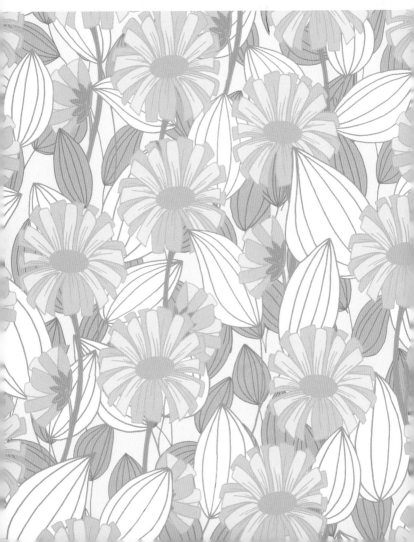

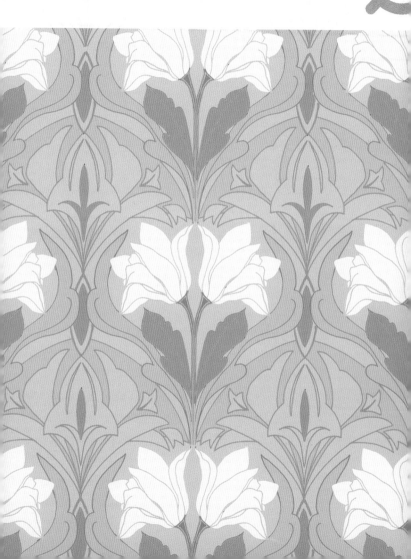

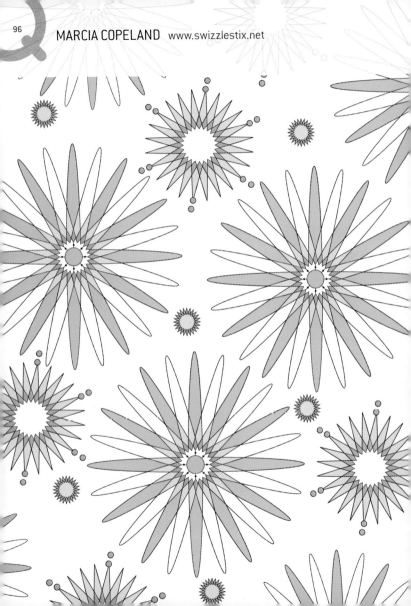

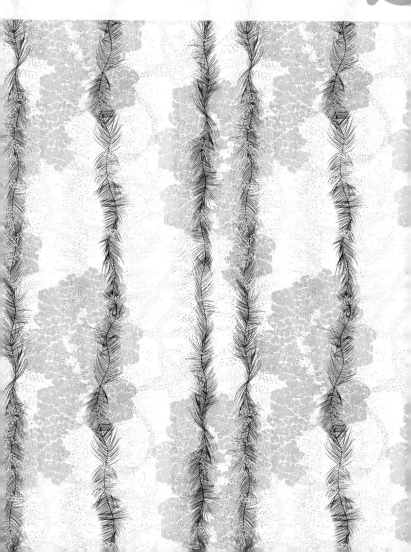

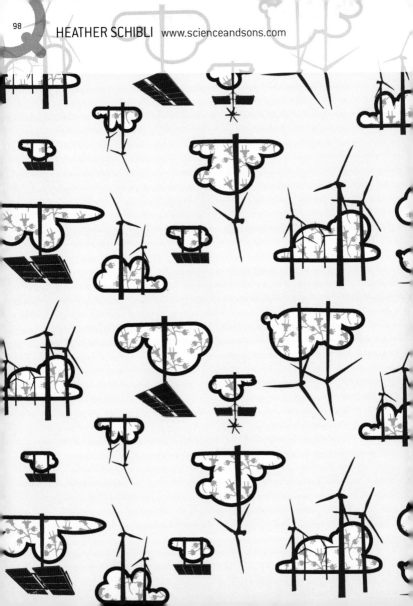

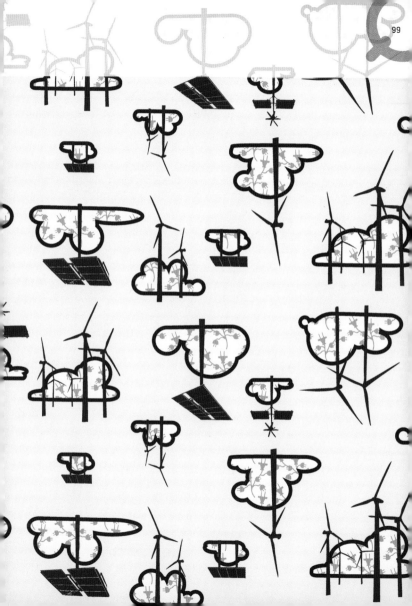

AIMEE WILDER DESIGNS www.aimeewilder.com

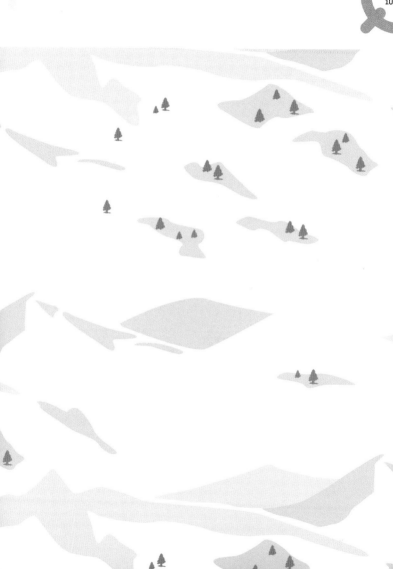

ISAK www.isak.co.uk

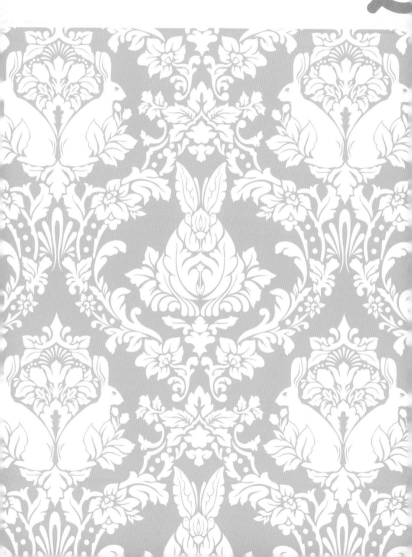

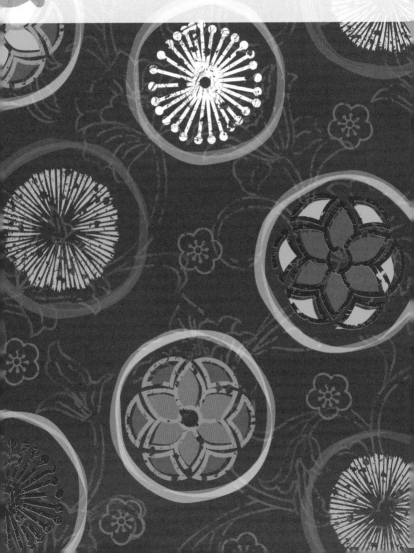

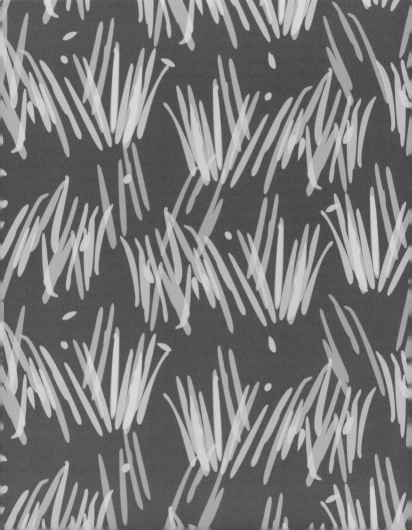

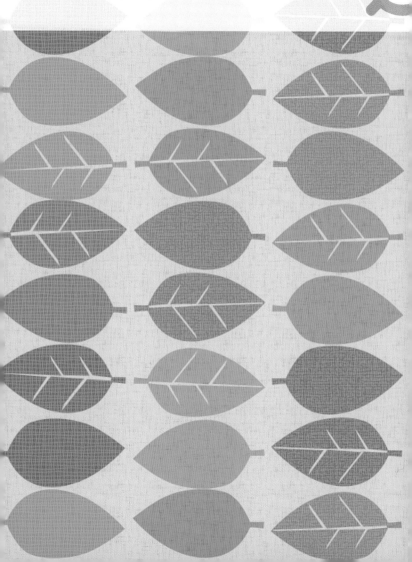

TULA PINK tulapink.com

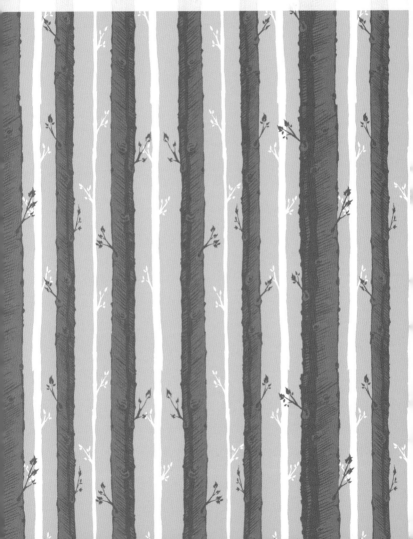

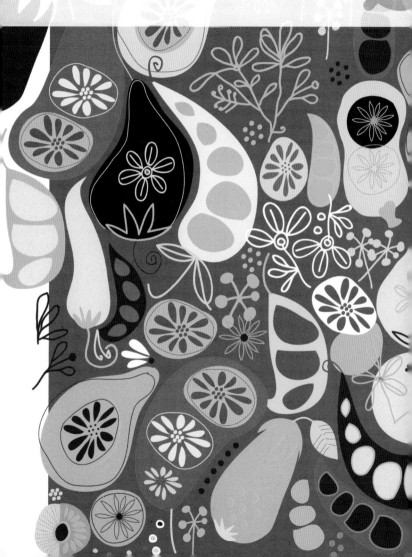

ANDRIO ABERO/33RPM www.33rpmdesign.com

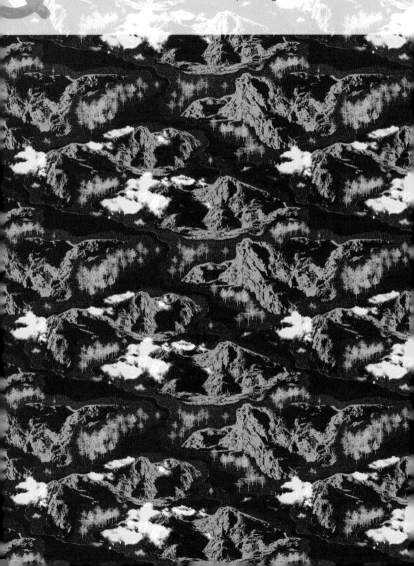

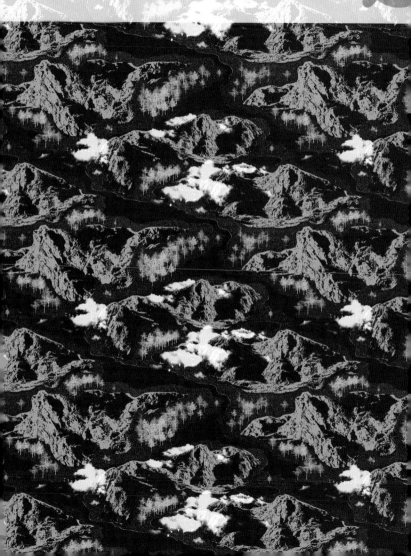

NATASHA CONNELL tashconnell@hotmail.com

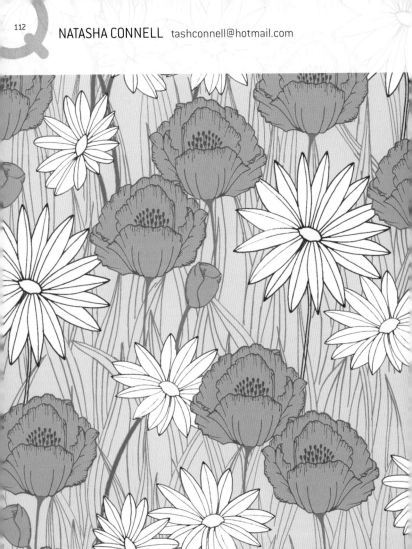

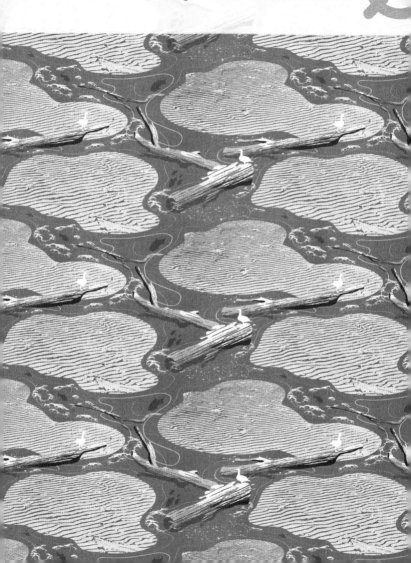

DAGMA SAFFA/CASAIDEAS ©® www.casaideas.com

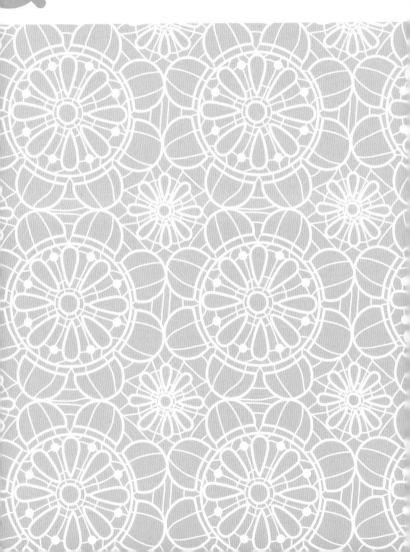

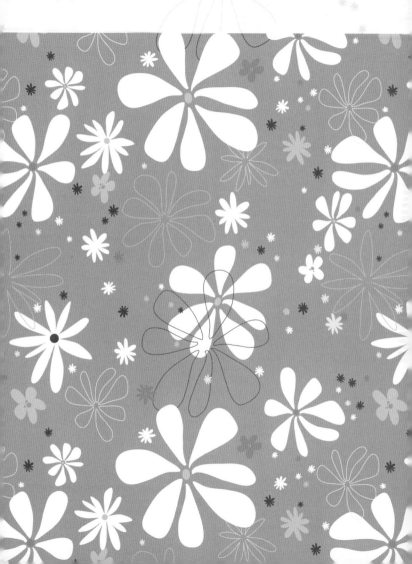

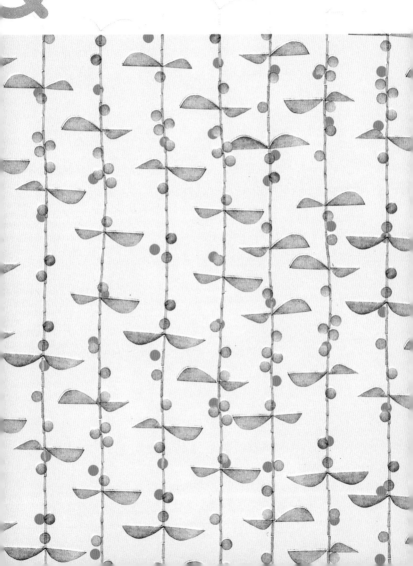

NATASHA CONNELL tashconnell@hotmail.com

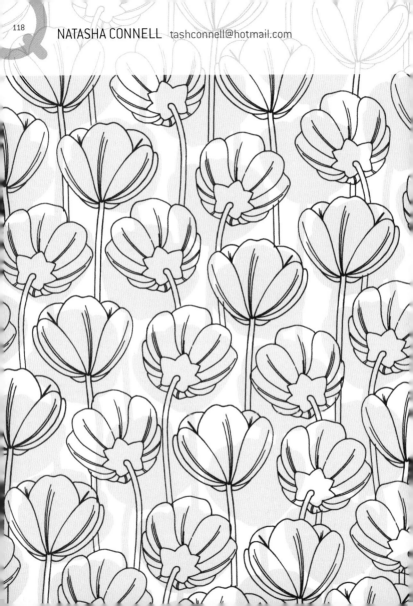

NADIA FLOWER www.peepshowsandpuppets.com

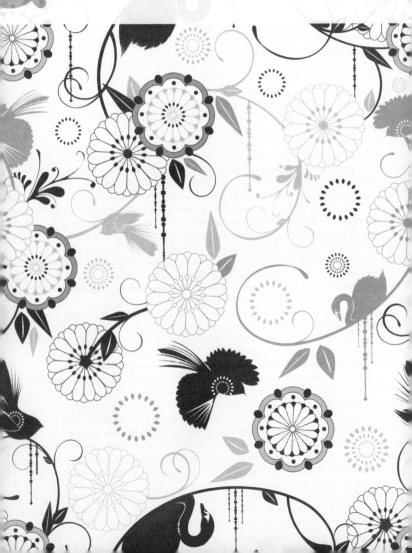

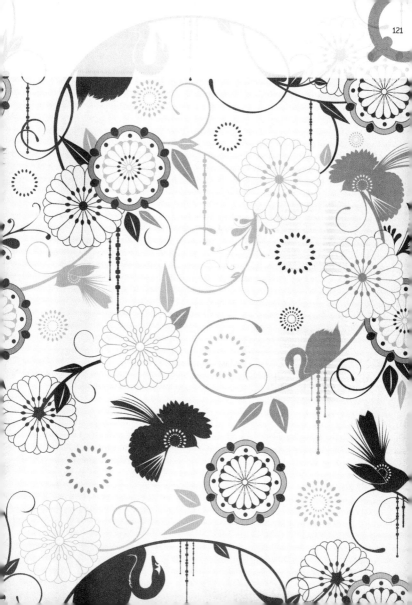

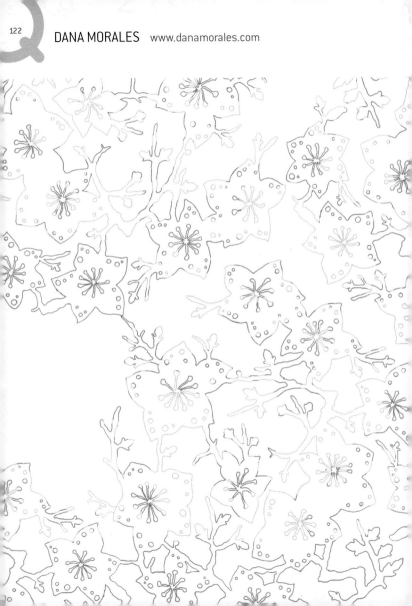

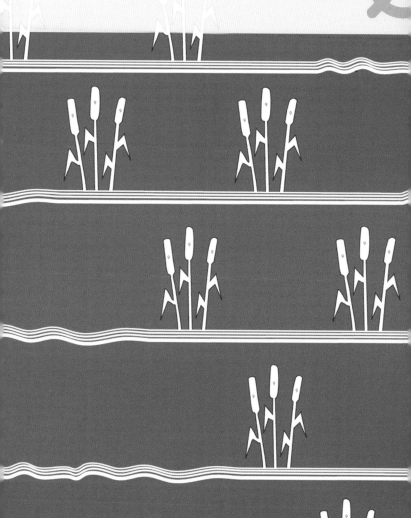

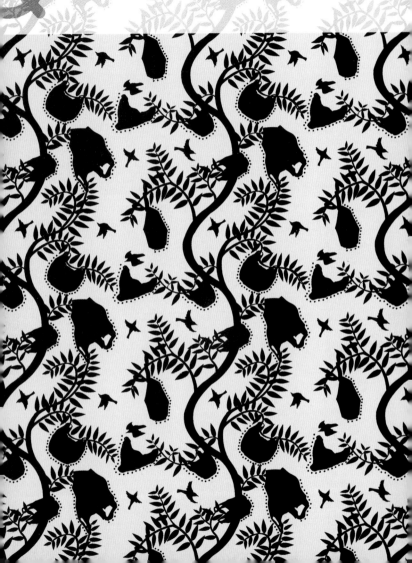

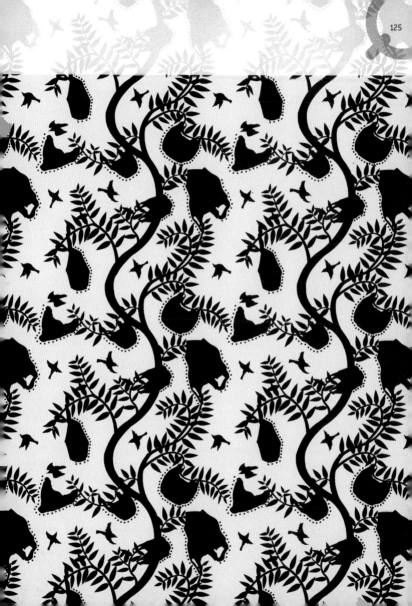

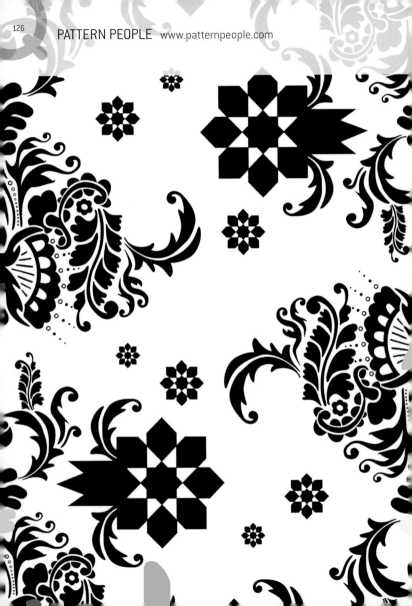

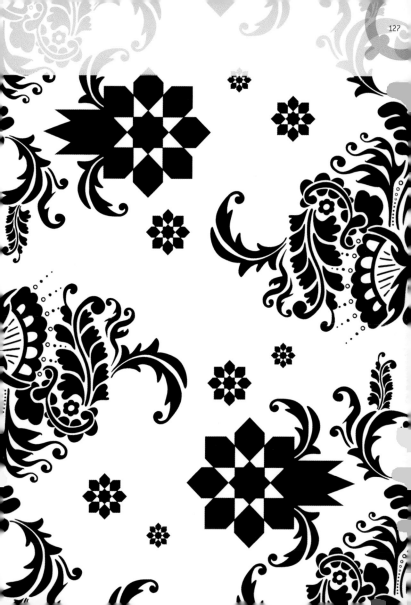

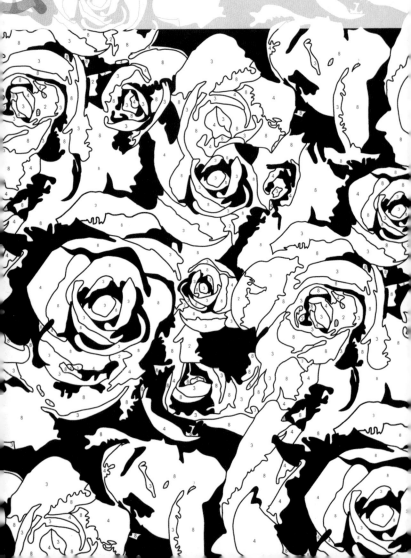

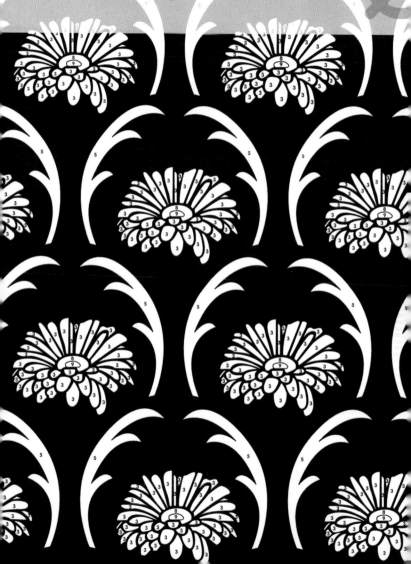

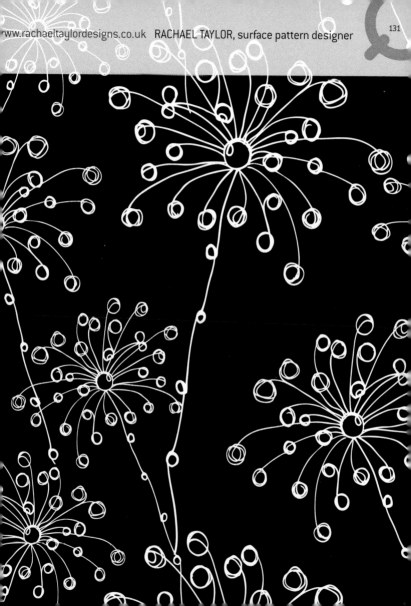

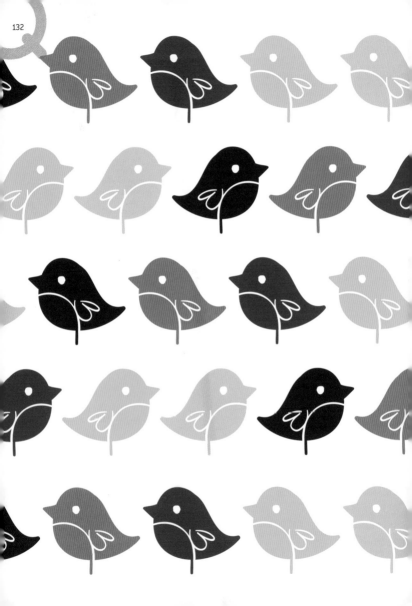

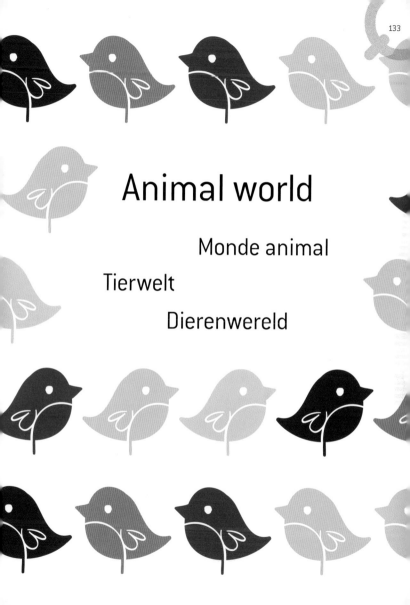

Animal world

Monde animal

Tierwelt

Dierenwereld

As the saying goes "it depends how you look at it".
That is why it is interesting to see artists' many
different interpretations of the animal world, and
how different individuals emphasize different
traits, use different concepts or abstract images,
or even place animals in completely different, and
even surreal, situations.

„Alles hat die Farbe des Glases, durch das
man schaut", sagt ein bekanntes Sprichwort.
Deshalb ist es interessant, die verschiedenen
Interpretationen rund um die Tierwelt zu
betrachten, denn es ist merkwürdig zu sehen, wie
– je nachdem, wer die Komposition kreiert – die
einen oder die anderen Züge betont werden, man
von einem Konzept oder von einer abstrakten Idee
ausgeht oder sich vielleicht dafür entscheidet, die
Tiere in vollkommen verschiedenen oder sogar
surrealistischen Welten darzustellen.

Comme le dit l'expression « Tout n'est qu'une
question de point de vue ». C'est pourquoi il s'avère
intéressant d'étudier les différentes interprétations
autour du monde animal, il est curieux d'observer que
selon l'auteur de la composition, certains traits sont
plus accentués que d'autres, qu'on part d'un concept
ou d'une image abstraite ou peut-être qu'on choisit
de placer les animaux dans des réalités totalement
différentes voire surréalistes.

«Alles wordt bepaald door de kleur van de bril waardoor je
het bekijkt» zegt een bekend Spaans gezegde. Daarom is het
interessant om de verschillende interpretaties rondom de
dierenwereld te bekijken. Het is namelijk eigenaardig, afhan-
kelijk van de persoon die de compositie maakt, om te zien hoe
de nadruk wordt gelegd op het ene of het andere kenmerk,
hoe van een bepaald concept of van een abstract beeld wordt
uitgegaan, of dat er wellicht voor wordt gekozen om de dieren
in geheel verschillende of zelfs surrealistische werkelijkheden
te plaatsen.

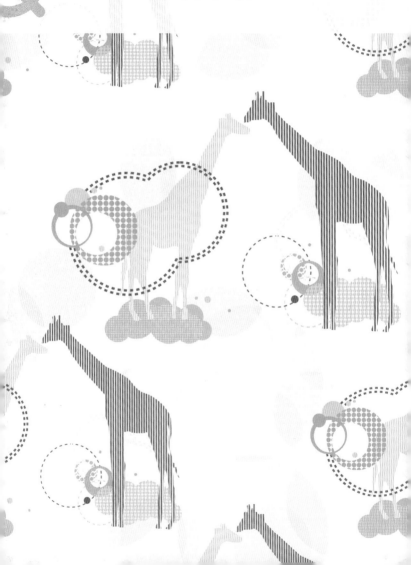

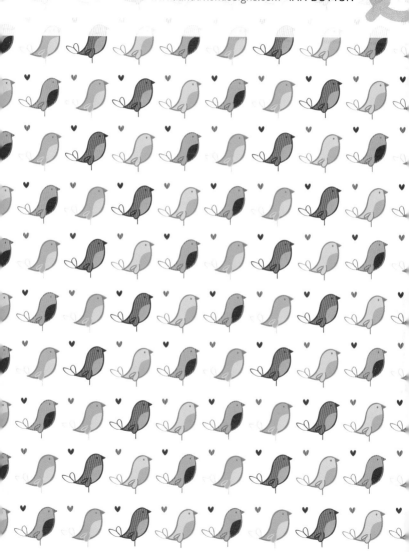

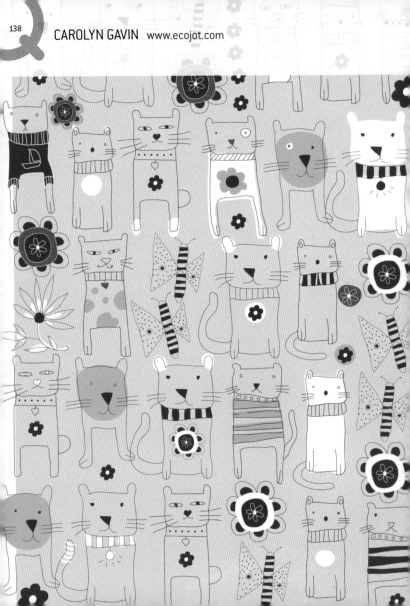

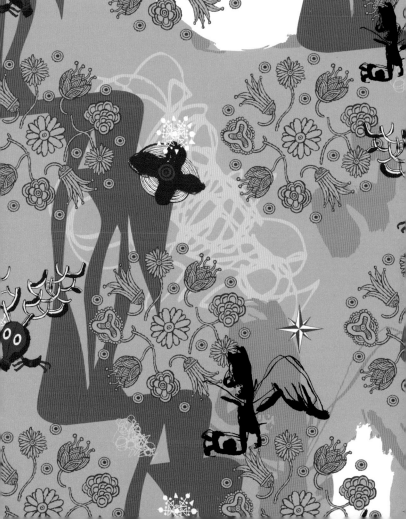

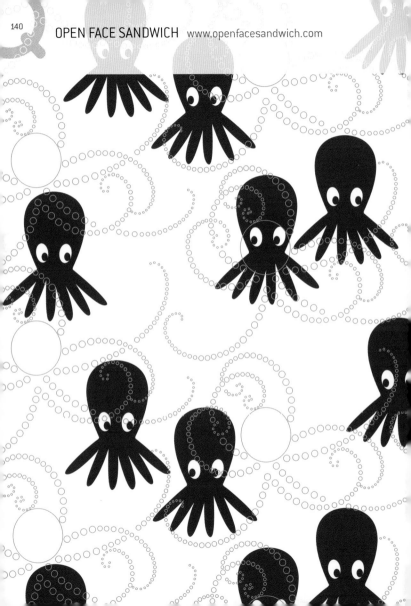

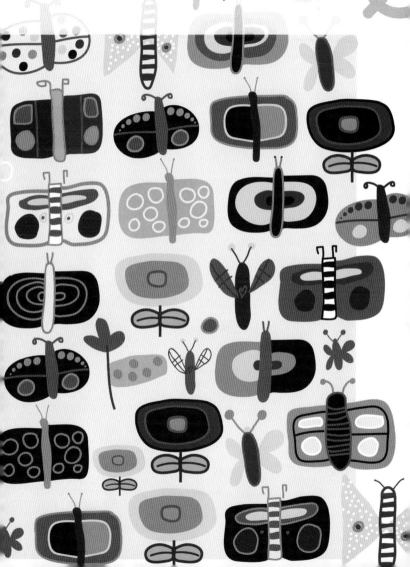

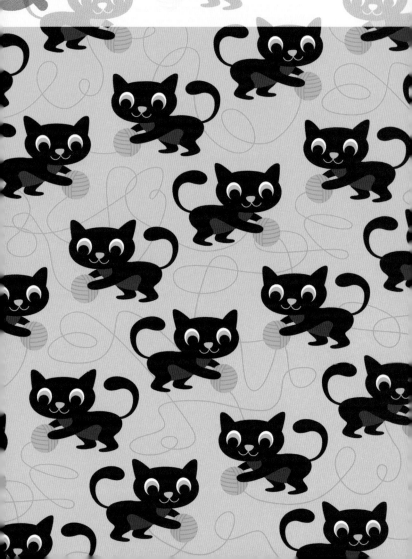

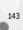
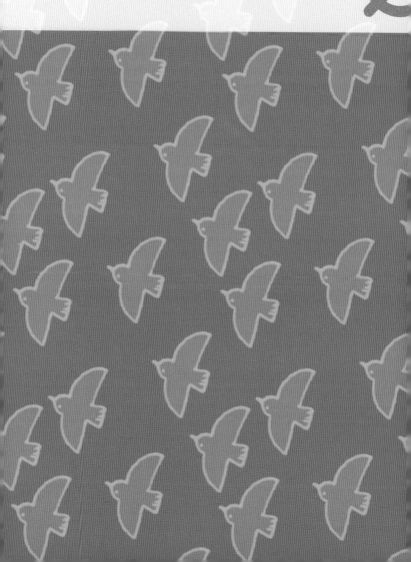

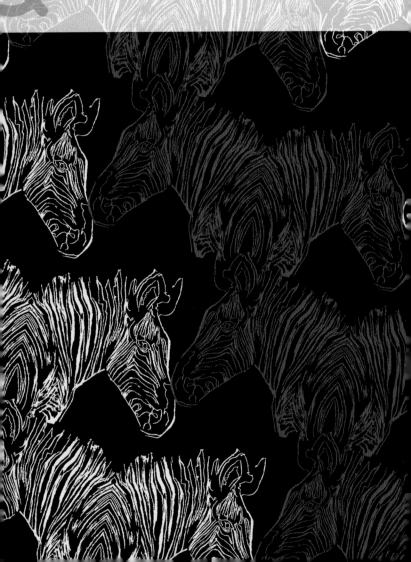

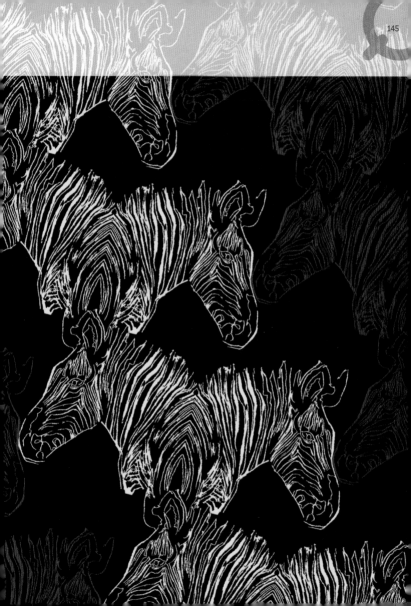

JUDIT GUETH www.juditgueth.com

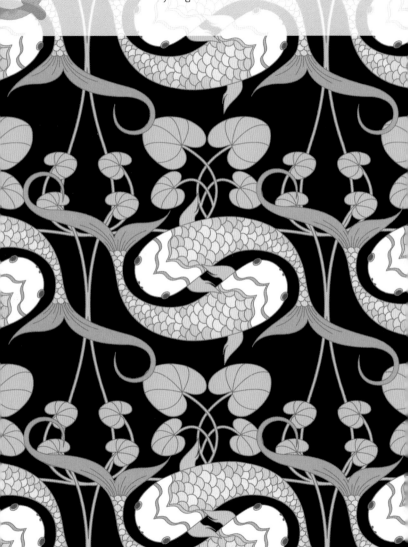

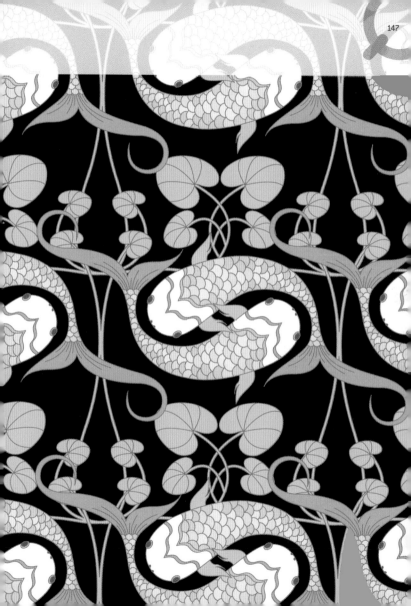

LAURA WILLIAMS www.laura-williams.com

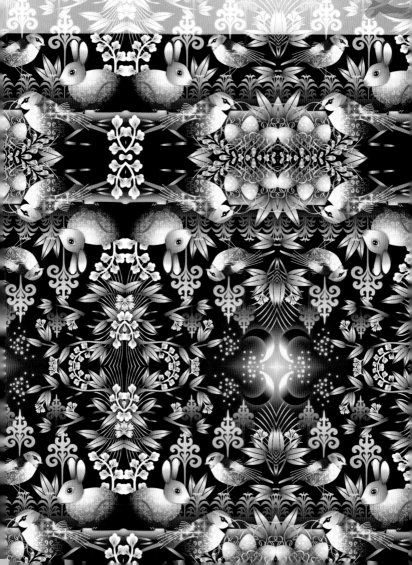

DELPHINE DOREAU/DEL4YO del4yo.squarespace.com

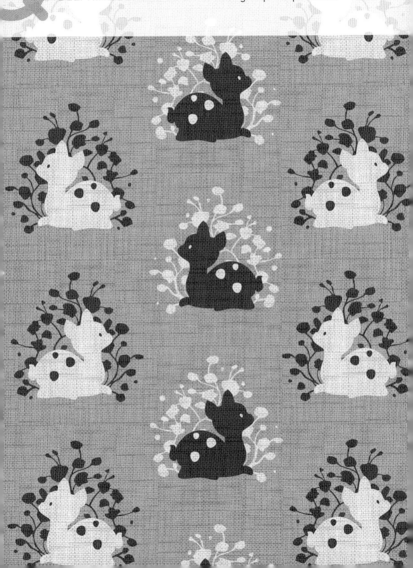

gemmamarierobinson@hotmail.co.uk **GEMMA ROBINSON**

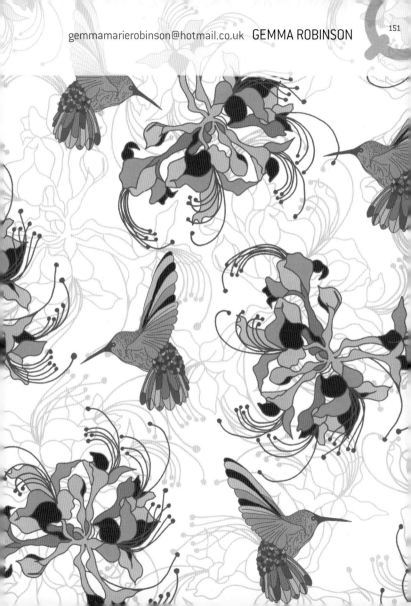

INGELA P ARRHENIUS www.ingelaparrhenius.com

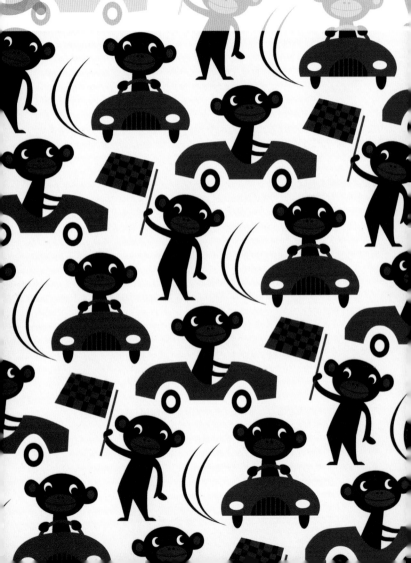

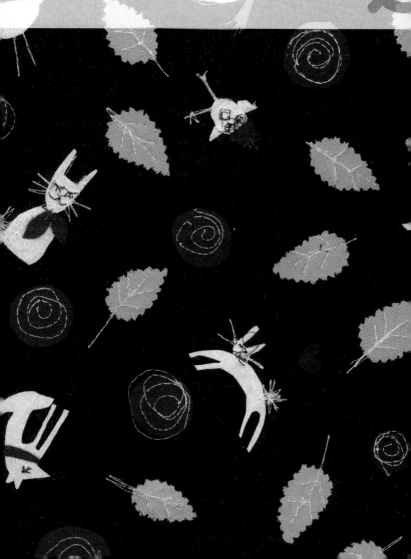

©carol eldridge

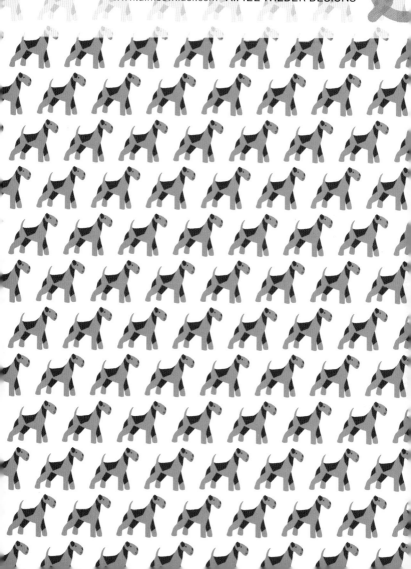

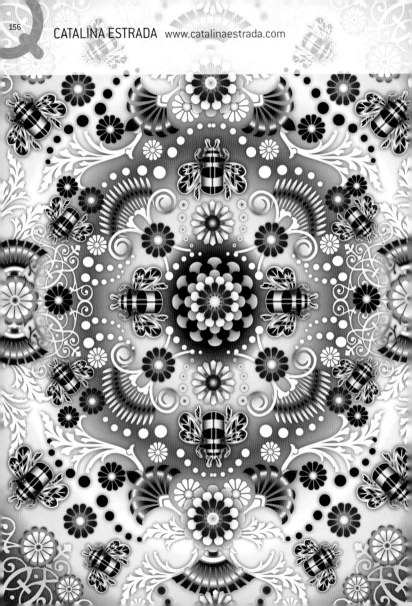

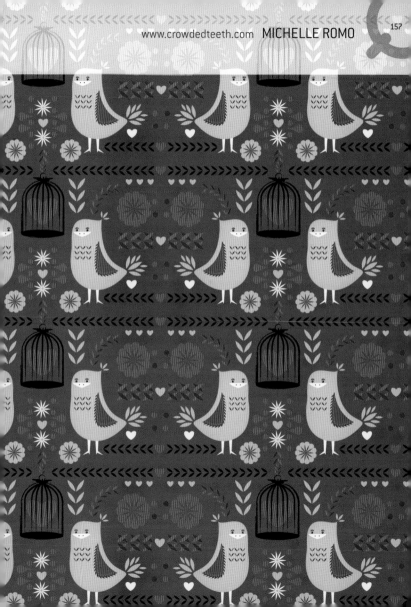

CHAN LYNN/JINJERUP jinjerup.blogspot.com

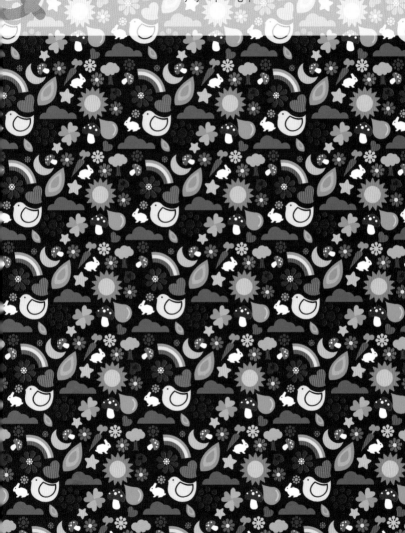

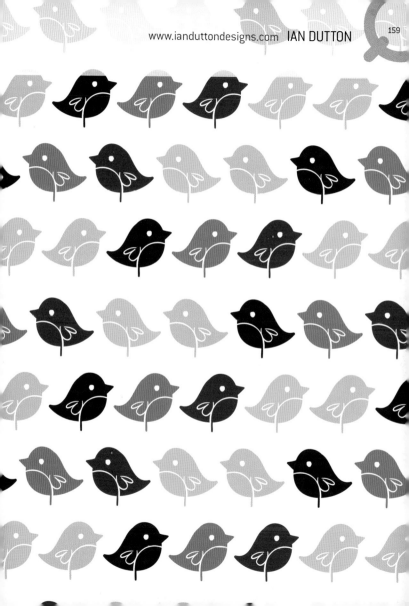

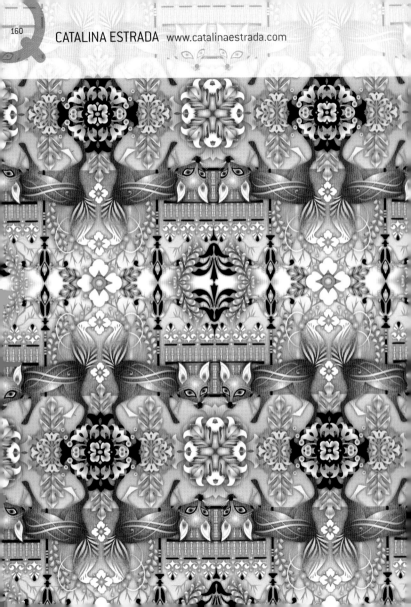

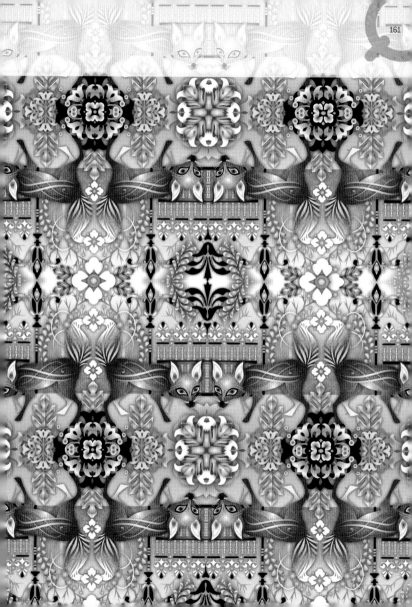

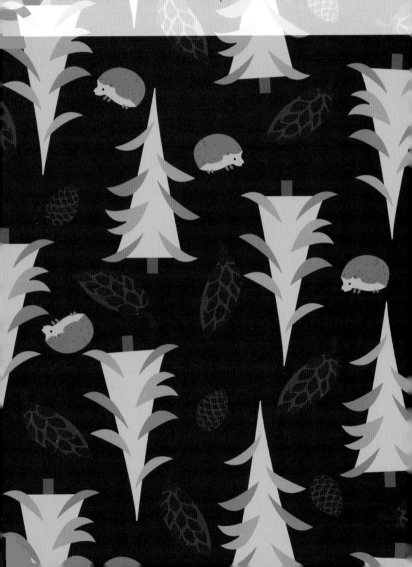

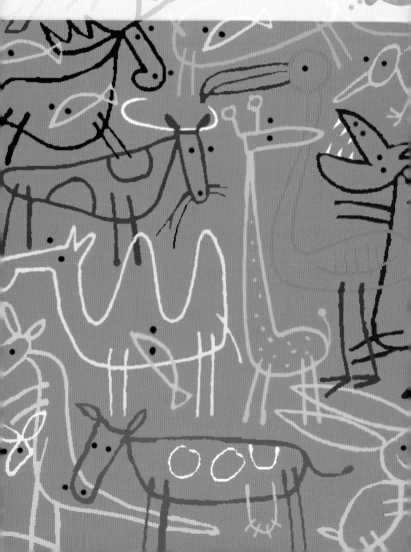

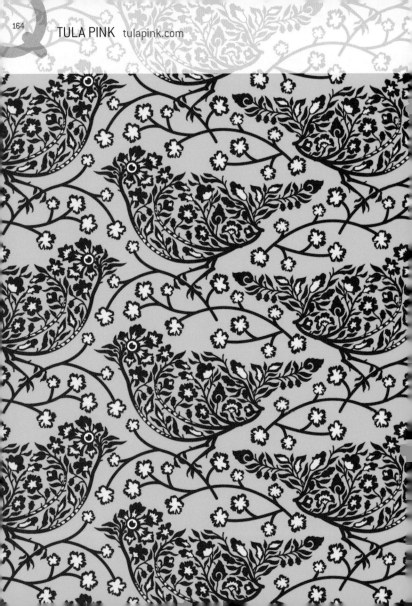

TULA PINK tulapink.com

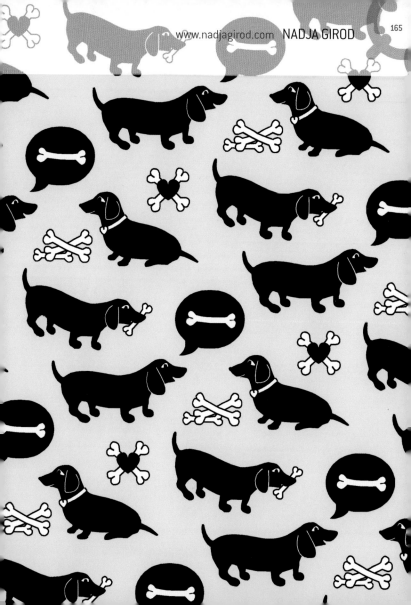

GUILHERME MARCONI www.marconi.nu

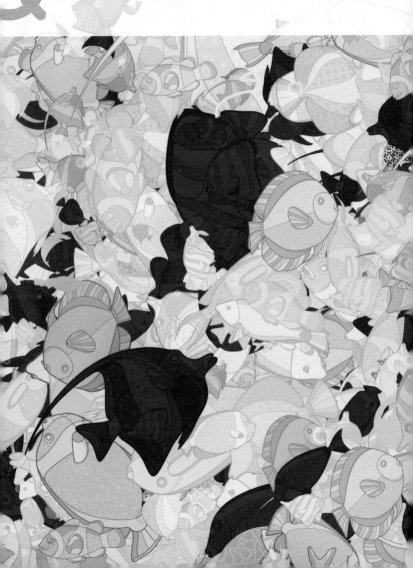

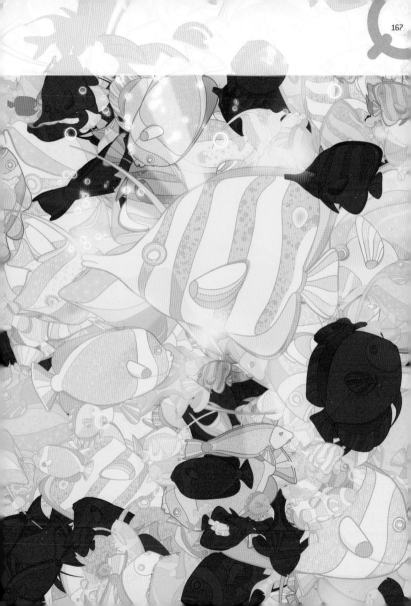

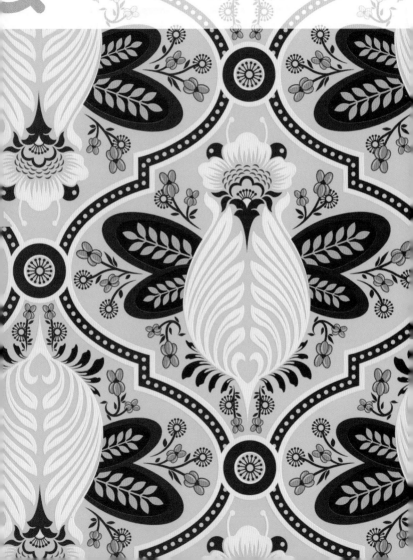

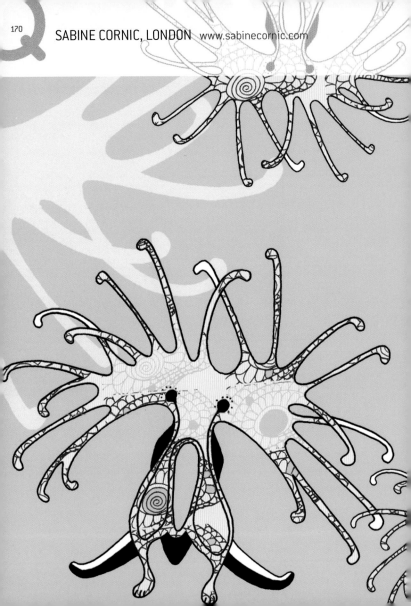

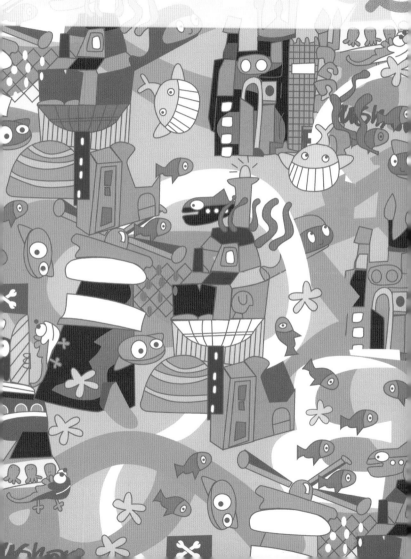

VIKKI THOMPSON vikthom@hotmail.co.uk

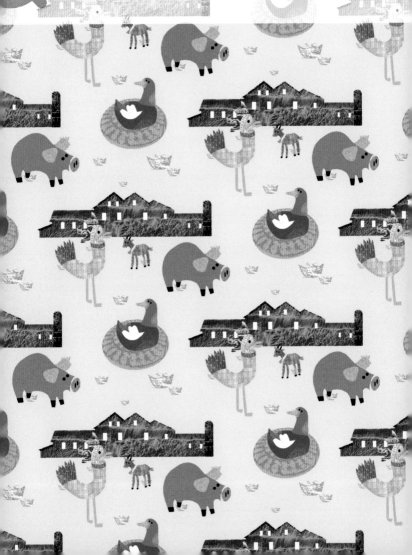

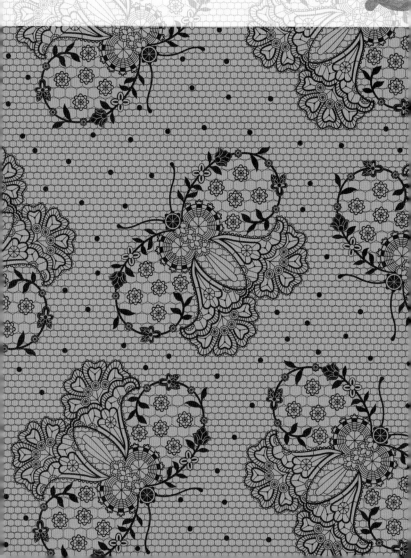

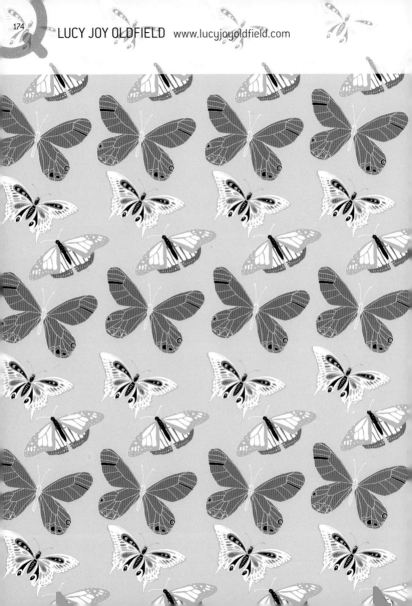

LUCY JOY OLDFIELD www.lucyjoyoldfield.com

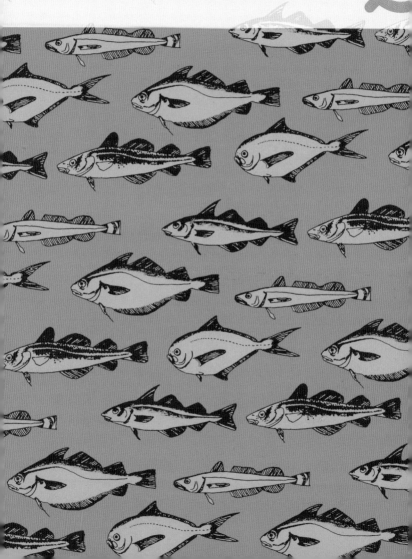

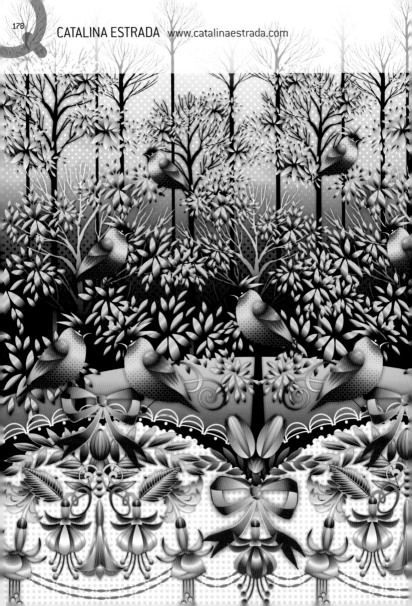

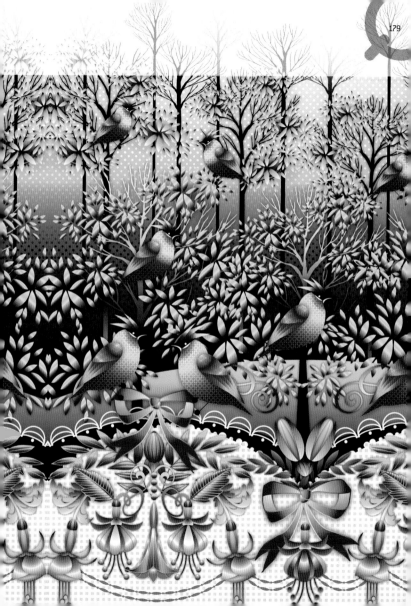

CATALINA ESTRADA www.catalinaestrada.com

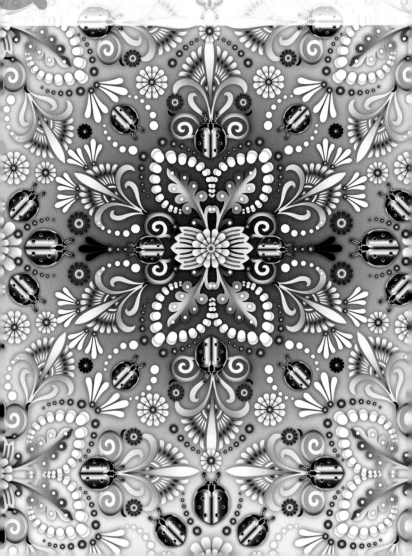

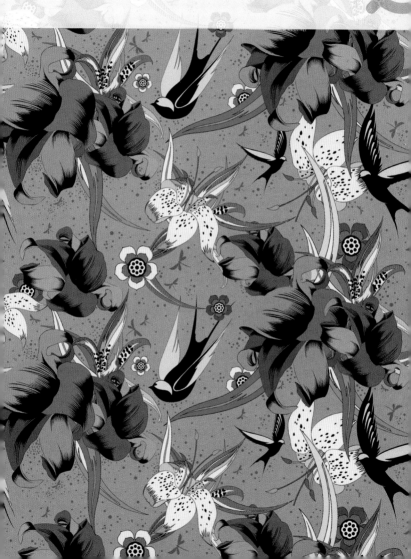

BRIAN WILLMONT www.brianwillmont.com

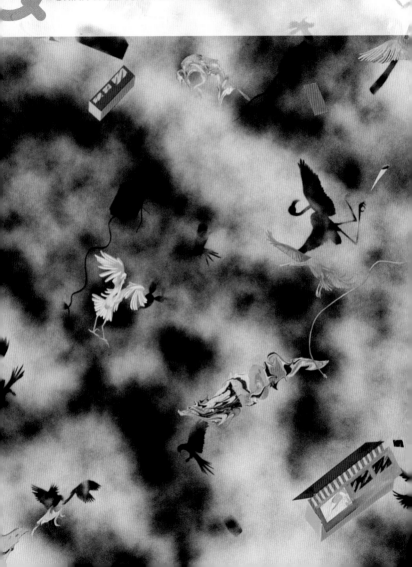

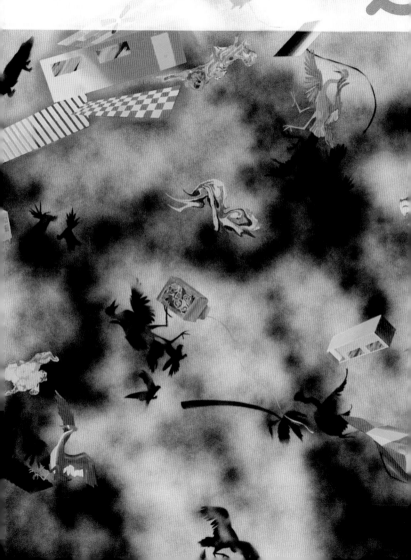

HENNIE HAWORTH www.henniehaworth.co.uk

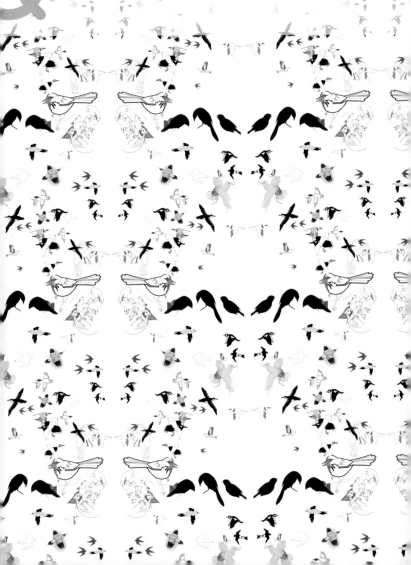

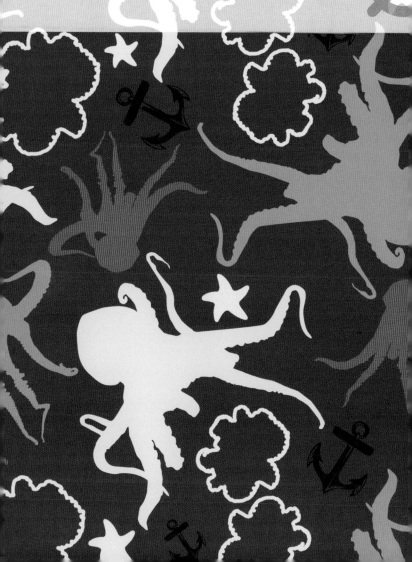

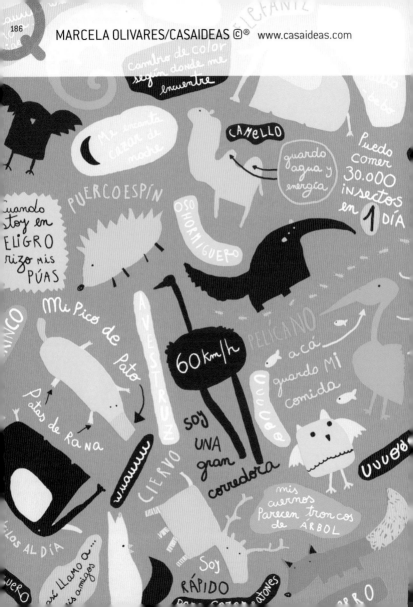

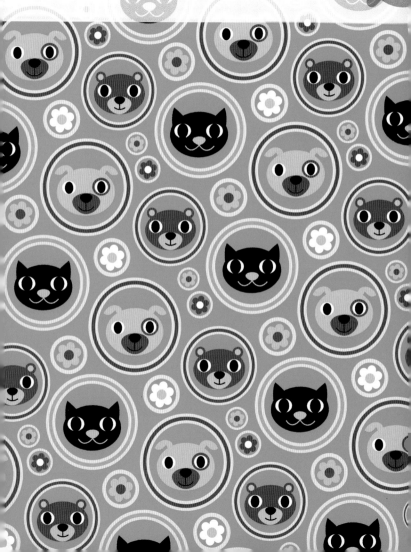

INGELA P ARRHENIUS www.ingelaparrhenius.com

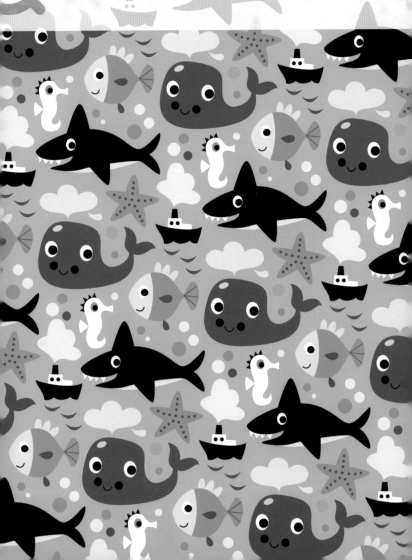

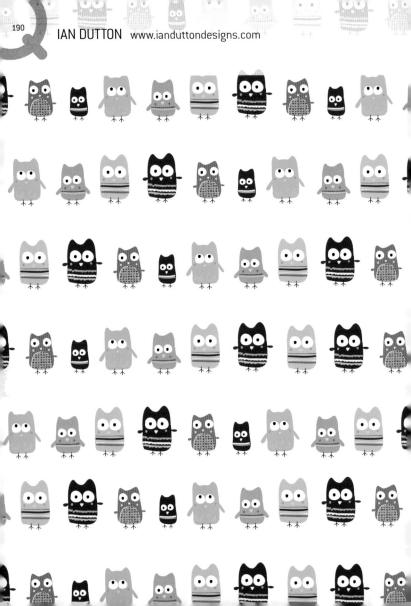

IAN DUTTON www.ianduttondesigns.com

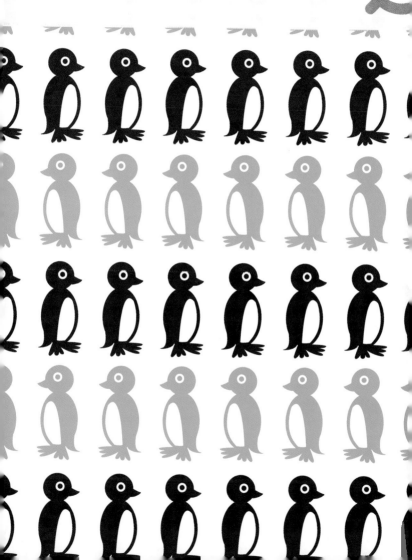

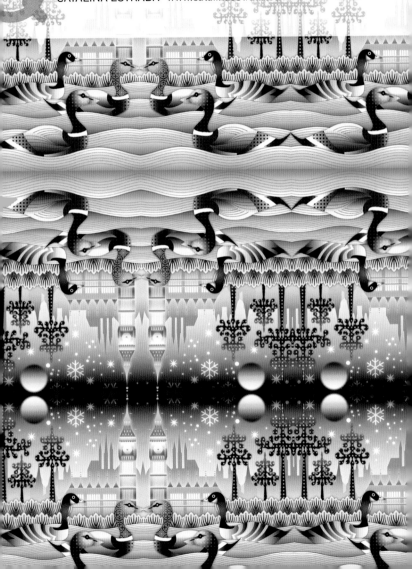

CATALINA ESTRADA www.catalinaestrada.com

JENNY WILKINSON www.jennywilkinson.com

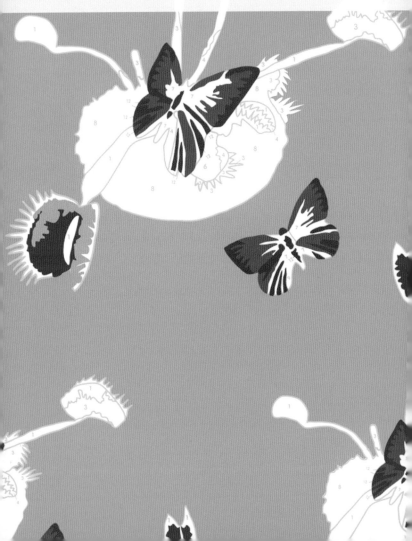

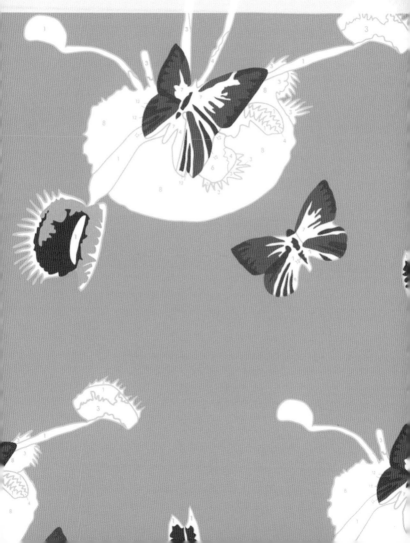

DELPHINE DOREAU/DEL4YO del4yo.squarespace.com

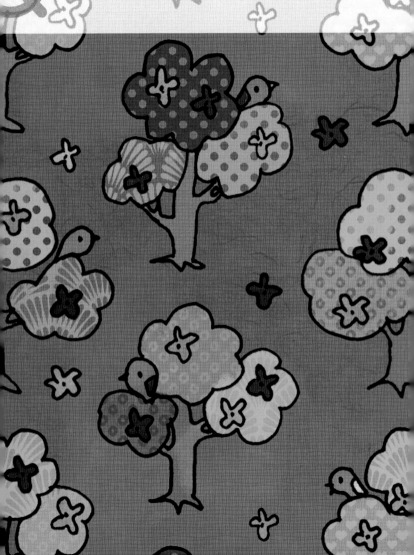

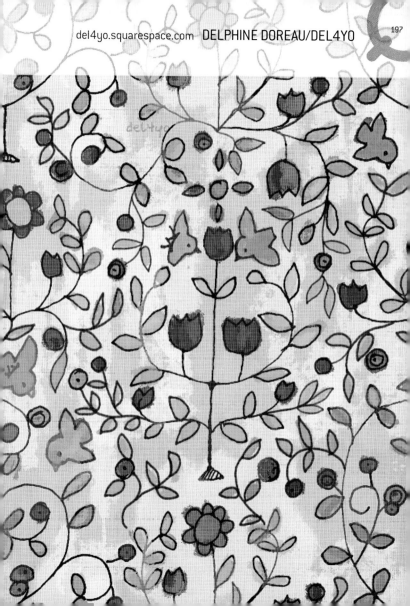

CAROLINE BOURLÈS mytextiledesign.com

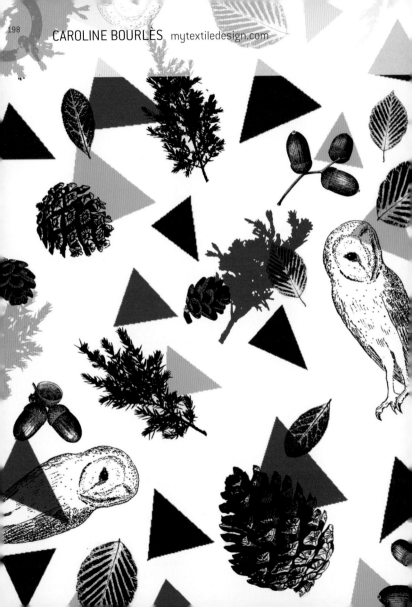

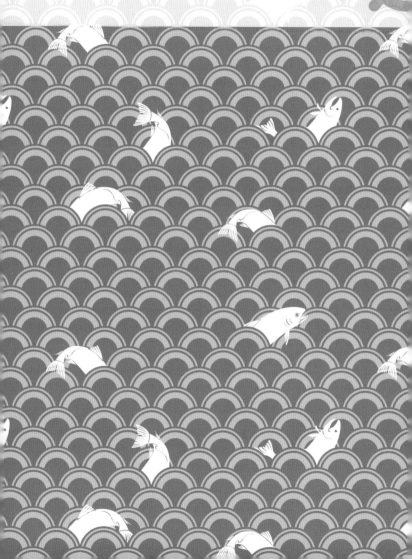

AIMEE WILDER DESIGNS www.aimeewilder.com

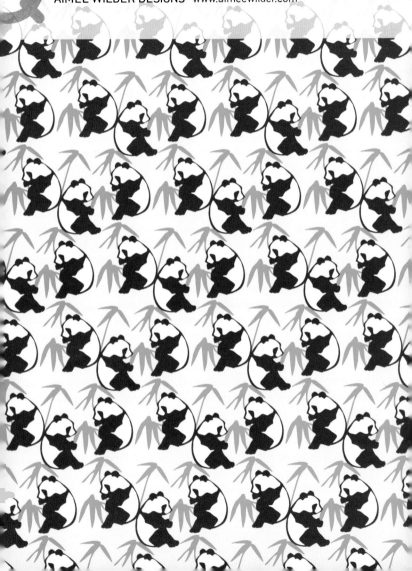

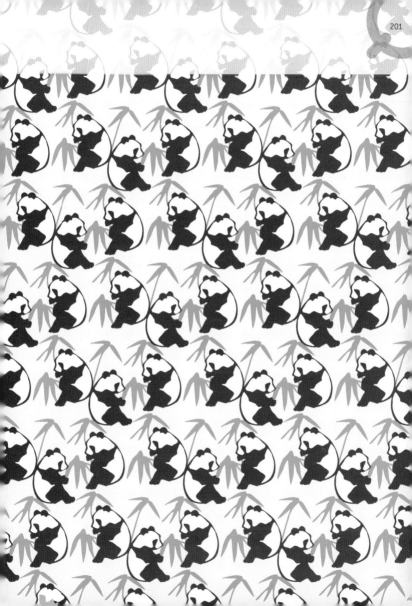

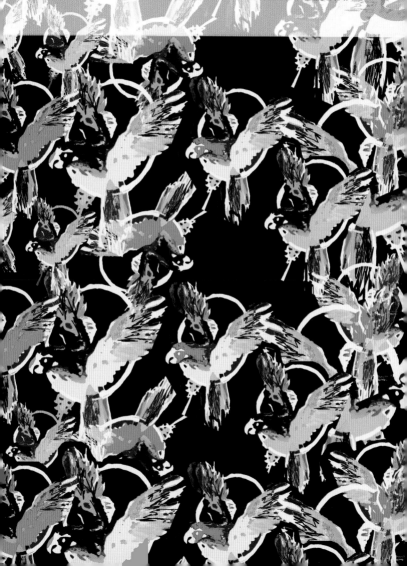

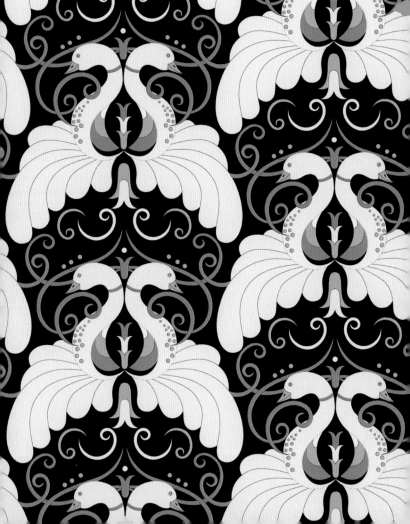

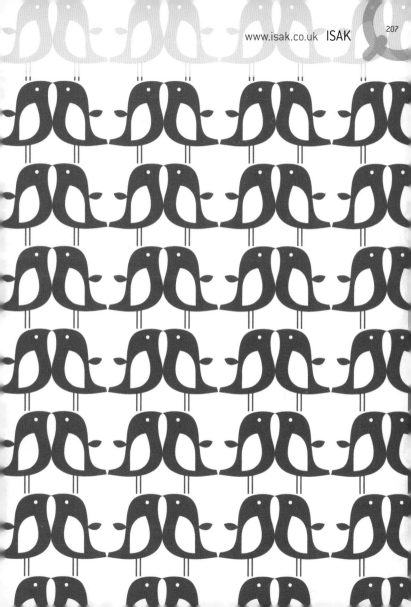

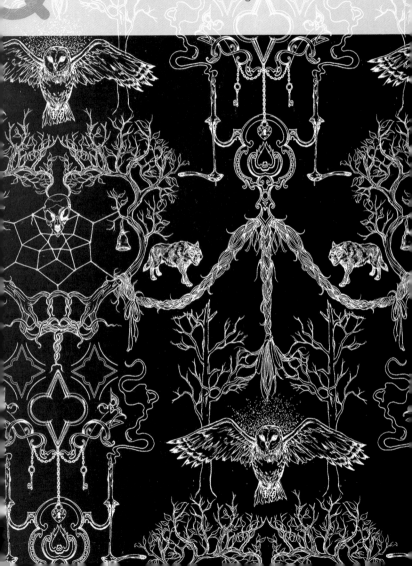

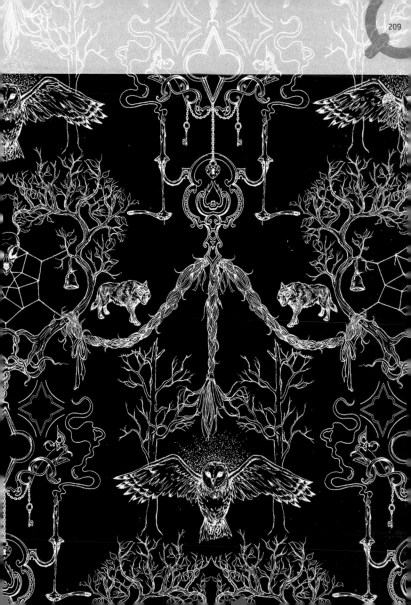

Man and his magical world

L'homme et son monde magique

Der Mensch und seine magische Welt

De mens en zijn magische wereld

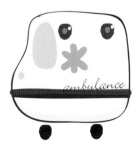

1.

3/-

.2

Drums, shoes, balls, pencils, fans... Man has created so many things for himself for all kinds of purposes. However, within this vast universe of things, each person chooses the objects they want according to their personal interests. Each person keeps the items they like and discards the ones they find less pleasing; in this way, and together with other people, individuals build their own surroundings, their own small, magical worlds.

Trommeln, Schuhe, Bälle, Bleistifte, Fächer... Wie viele Dinge könnte man nennen, die der Mensch für sich selbst zu den unterschiedlichsten Zwecken geschaffen hat? Jedoch wählt jeder einzelne aus diesem weiten Kosmos von Dingen diejenigen, die er sich je nach seinen Neigungen wünscht. Jeder Mensch behält die Objekte, die ihm gefallen, und verwirft diejenigen, die ihm unangenehm sind; auf diese Weise konstruiert er zusammen mit anderen Menschen seine eigene Umgebung, seine kleine magische Welt.

Des tambours, des chaussures, des ballons, des crayons, des éventails... On pourrait énumérer tant de choses que l'homme a créées à des fins diverses. Mais dans ce vaste univers d'objets, chacun choisit ceux qu'il veut, selon ses préférences. Chacun se focalise sur les objets qui lui plaisent et met de côté ceux qui lui sont peu agréables, il construit ainsi avec d'autres personnes son propre univers, son petit monde magique.

Trommels, schoenen, ballen, potloden, waaiers... Hoeveel dingen zouden er niet genoemd kunnen worden met betrekking tot datgene wat de mens voor allerlei doeleinden voor zichzelf heeft gecreëerd. Niettegenstaande kiest iedereen binnen dit ruime universum van dingen, die voorwerpen uit die hij leuk vindt en laat andere dingen weg. Op deze manier bouwt hij, samen met andere personen, zijn eigen omgeving op, zijn eigen kleine magische wereld.

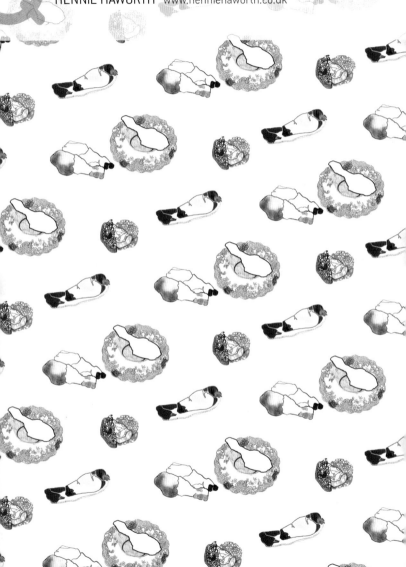

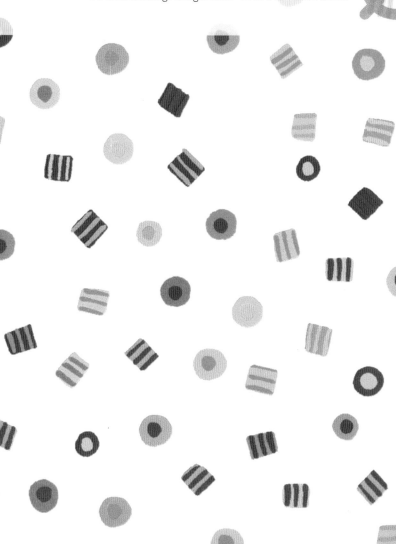

IAN DUTTON www.ianduttondesigns.com

some things are meant to be.

me · love

some things are meant to be. wishing you a happy ever after.

you & me · love you & me

some things are meant to be.

some things are meant to be. wishing you a happy ever after. some things are

you with love

some things are meant to be.

some things are meant to be. wishing you a happy ever after.

you with love me

some things are meant to be.

some things are meant to be. wishing you a happy ever after. some things are

you with love me

some things are meant to be.

some things are meant to be. wishing you a happy ever after.

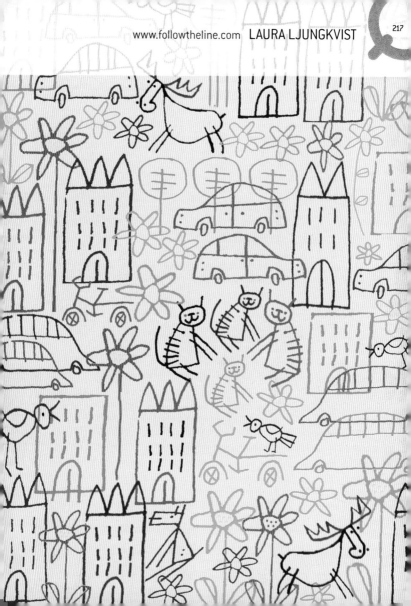

IAN DUTTON www.ianduttondesigns.com

CAROLINE BOURLÈS mytextiledesign.com

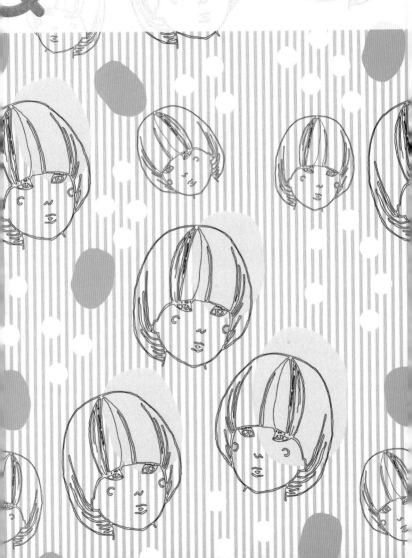

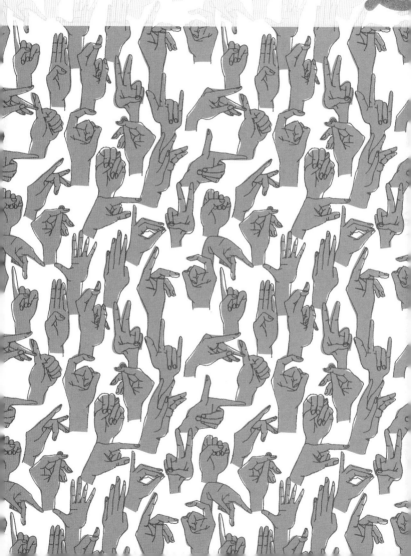

JAAKKO PALLASVUO www.jaakkopallasvuo.com

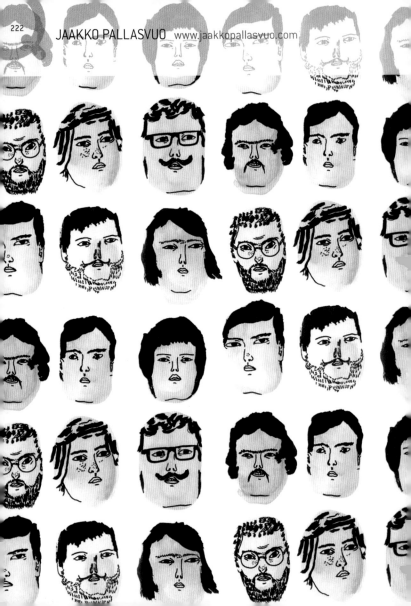

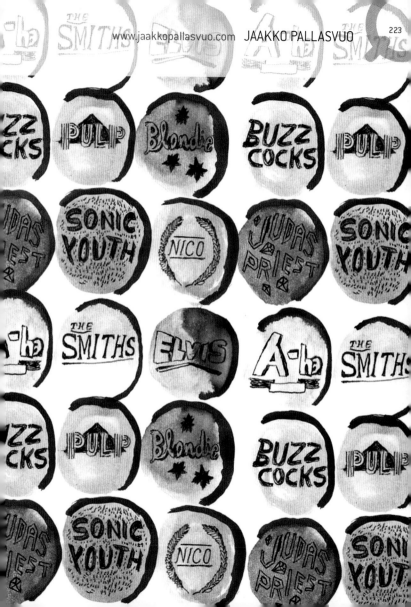

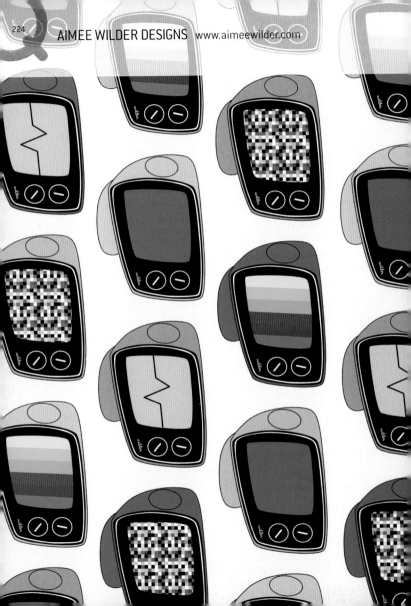

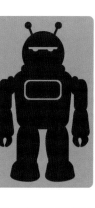
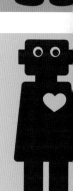
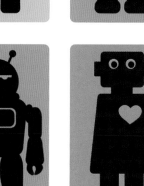
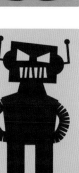
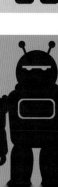

LABOLAULULINTU labolaululintu@gmail.com

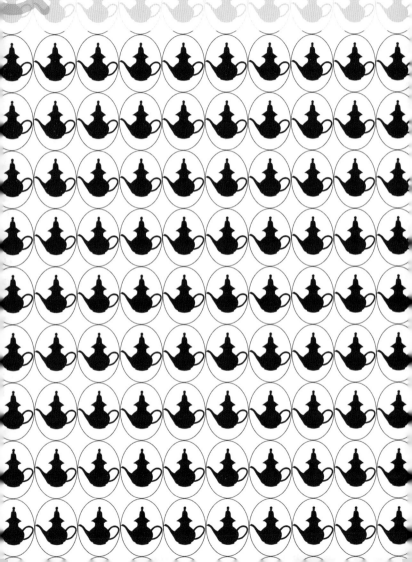

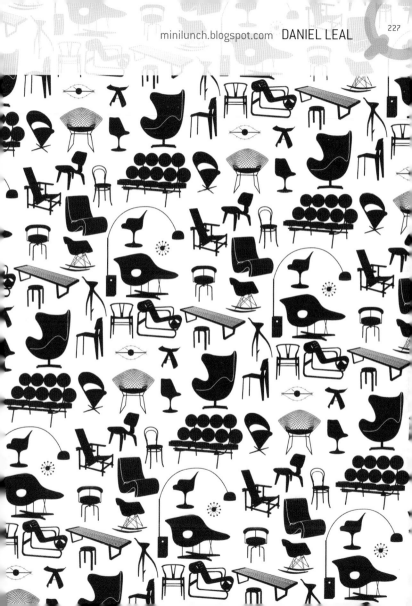

KAREN HALL www.karenhallillustration.com

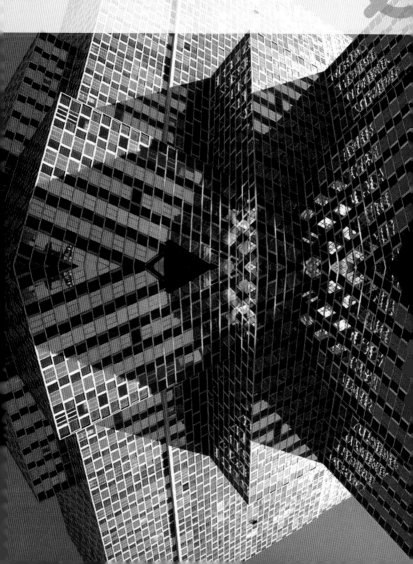

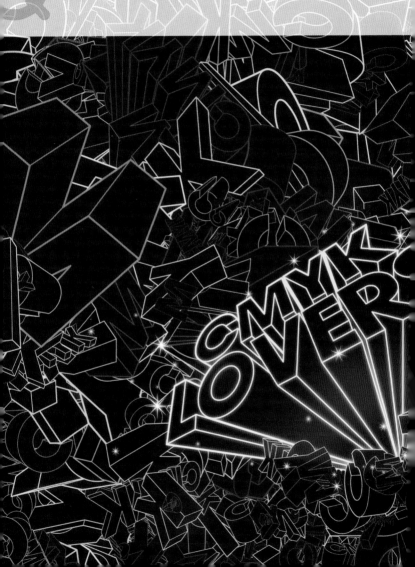

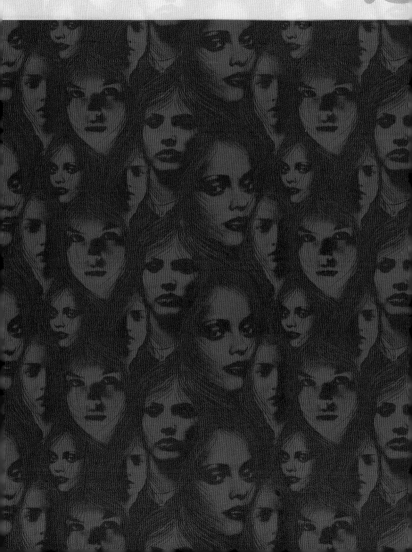

IAN DUTTON www.ianduttondesigns.com

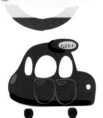
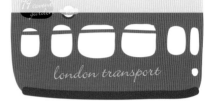

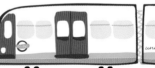

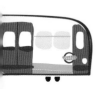

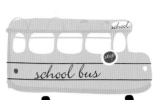

LABOLAULULINTU labolaululintu@gmail.com

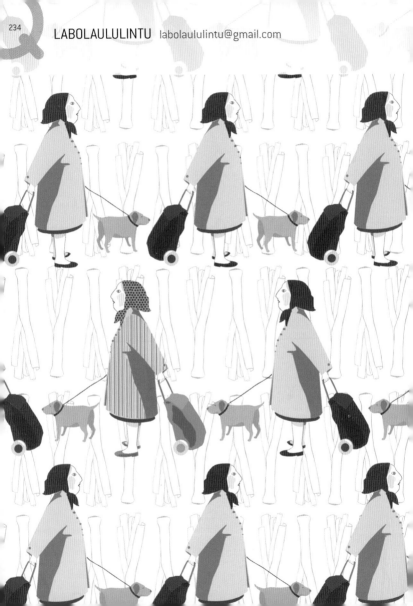

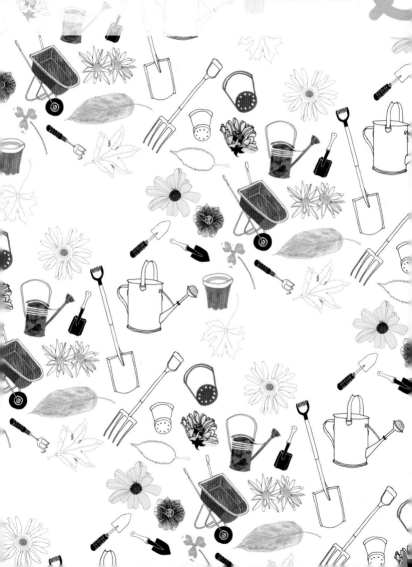

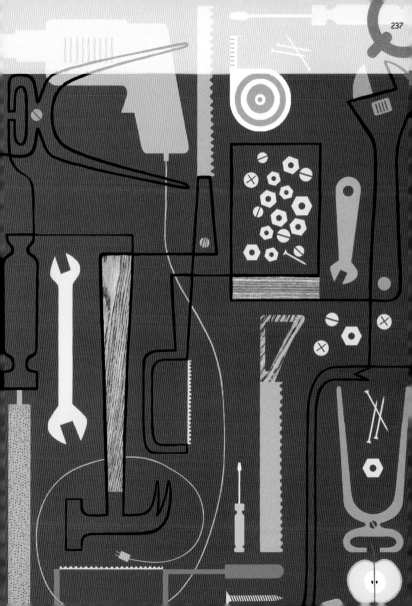

LULU HORSFIELD www.luluhorsfield.com

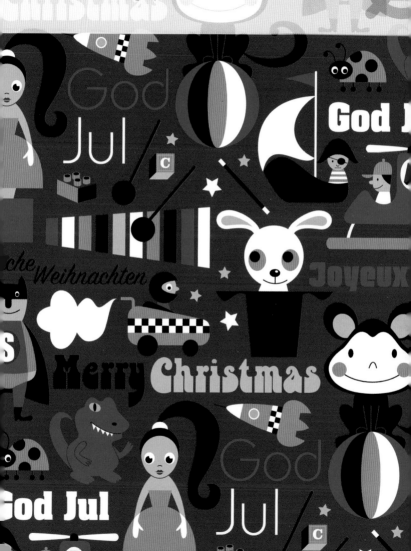

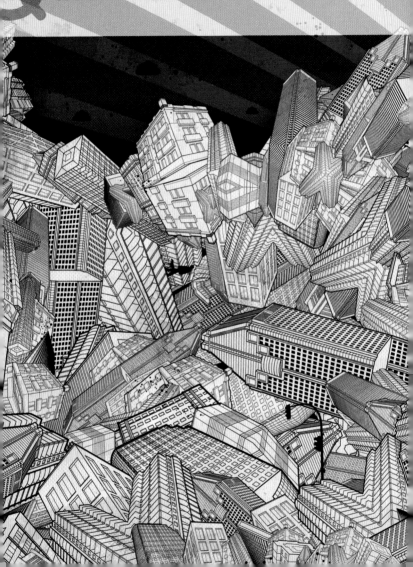

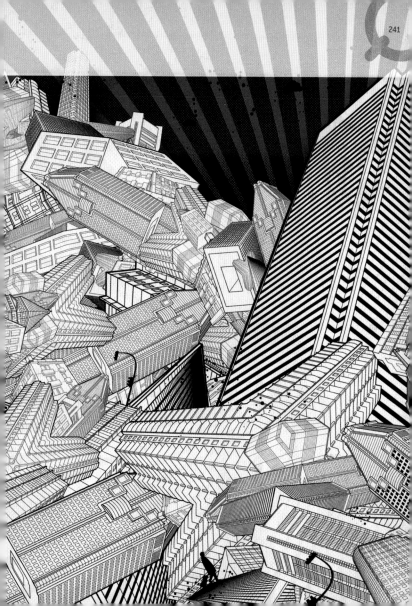

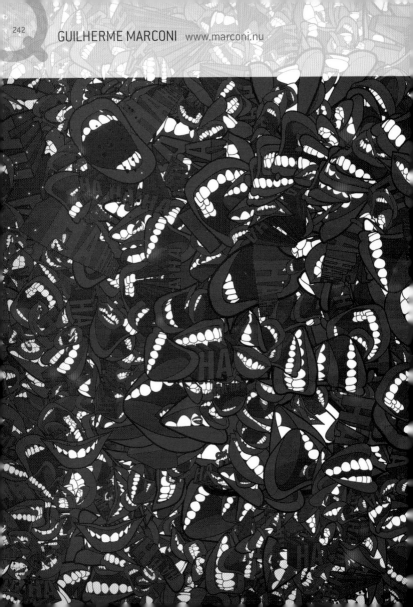

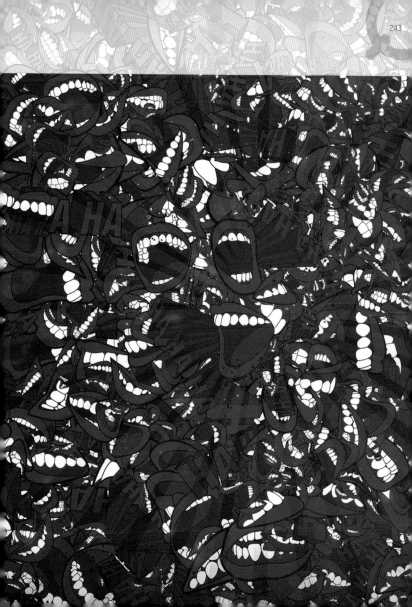

INGELA P ARRHENIUS www.ingelaparrhenius.com

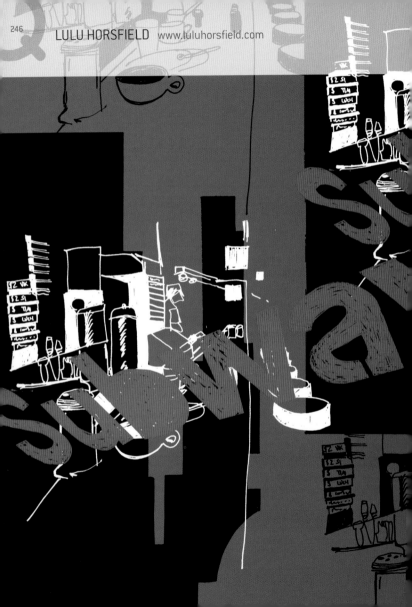

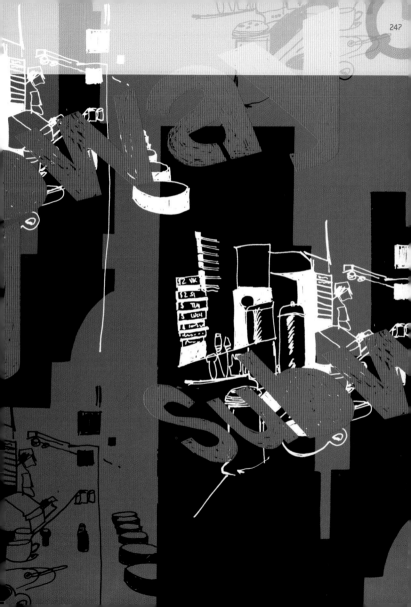

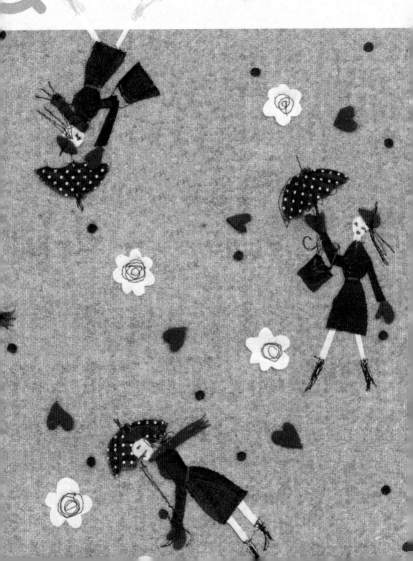

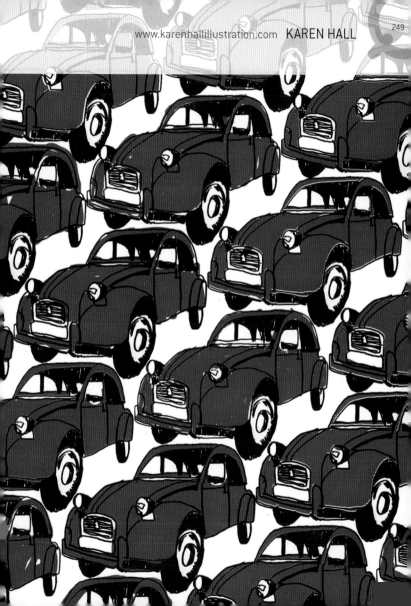

DONNA SNOWDON donna_snowdon@hotmail.com

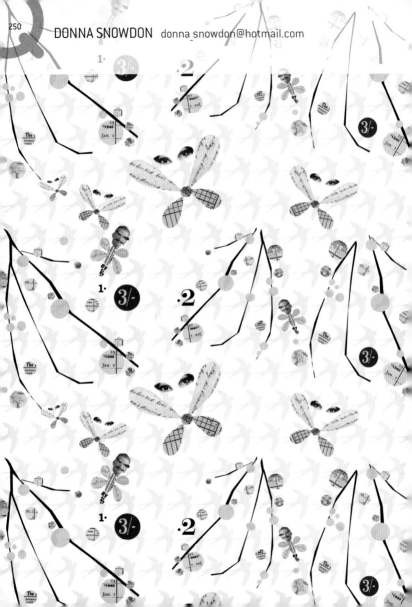

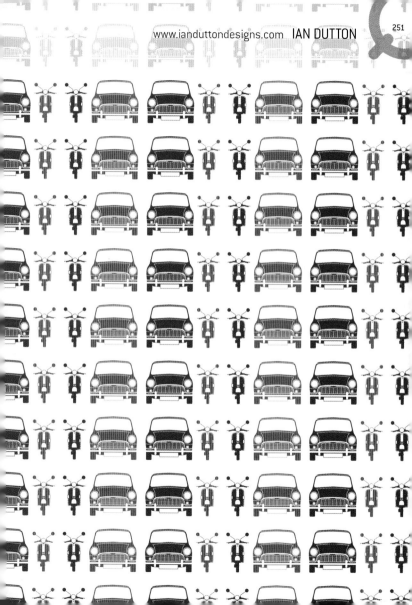

HENNIE HAWORTH www.henniehaworth.co.uk

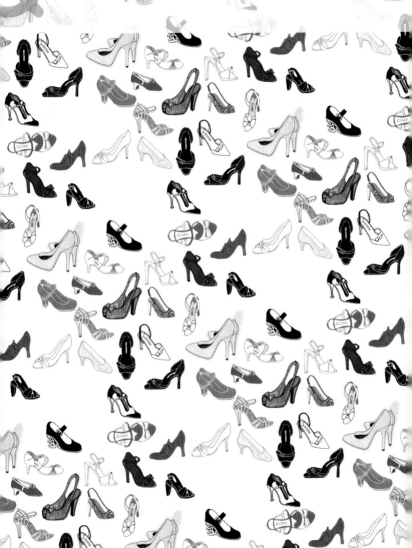

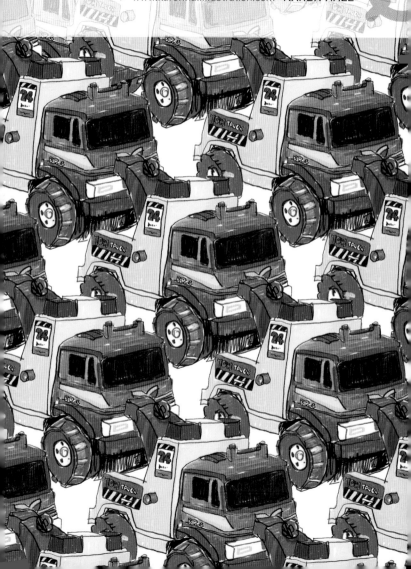

CECILIA ARIZTÍA LARRAÍN www.ceciliaariztia.cl

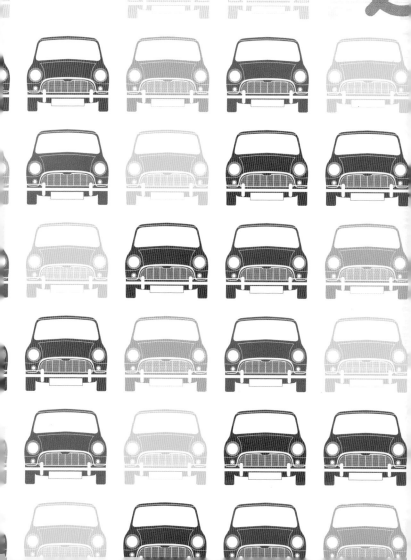

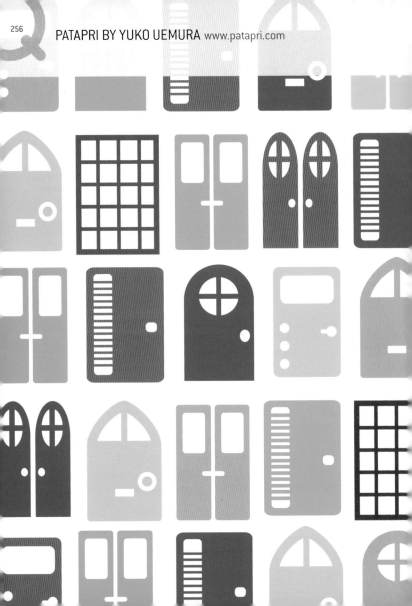

PATAPRI BY YUKO UEMURA www.patapri.com

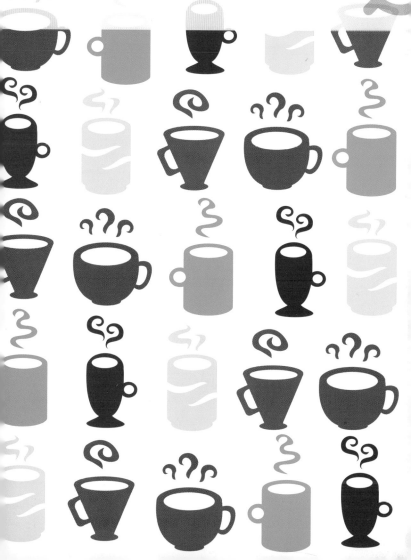

JON BURGERMAN www.jonburgerman.com

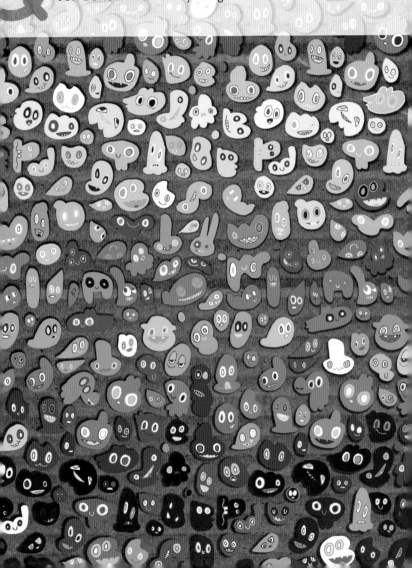

LAURA LJUNGKVIST www.followtheline.com

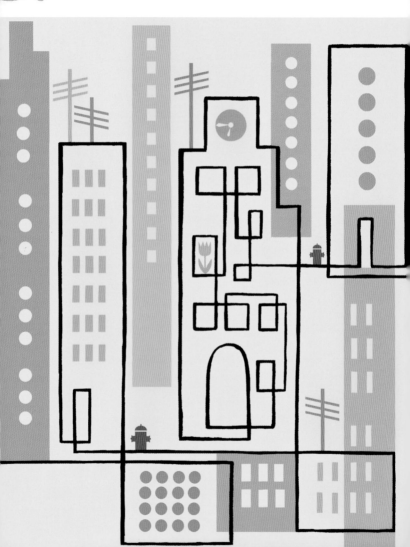

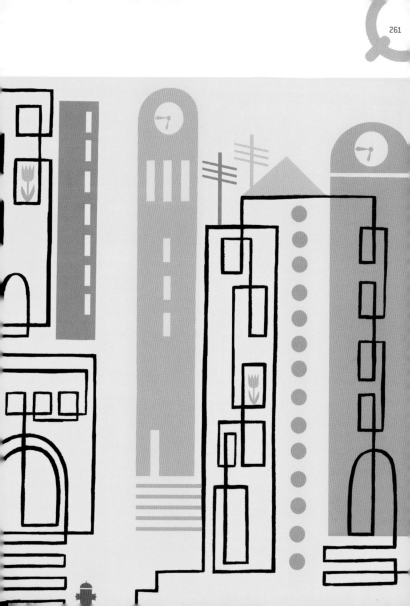

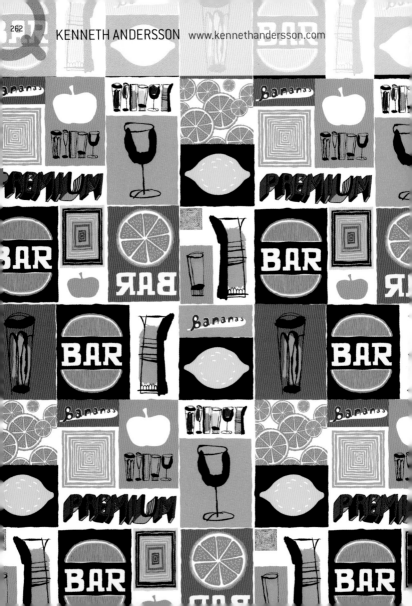

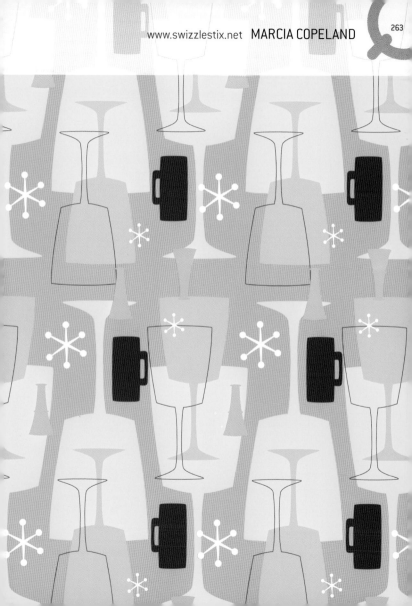

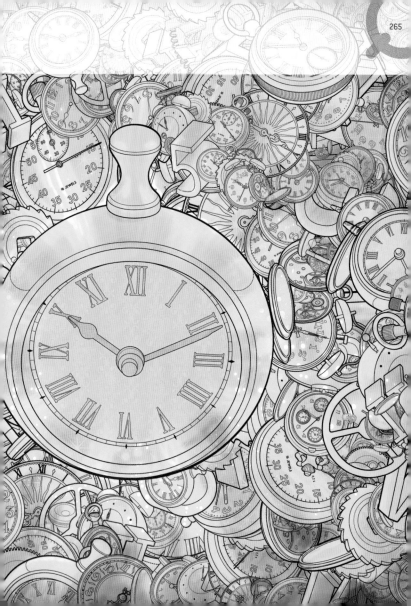

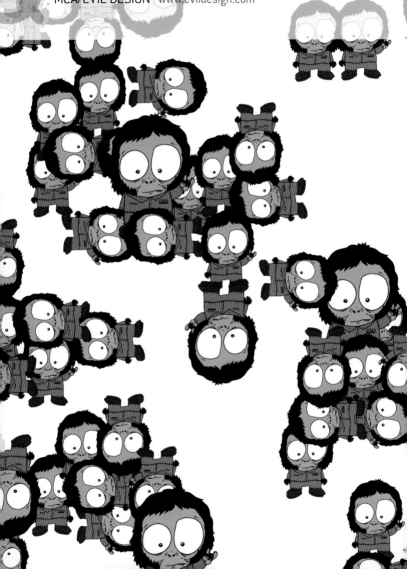

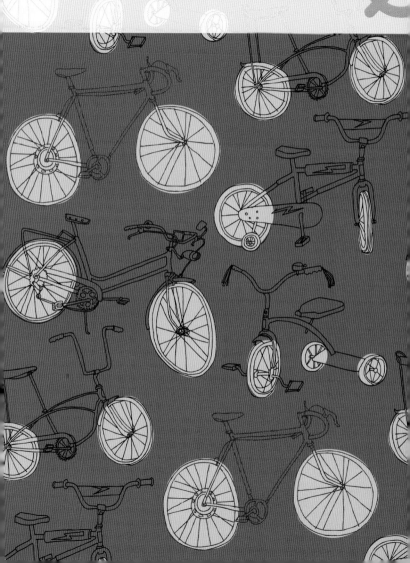

CAROLINE BOURLÈS mytextiledesign.com

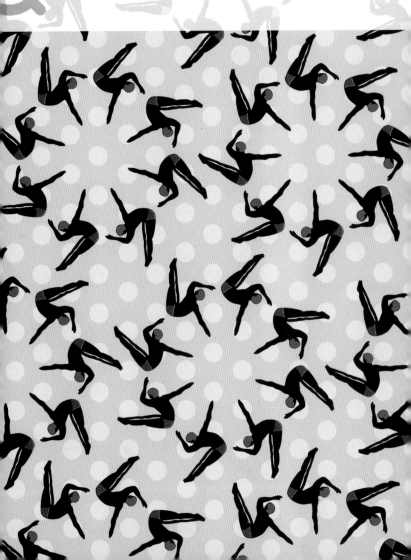

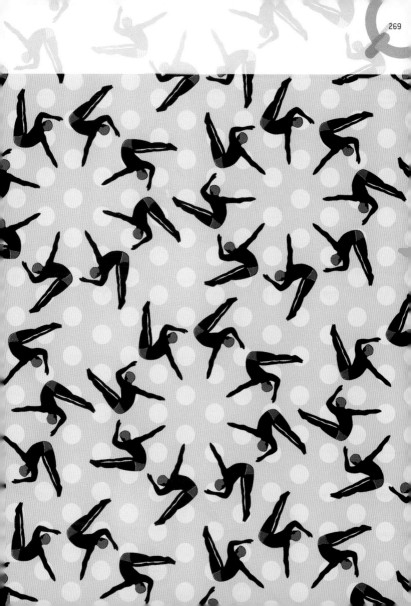

GALIT LURYA galitlurya.carbonmade.com

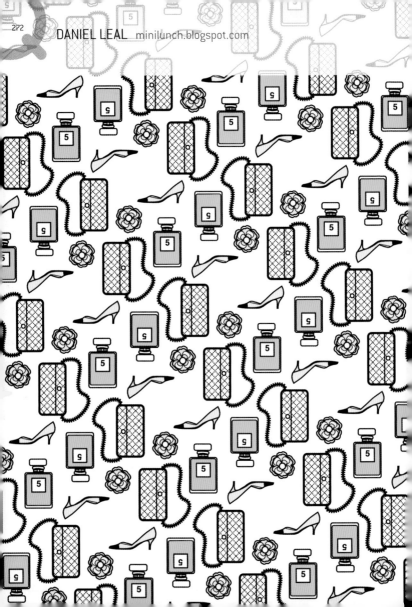

DANIEL LEAL minilunch.blogspot.com

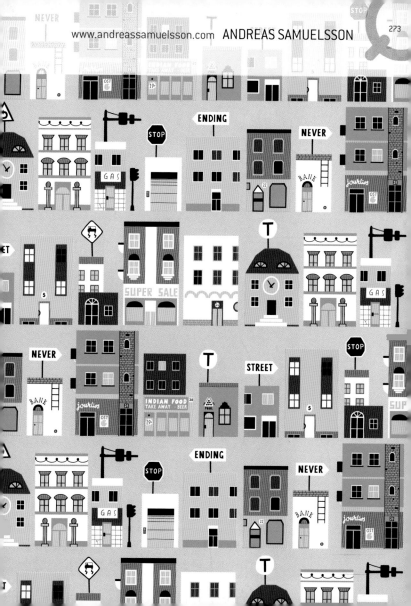

GALIT LURYA galitlurya.carbonmade.com

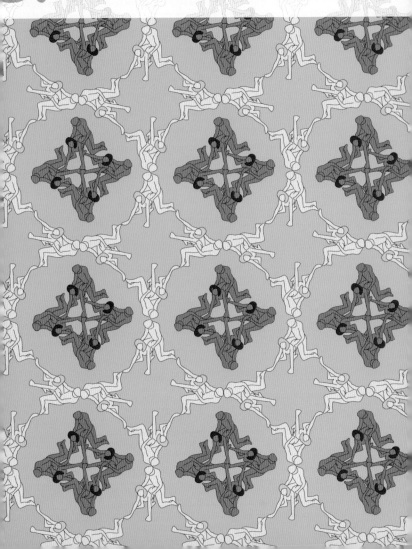

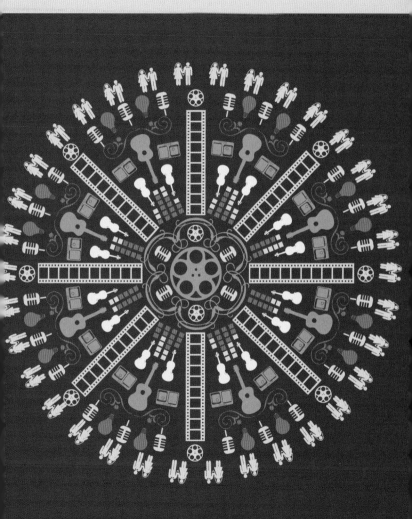

LABOLAULULINTU labolaululintu@gmail.com

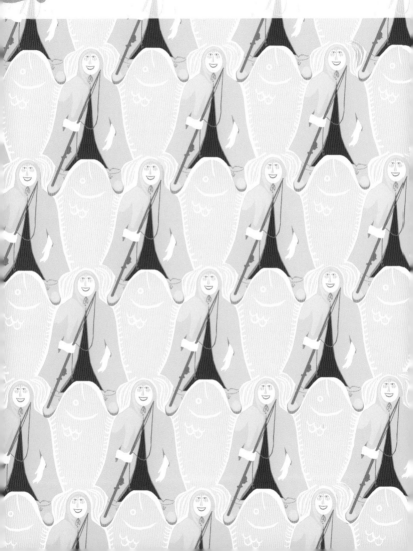

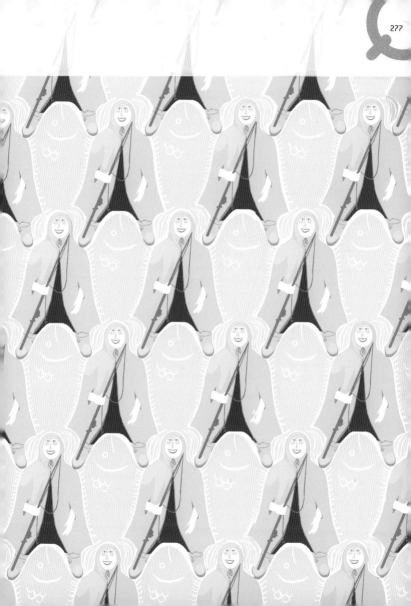

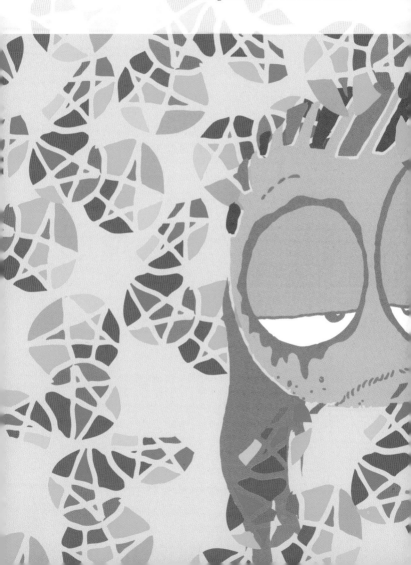

DELPHINE DOREAU/DEL4YO del4yo.squarespace.com

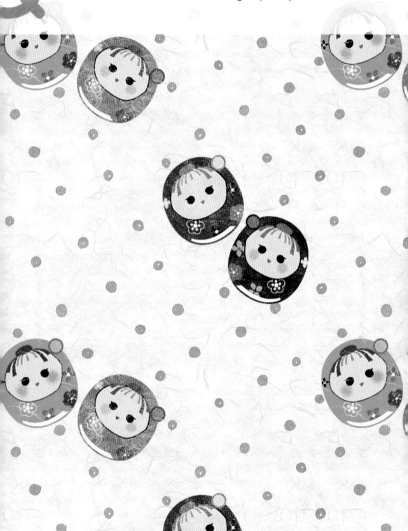

MICHELLE ROMO www.crowdedteeth.com

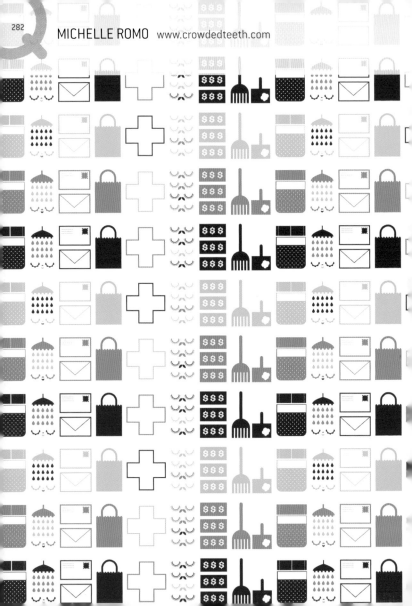

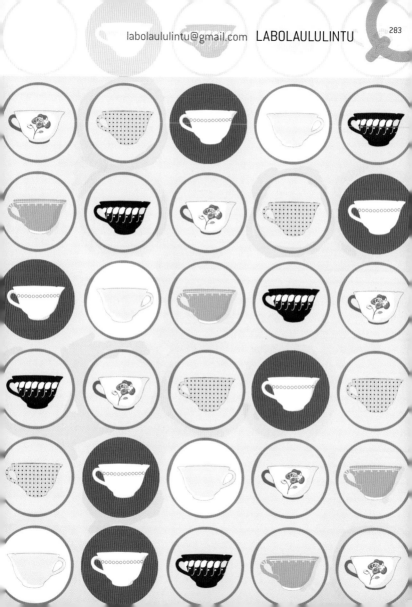

LABOLAULULINTU labolaululintu@gmail.com

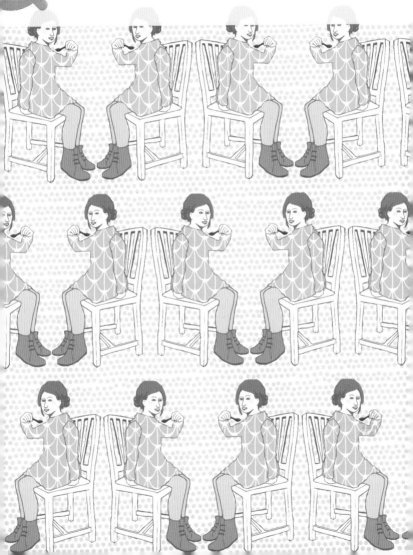

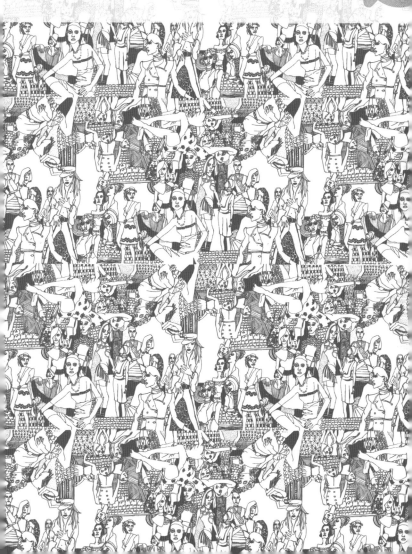

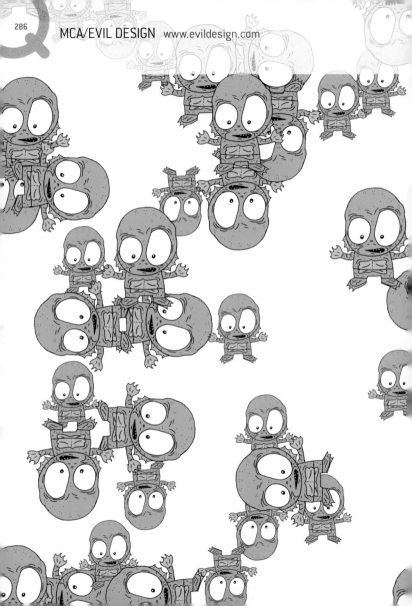

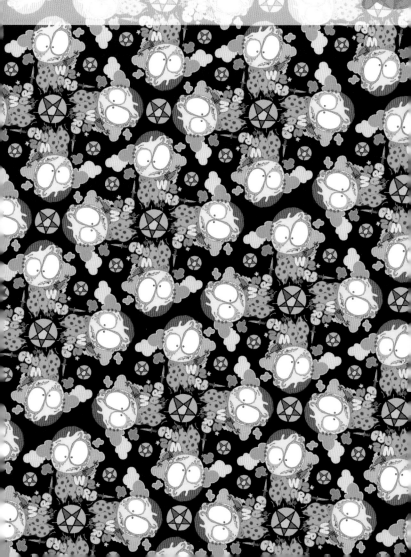

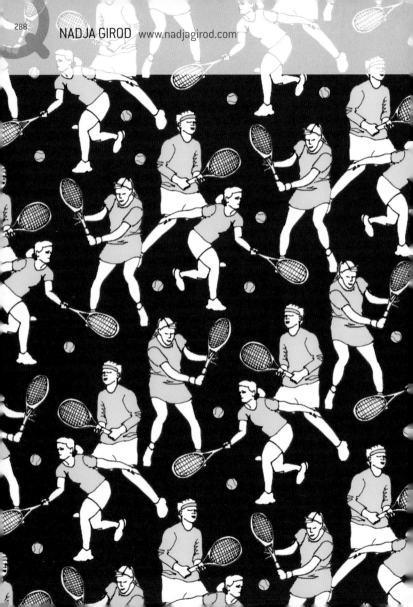

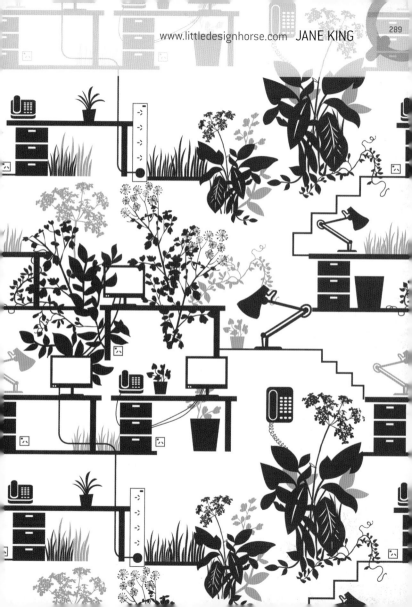

JON BURGERMAN www.jonburgerman.com

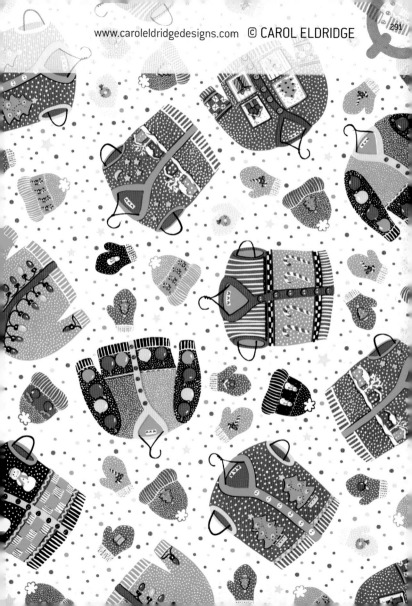

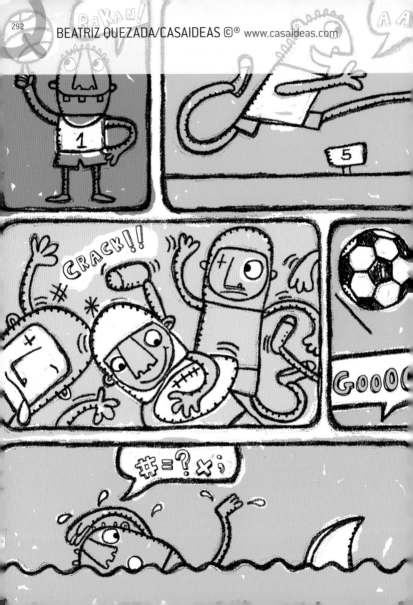

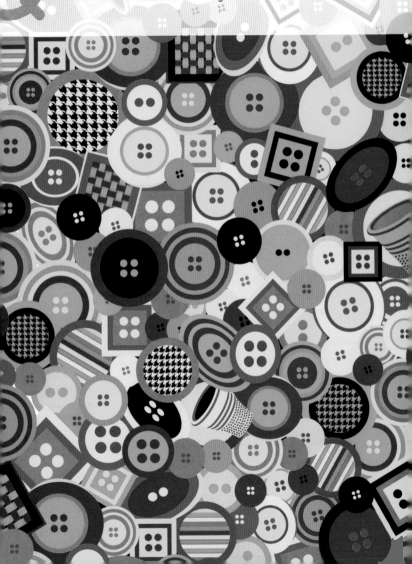

KELLY ALFORD/IOTA www.everyiota.com

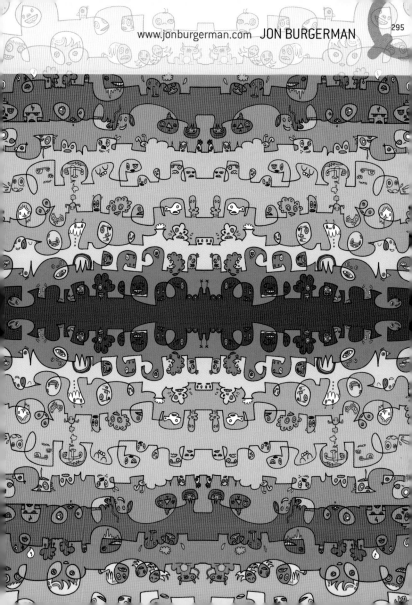

GUILHERME MARCONI www.marconi.nu

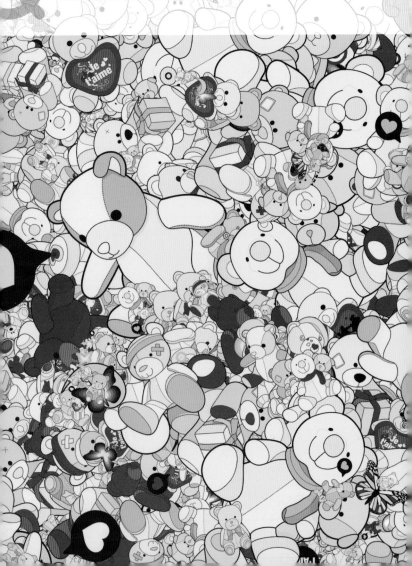

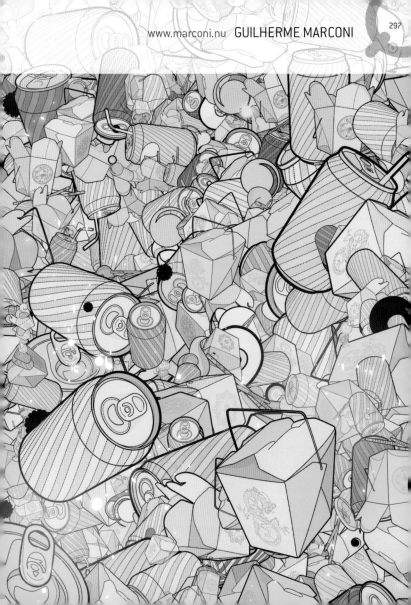

MARCIA COPELAND www.swizzlestix.net

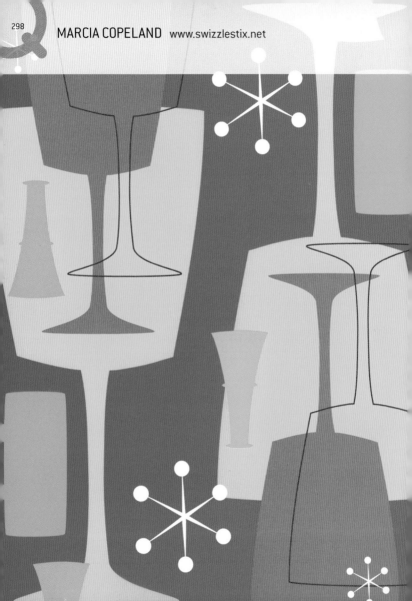

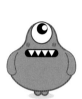

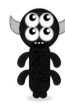

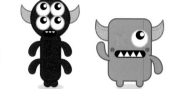

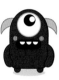

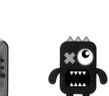

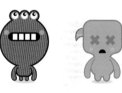

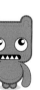

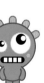

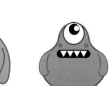

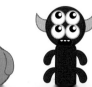

LAURA LJUNGKVIST www.followtheline.com

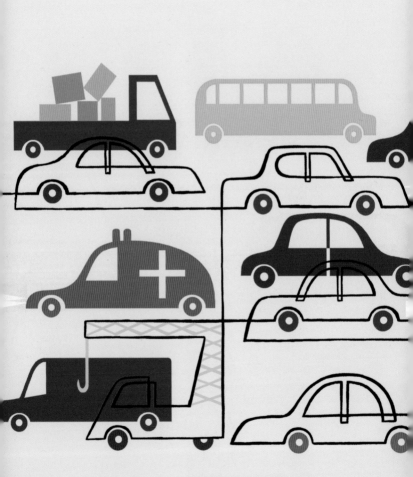

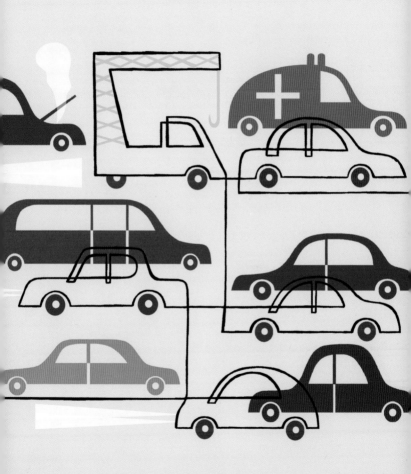

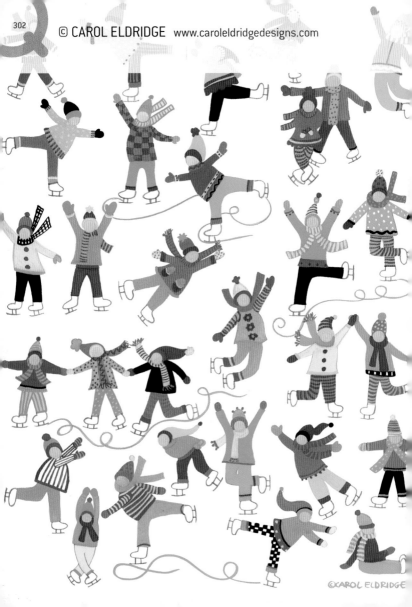

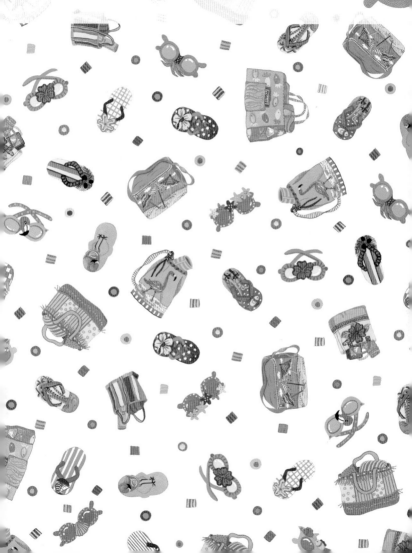

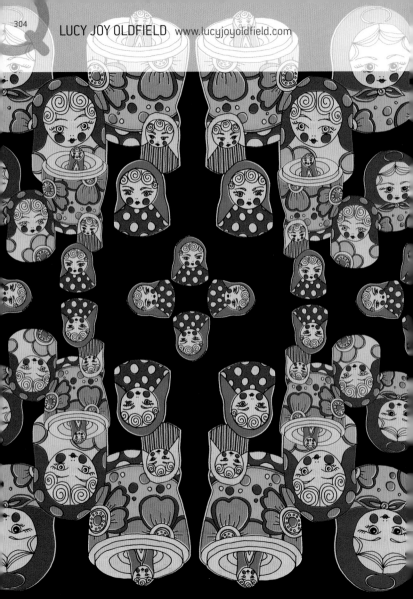

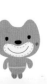

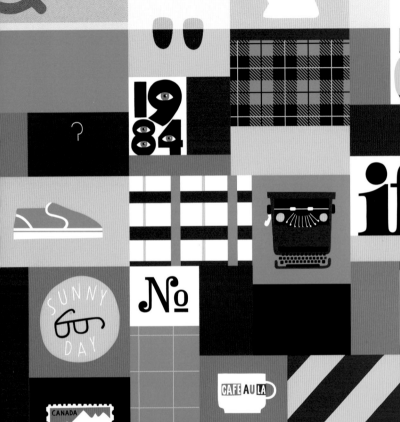

LUCKY

LIGHTS

WILL BE BACK

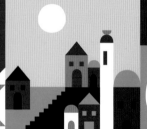

PRESSURE PACKED
Chase &
Sanborn
COFFEE

PRICELESS

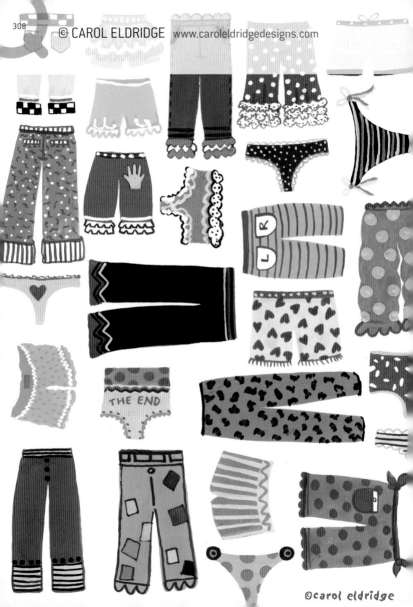

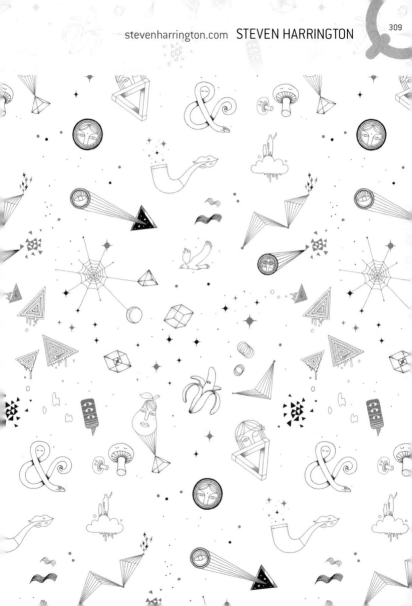

DONNA SNOWDON donna_snowdon@hotmail.com

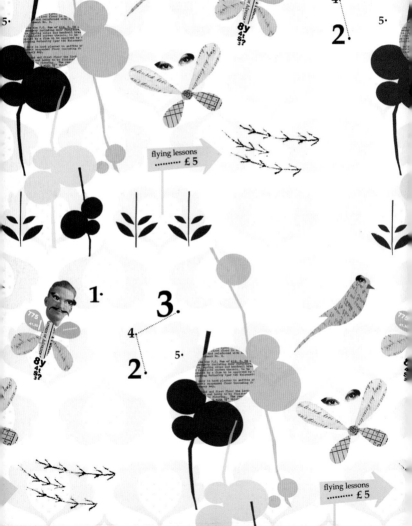

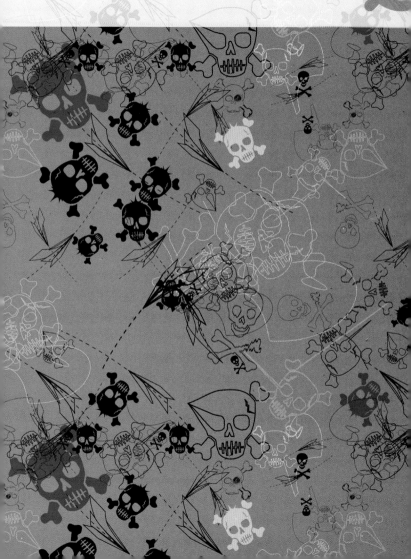

AIMEE WILDER DESIGNS www.aimeewilder.com

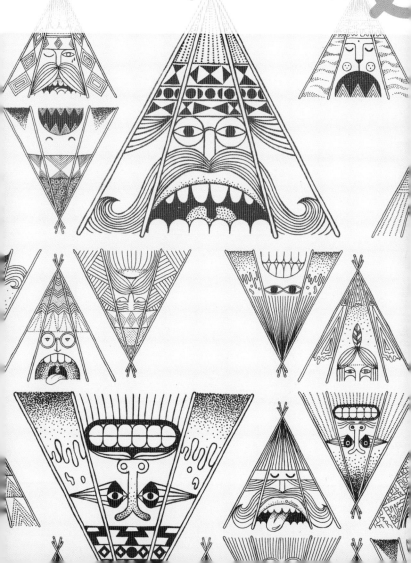

STEVEN HARRINGTON stevenharrington.com

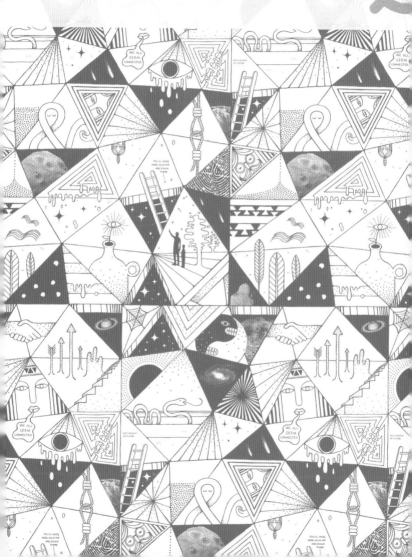

EMMA RAMPTON www.emmarampton.com

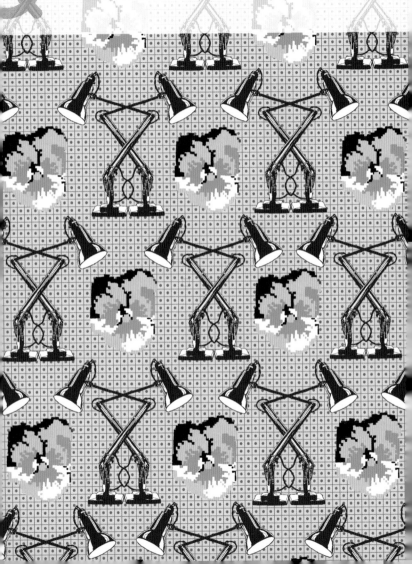

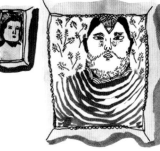

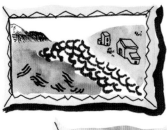

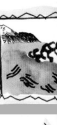

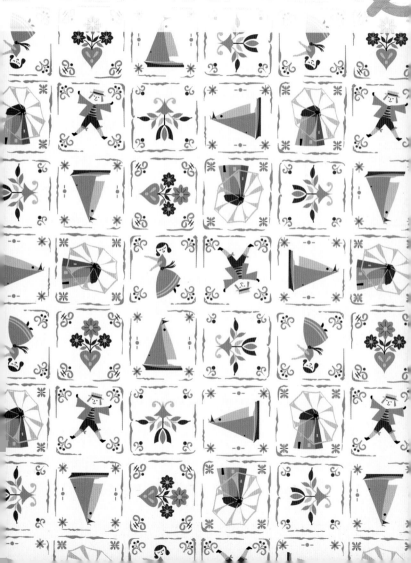

AIMEE WILDER DESIGNS www.aimeewilder.com

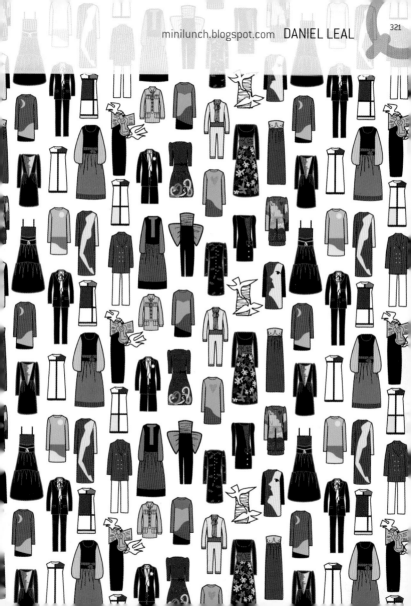

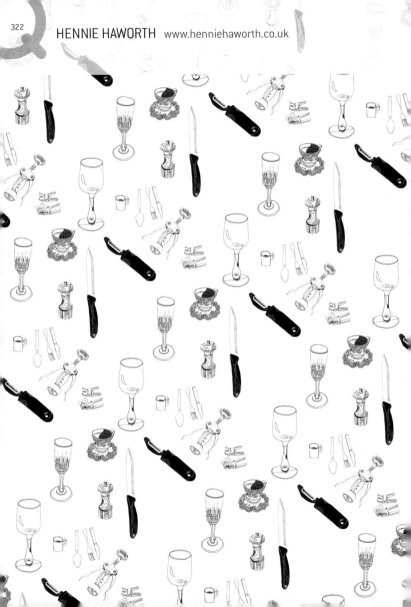

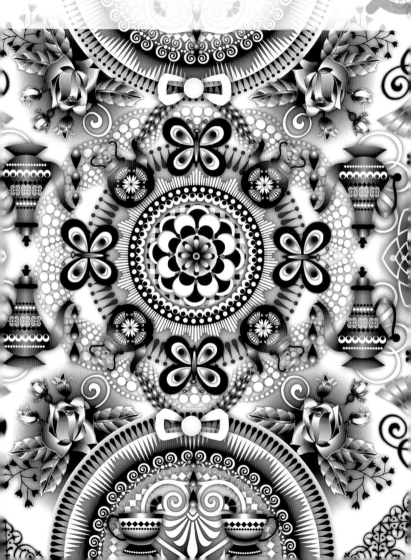

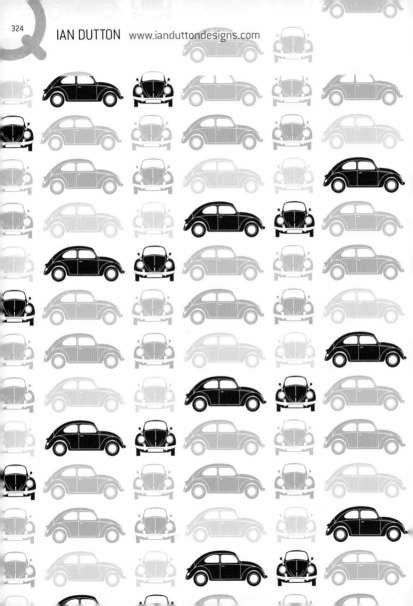

IAN DUTTON www.ianduttondesigns.com

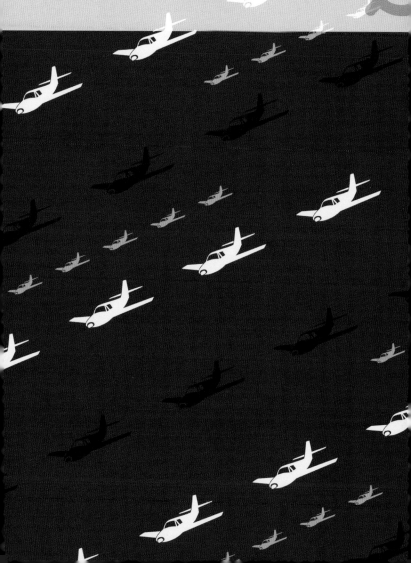

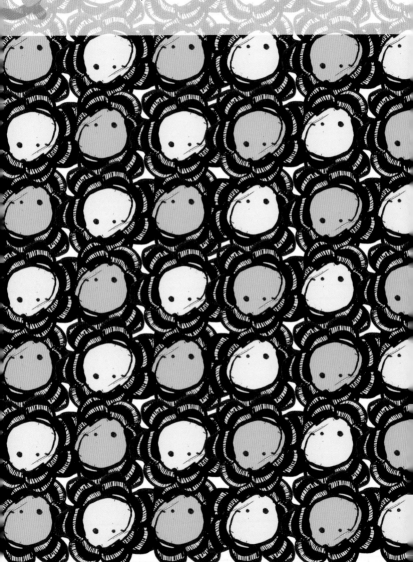

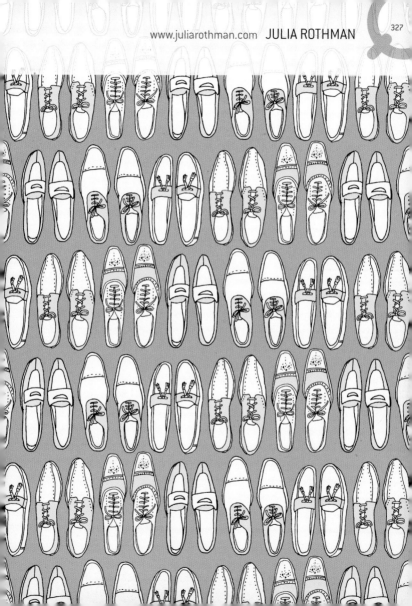

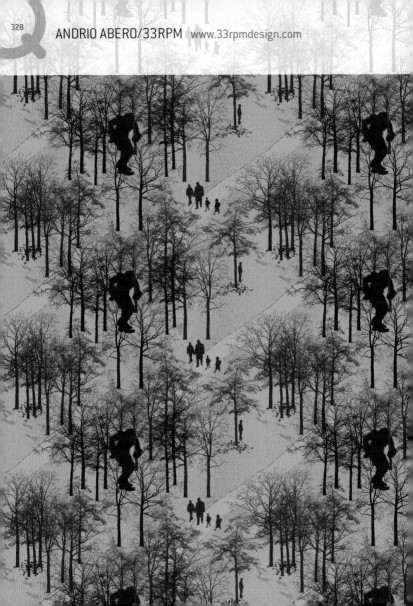

MCA/EVIL DESIGN www.evildesign.com

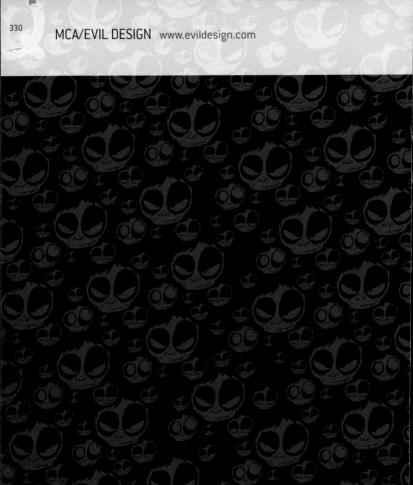

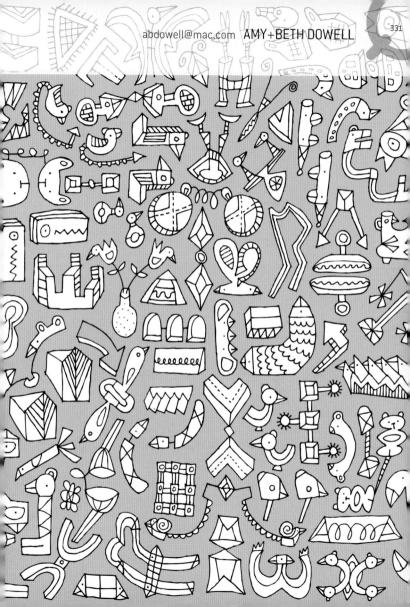

KAREN HALL www.karenhallillustration.com

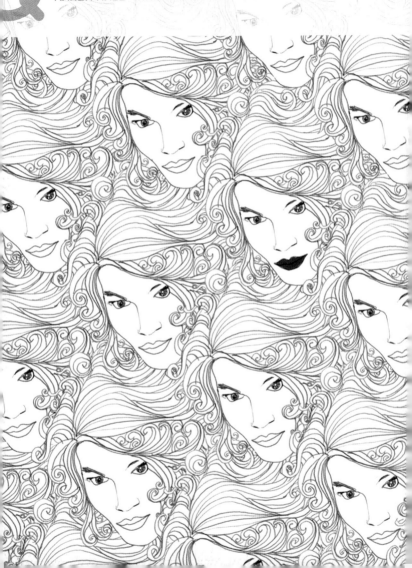

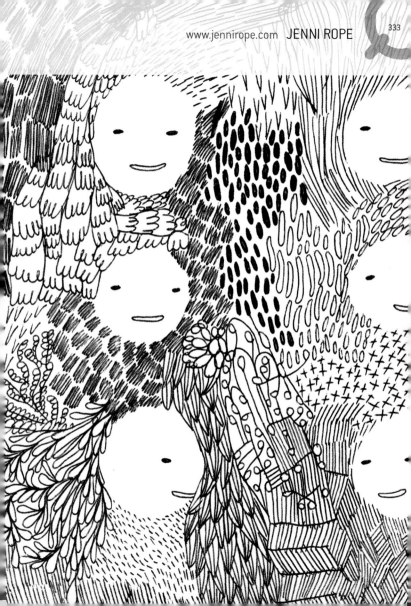

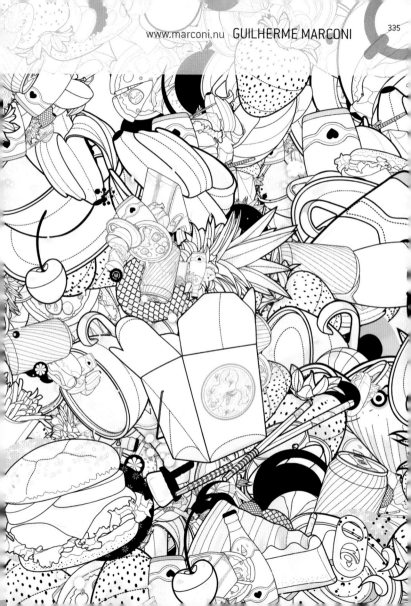

DANIEL LEAL minilunch.blogspot.com

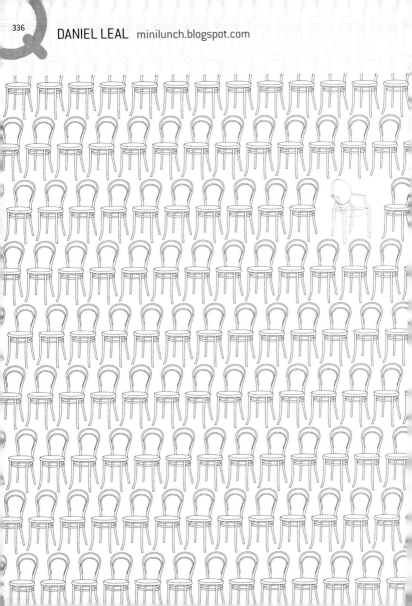

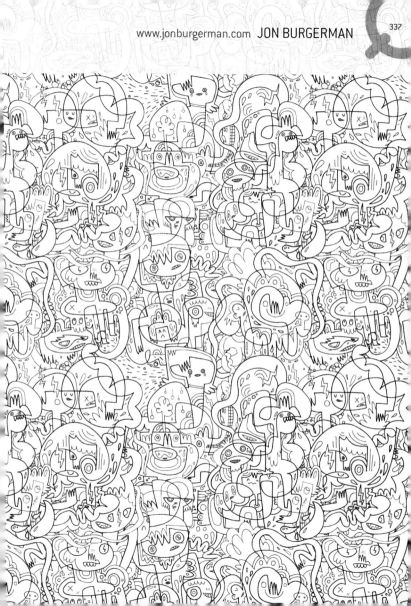

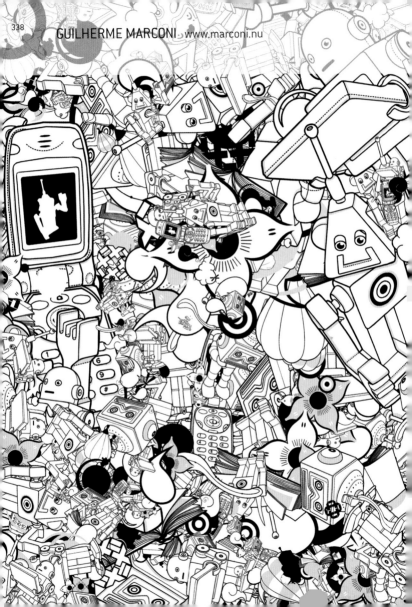

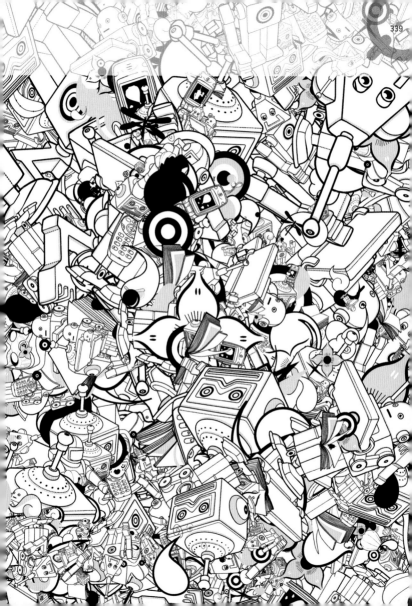

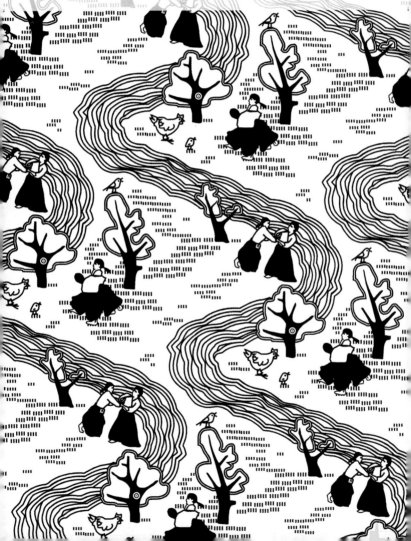

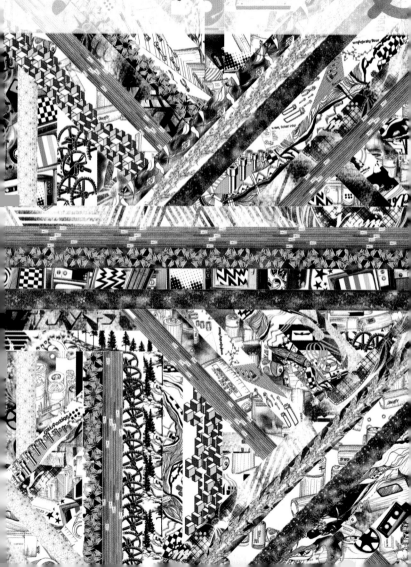

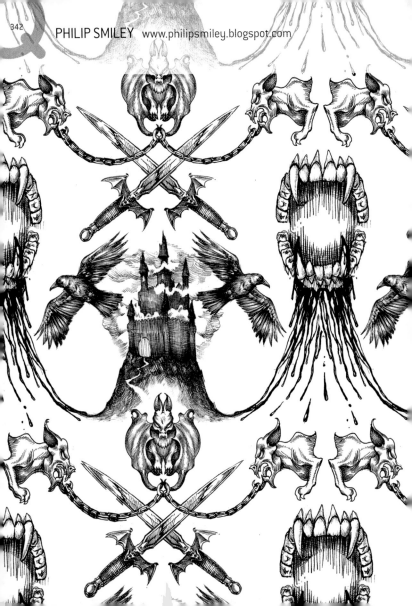

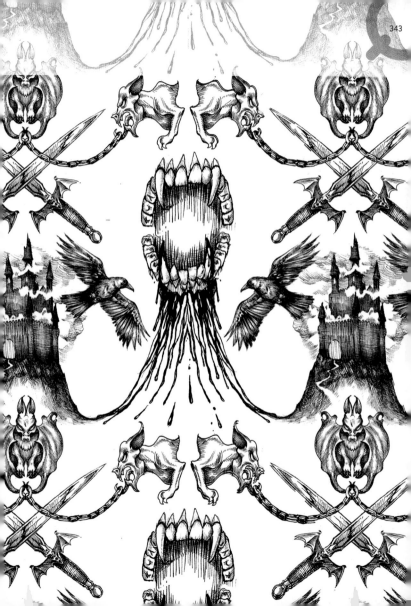

ANDRIO ABERO/33RPM www.33rpmdesign.com

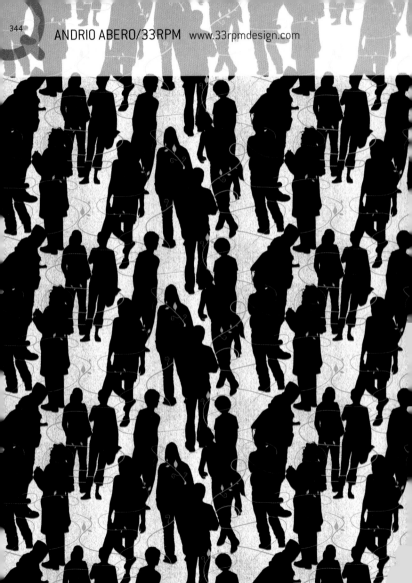

MCA/EVIL DESIGN www.evildesign.com

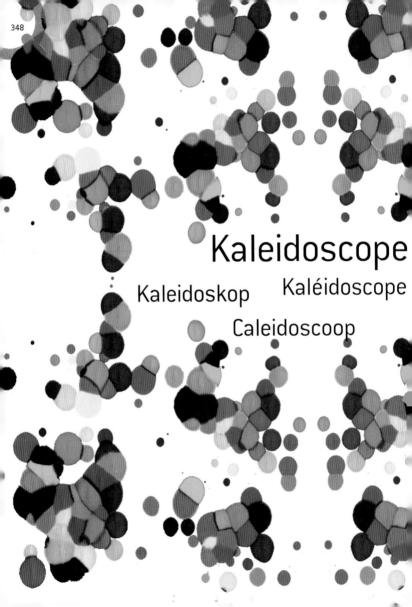

Kaleidoscope

Kaleidoskop

Kaléidoscope

Caleidoscoop

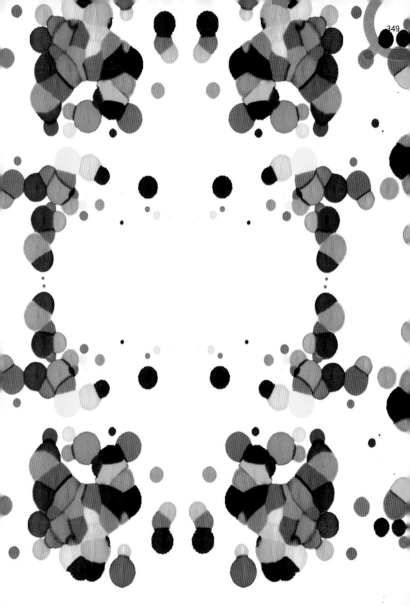

The kaleidoscope is one of the most appealing toys that most captures children's attention. Kids can spend hours and hours turning it, losing themselves in the shapes, and trying to decipher the contents. Interestingly, this appeal is something that does not fade with age. In anyone's hands, this instrument creates the same hypnotic reaction of wanting to enjoy endless hours of symmetry and color; seeking something different with each new twist of the tube.

Eines der Spielzeuge, das bei Kindern die größte Aufmerksamkeit hervorruft, ist das Kaleidoskop: die Kleinen können Stunden damit verbringen, es zu drehen, sich in seinen Figuren zu verlieren und zu versuchen, herauszufinden, was sich in seinem Inneren befindet. Erstaunlicherweise handelt es sich bei dieser Vorliebe um etwas, das im Alter nicht verschwindet. In wessen Hände es auch fällt, dieses Instrument ruft dieselbe hypnotische Reaktion hervor, sich lange Zeit an der Symmetrie und den Farben zu erfreuen, auf der Suche nach Unterschieden bei jeder neuen Drehung.

L'un des jouets qui attire le plus l'attention des enfants est le kaléidoscope : ils peuvent passer des heures à le faire tourner, à se perdre dans ses images et à essayer de distinguer ce qu'il y a à l'intérieur. Curieusement cet intérêt ne disparaît pas avec le temps. Cet instrument provoque toujours la même réaction hypnotique, quiconque l'ait entre les mains : s'amuser longuement avec la symétrie et les couleurs, en quête de quelque chose de différent à chaque nouveau tour.

Eén van de speeltjes dat het meeste succes heeft bij de kinderen is de caleidoscoop: ze kunnen er urenlang aan draaien en opgaan in de figuren, terwijl ze proberen te ontcijferen wat er zich aan de binnenkant bevindt. Vreemd genoeg is dit een liefhebberij die niet verdwijnt naarmate men ouder wordt. De caleidoscoop veroorzaakt bij iedereen, het maakt niet uit wie, dezelfde hypnotische reactie: men geniet langdurig van de symmetrie en kleuren terwijl men bij elke draai op zoek gaat naar iets anders.

ANA MONTIEL/ALAN THE GALLANT www.alanthegallant.com

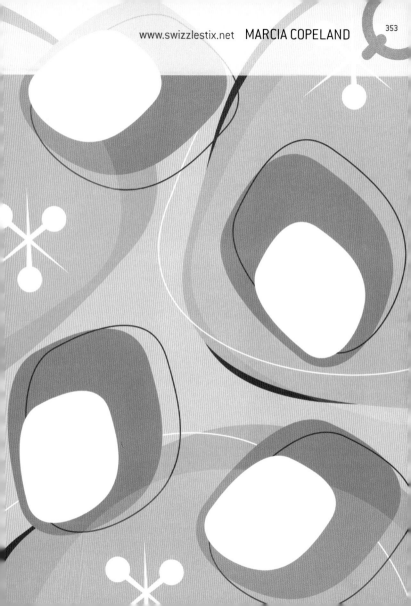

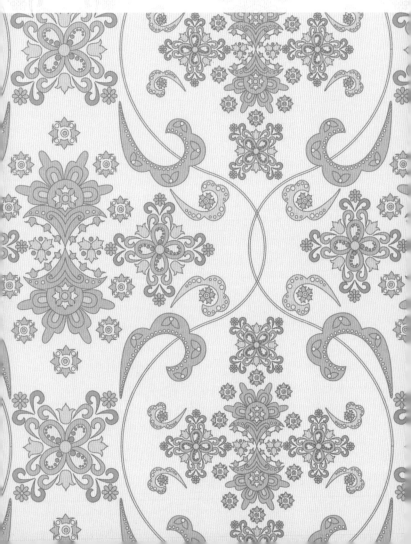

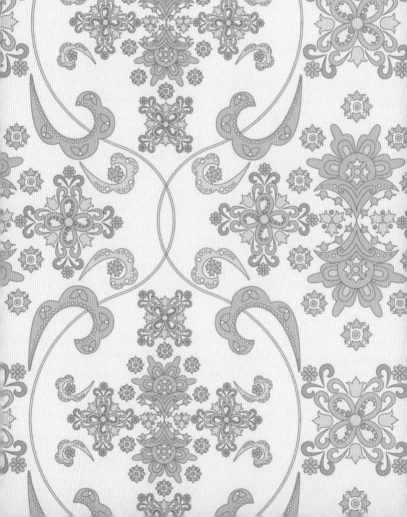

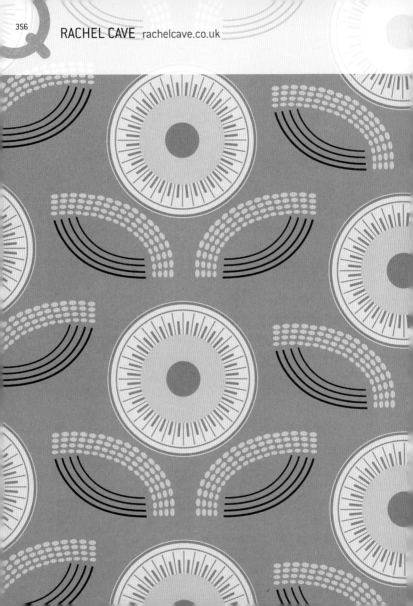

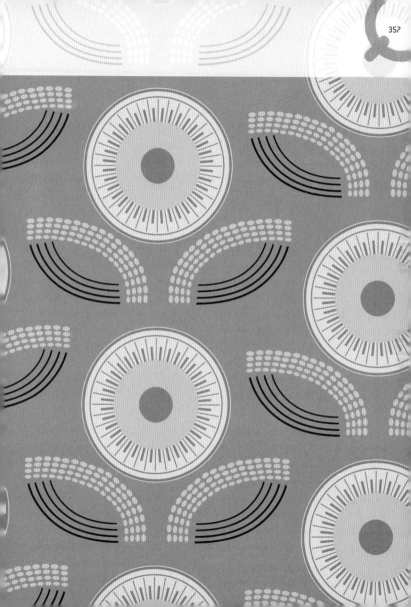

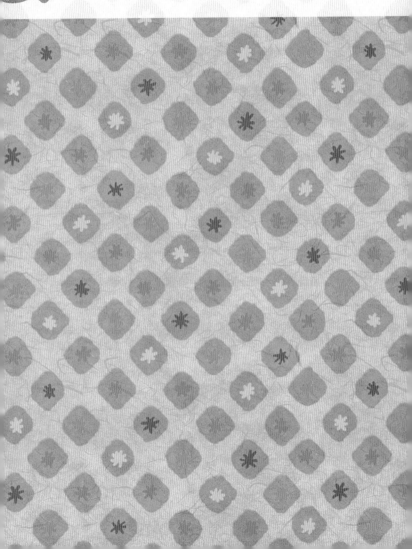

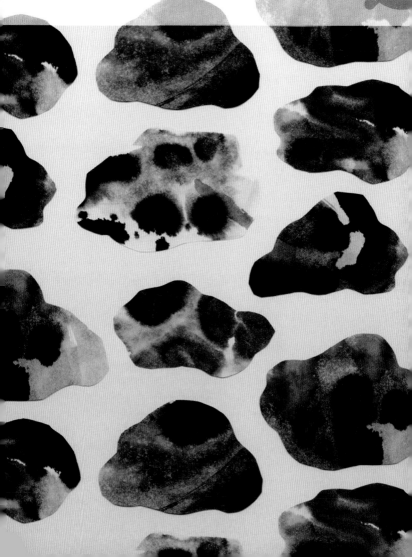

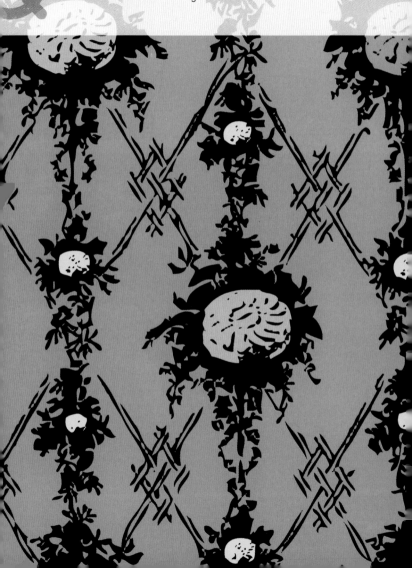

DIANA SKYLACOS dskylacos.com

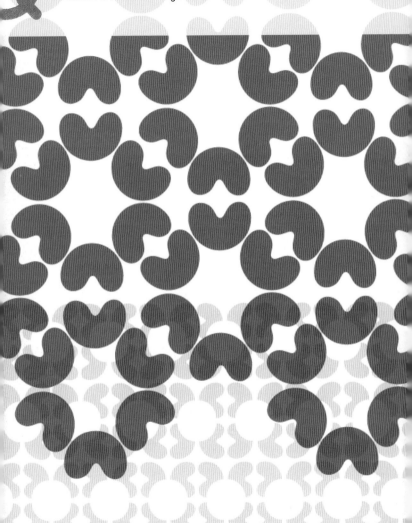

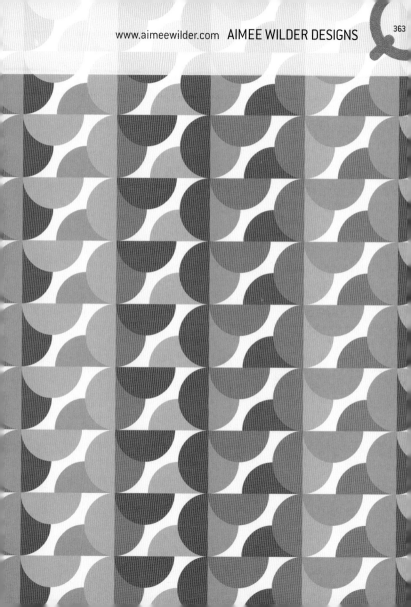

PAUL THEODORE WISNIEWSKI
www.paultheodoreart.com

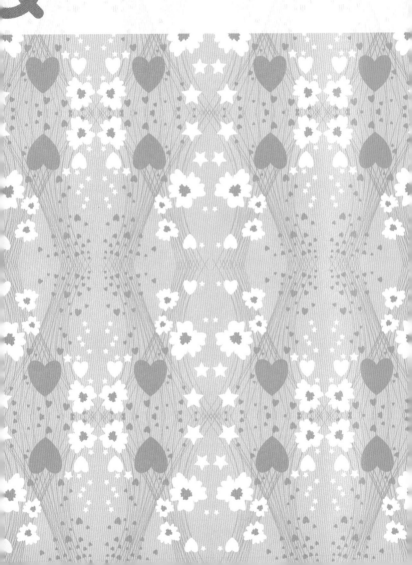

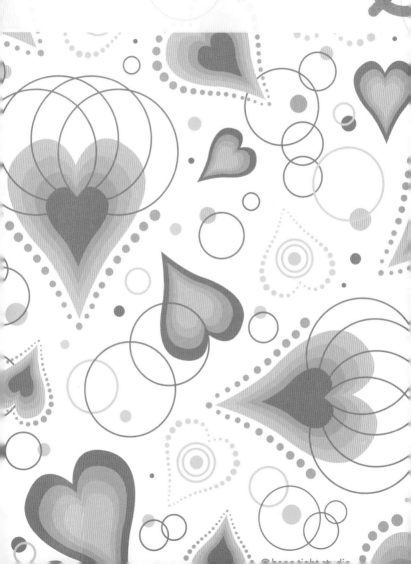

JENNIFER HILL/JHILL DESIGN www.jhilldesign.com

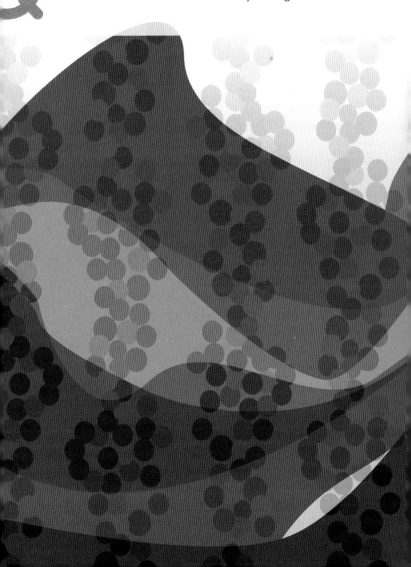

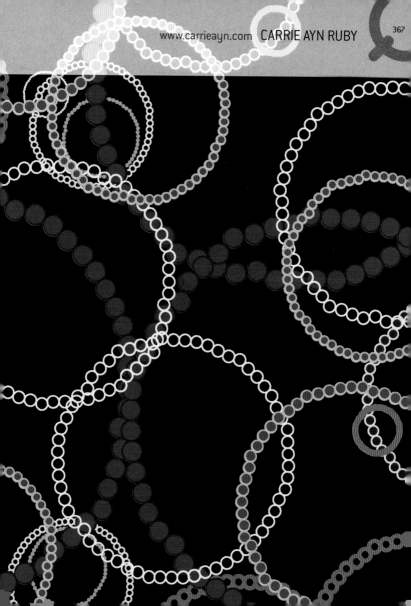

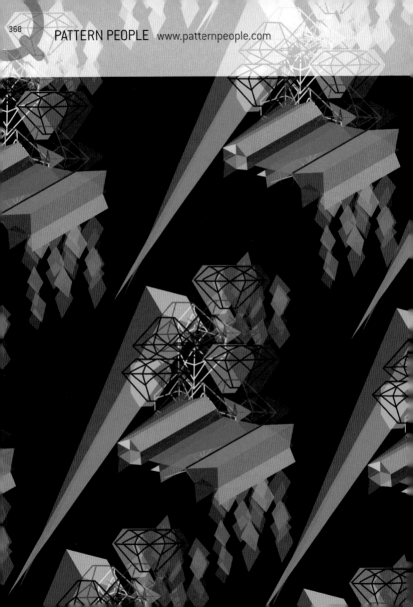

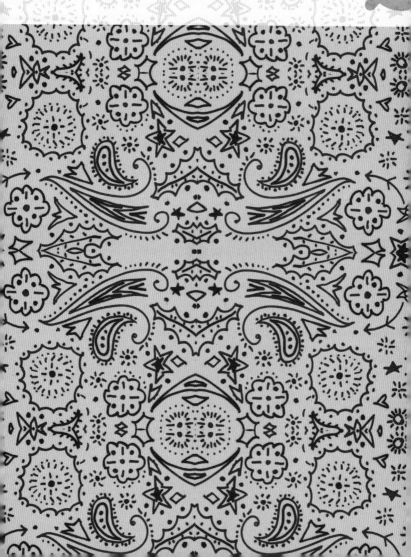

JENNIFER HILL/JHILL DESIGN www.jhilldesign.com

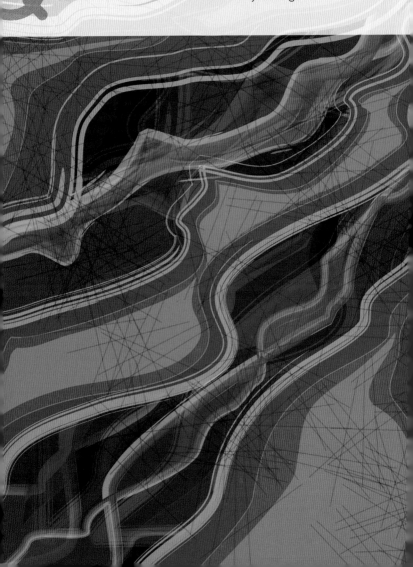

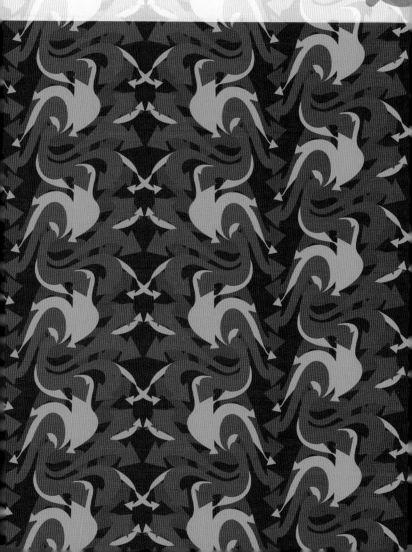

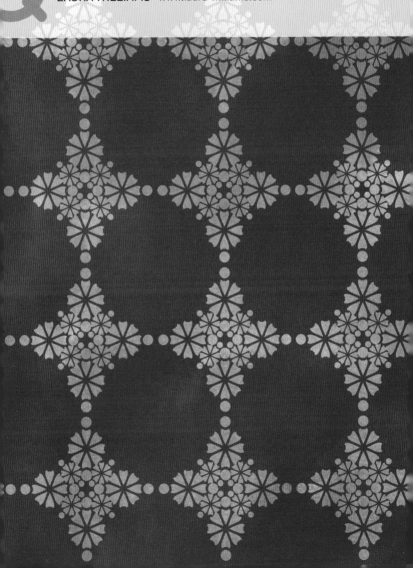

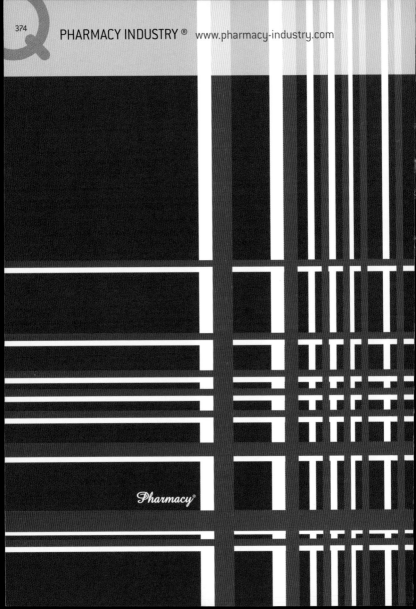

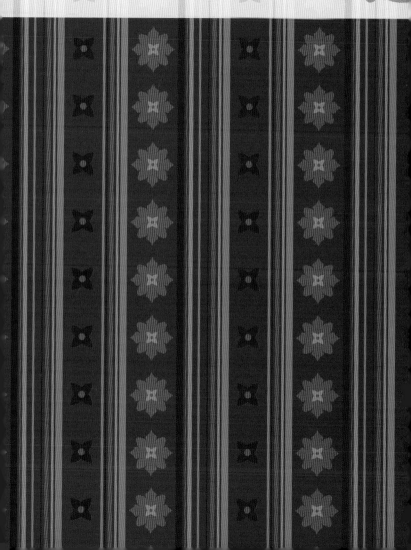

JUDIT GUETH www.juditgueth.com

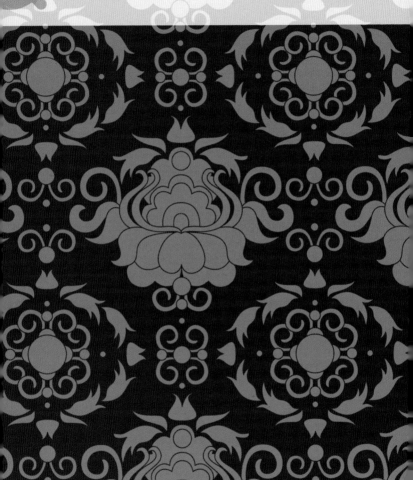

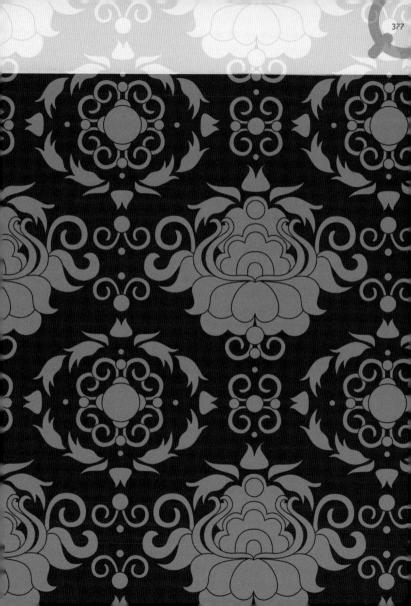

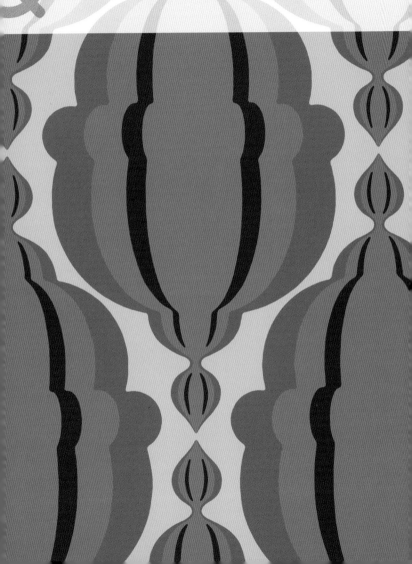

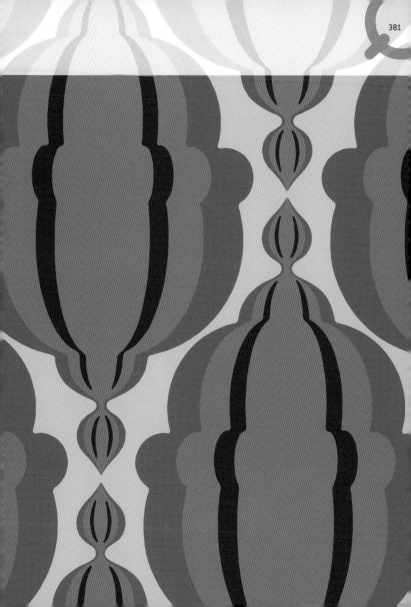

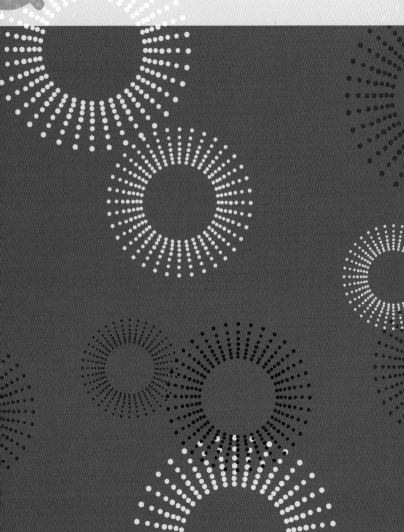

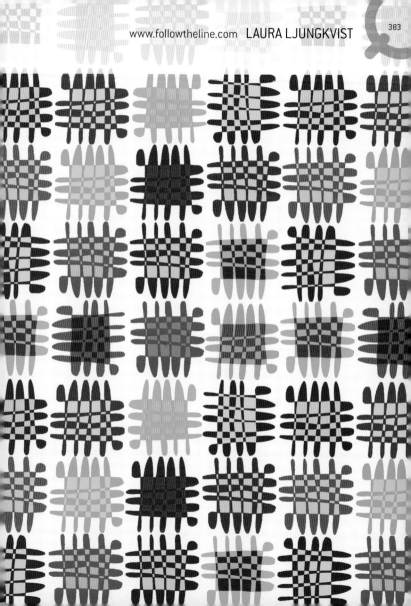

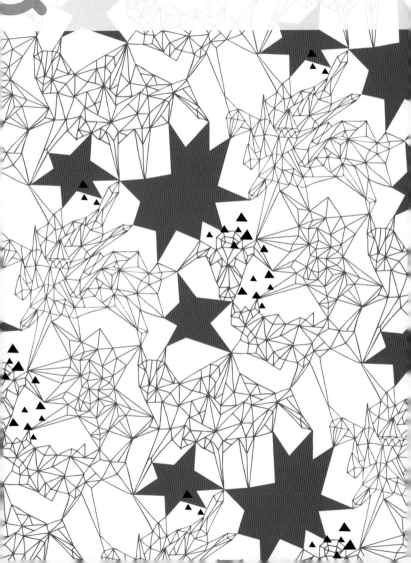

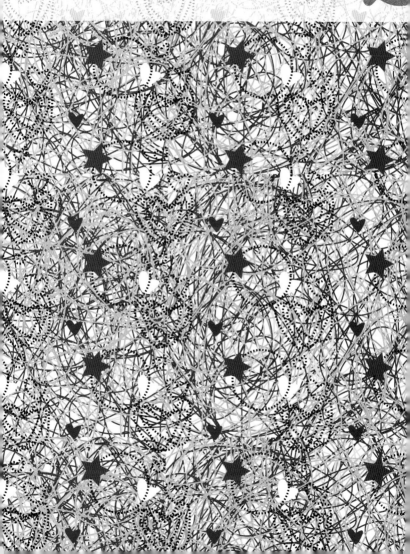

KELLY ALFORD/IOTA www.everyiota.com

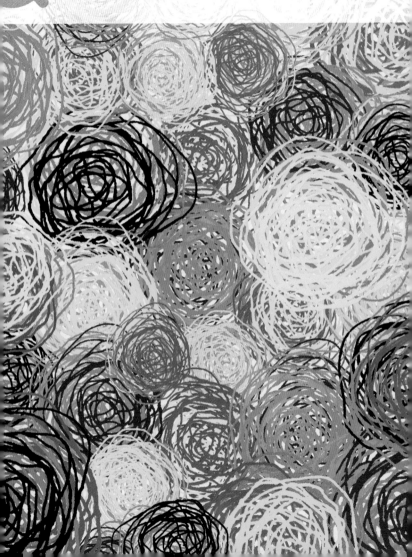

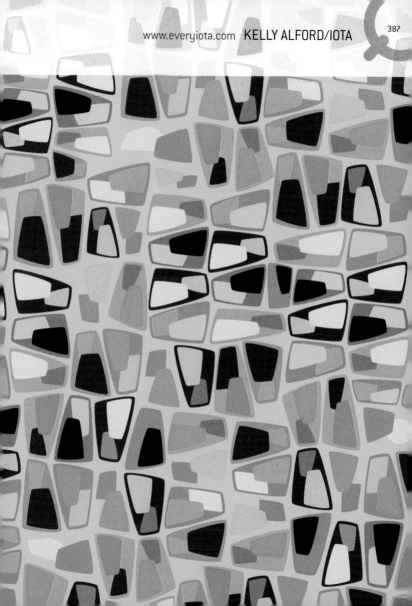

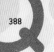

NADJA GIROD www.nadjagirod.com

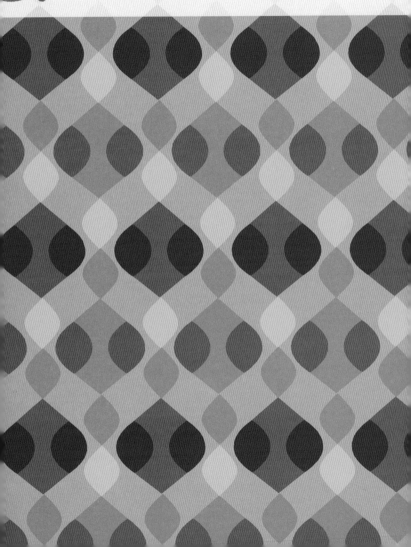

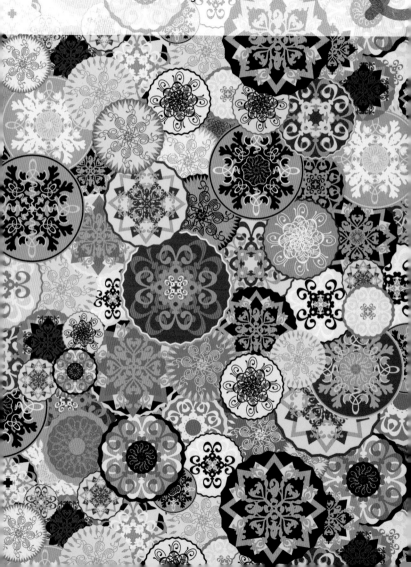

TULA PINK tulapink.com

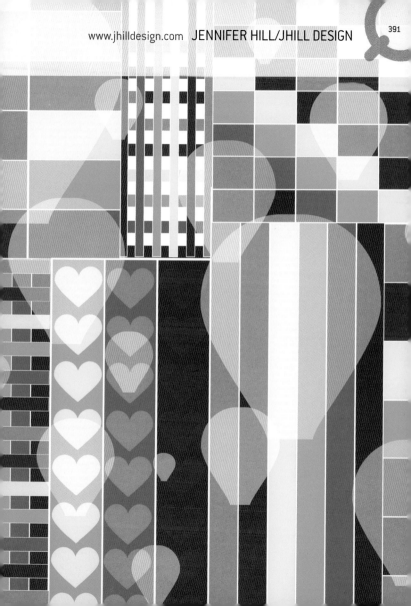

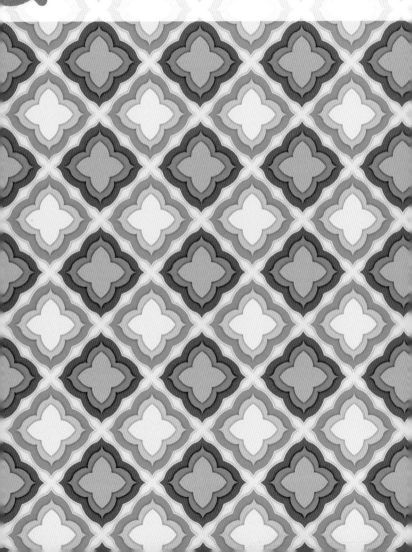

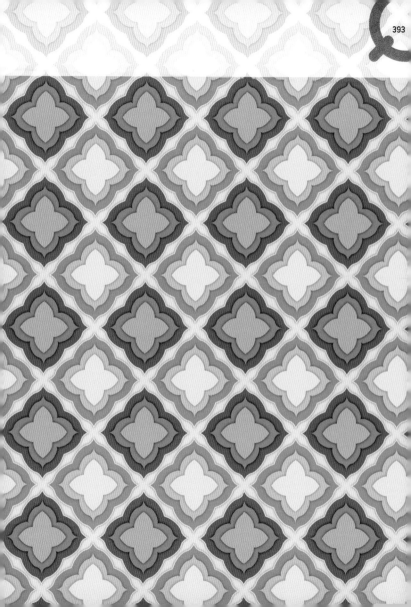

AMY+BETH DOWELL abdowell@mac.com

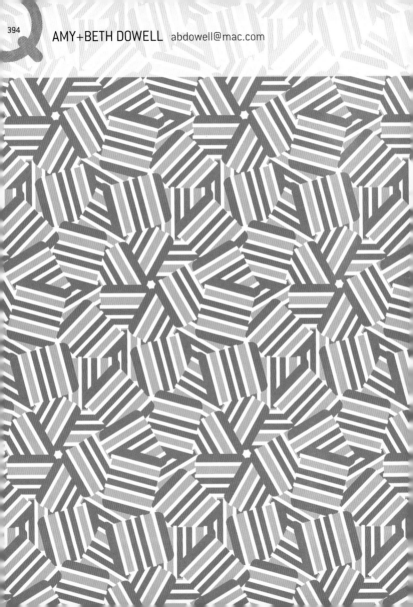

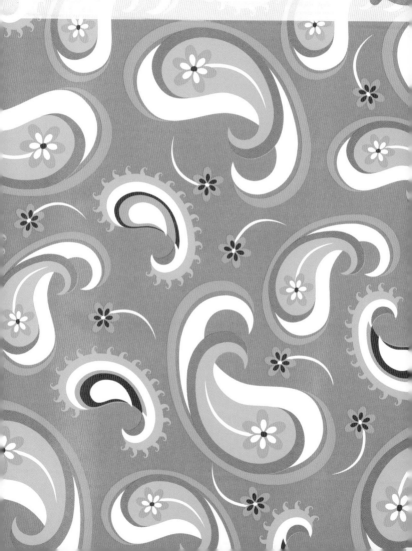

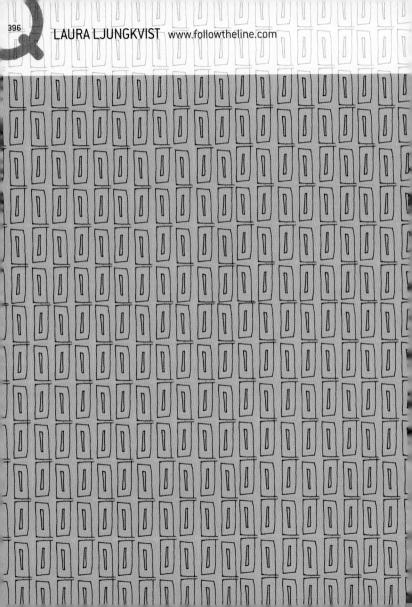

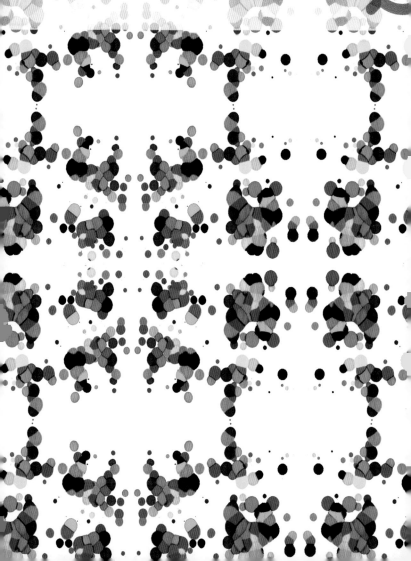

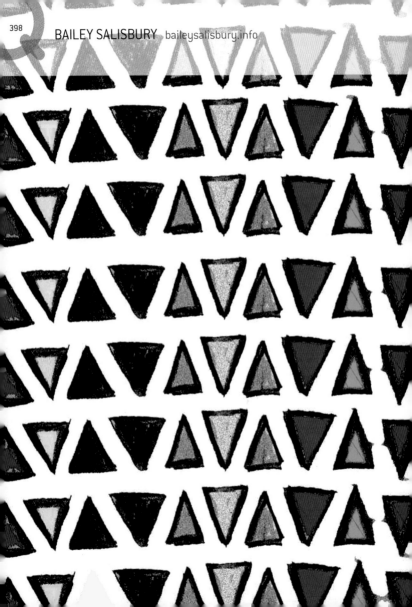

BAILEY SALISBURY baileysalisbury.info

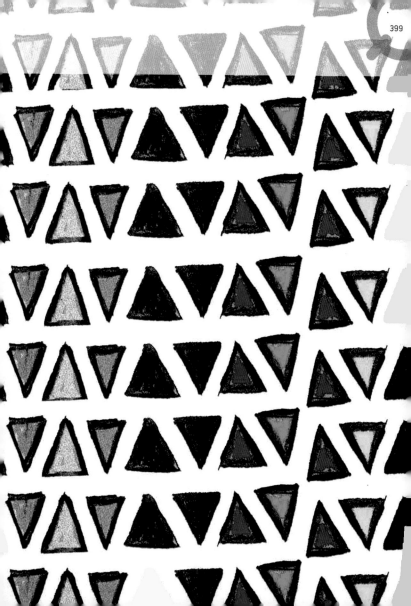

ANDREAS SAMUELSSON www.andreassamuelsson.com

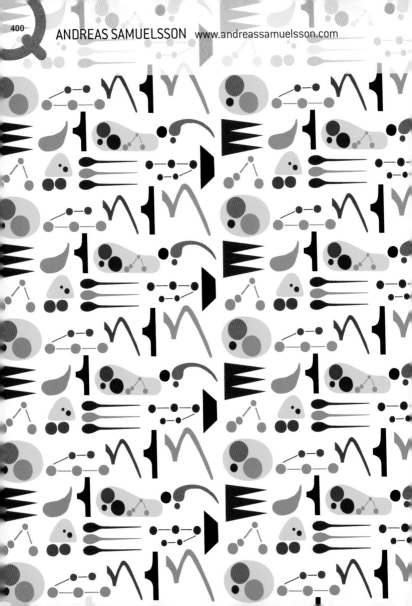

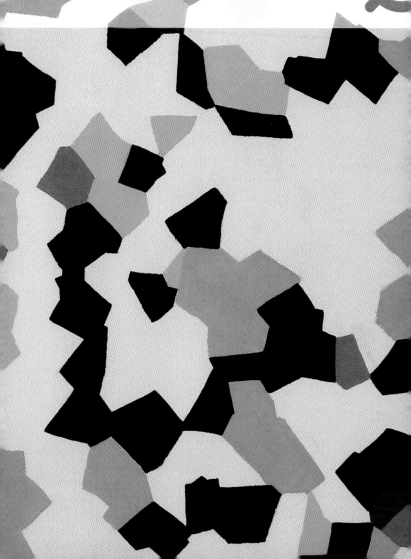

IZABELA OLDAK picasaweb.google.pl/izabela.oldak

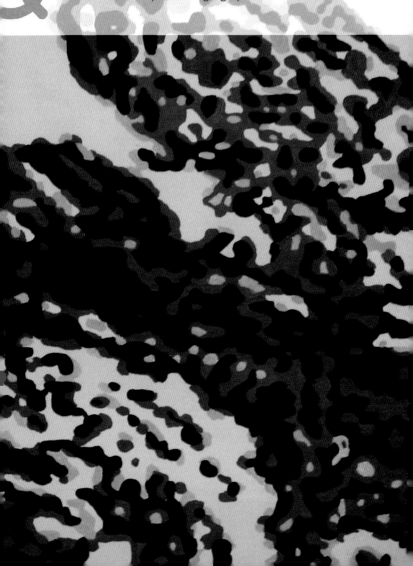

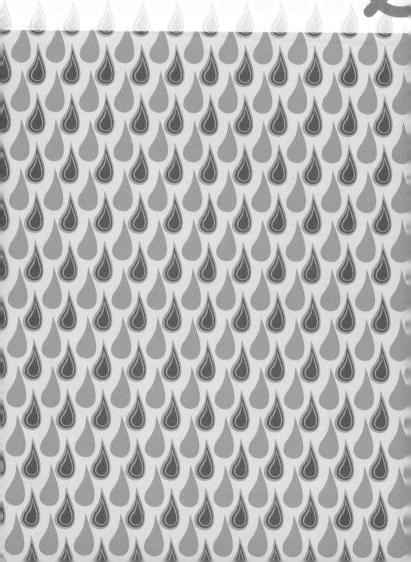

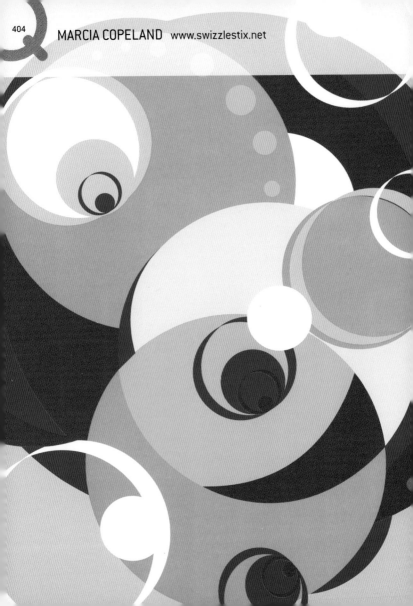

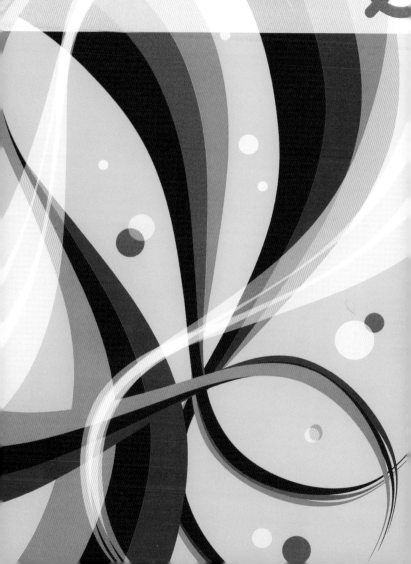

AIMEE WILDER DESIGNS www.aimeewilder.com

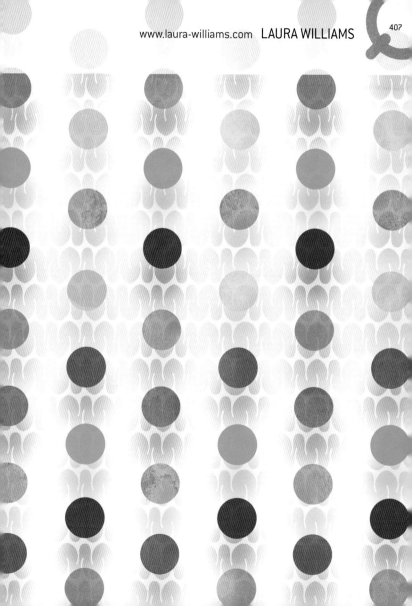

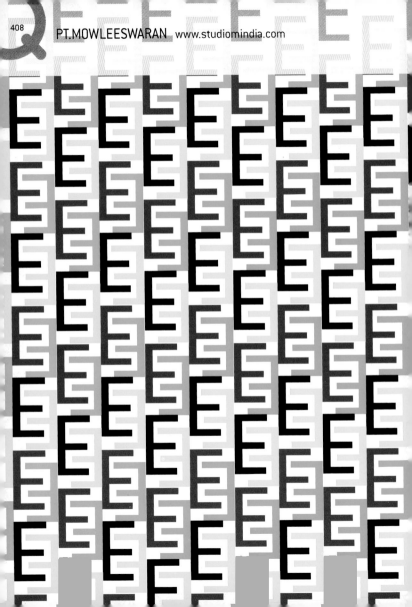

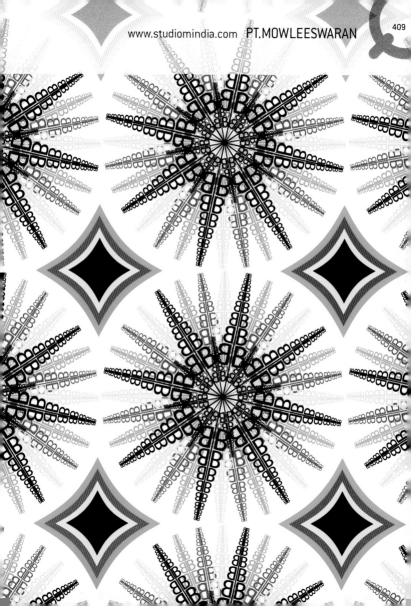

HENNIE HAWORTH www.henniehaworth.co.uk

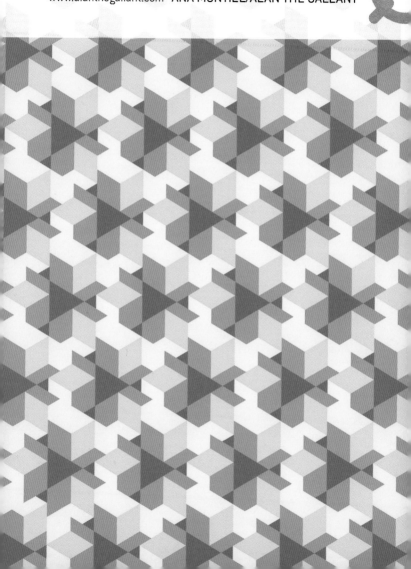

MARCIA COPELAND www.swizzlestix.net

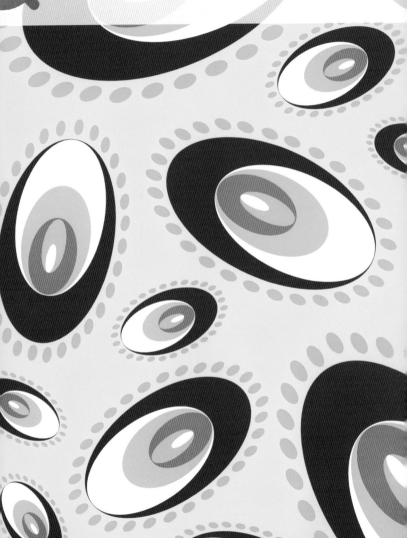

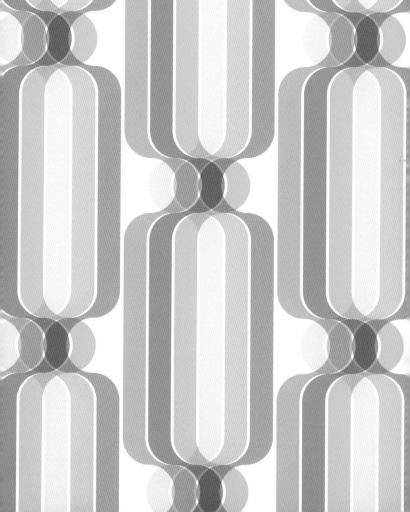

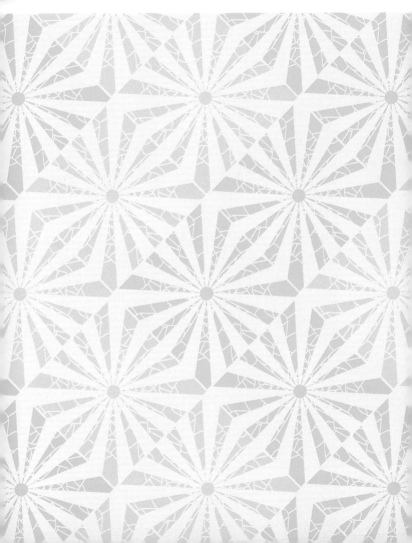

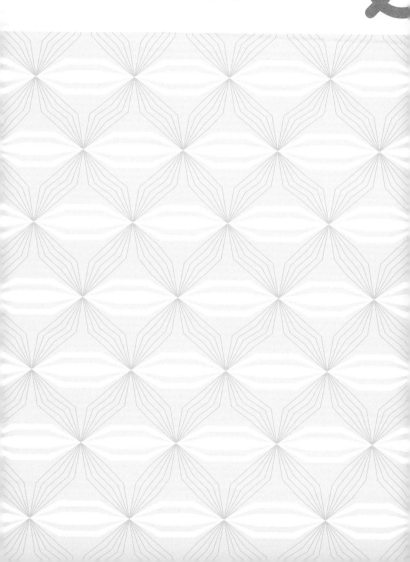

CAROLINE BOURLÈS mytextiledesign.com

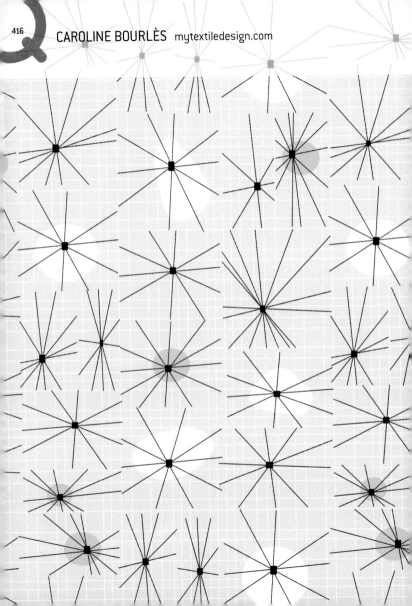

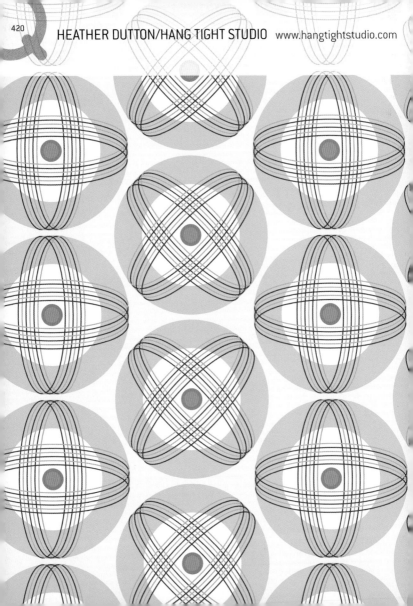

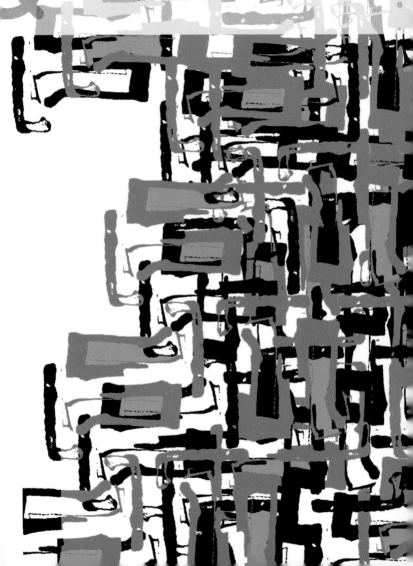

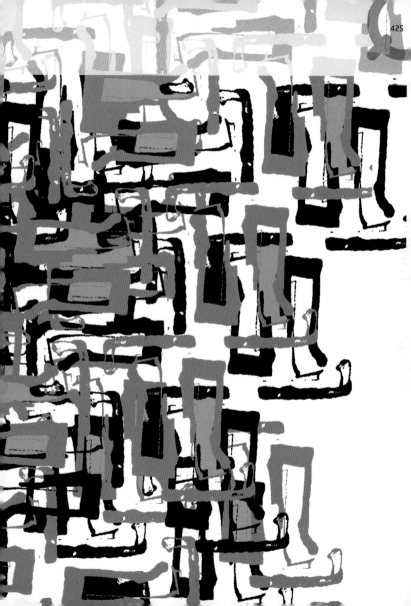

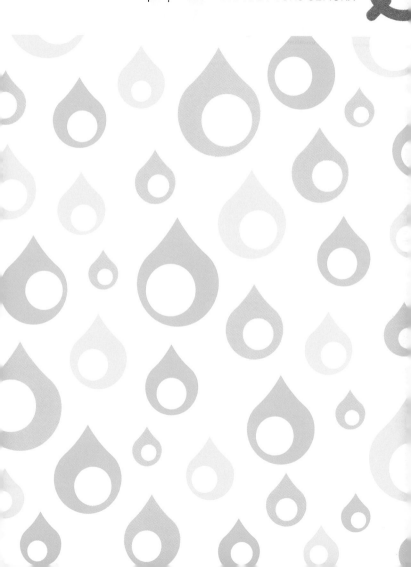

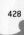

RACHEL CAVE rachelcave.co.uk

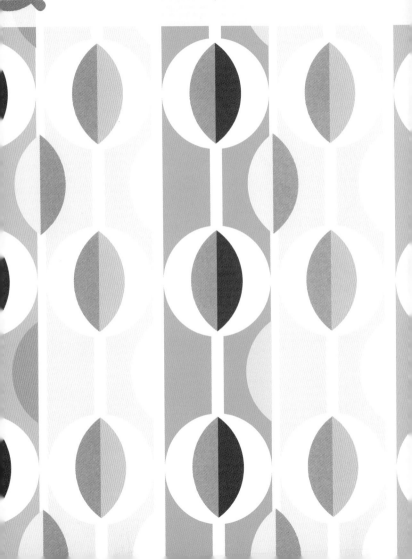

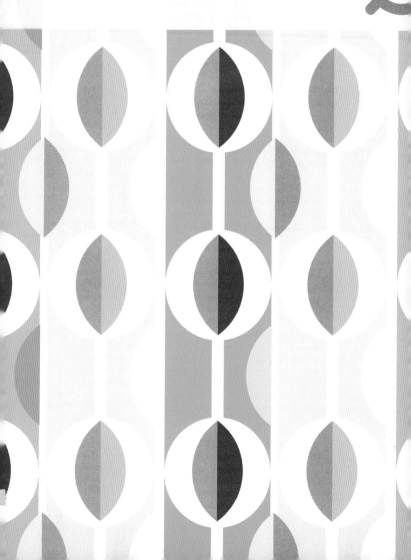

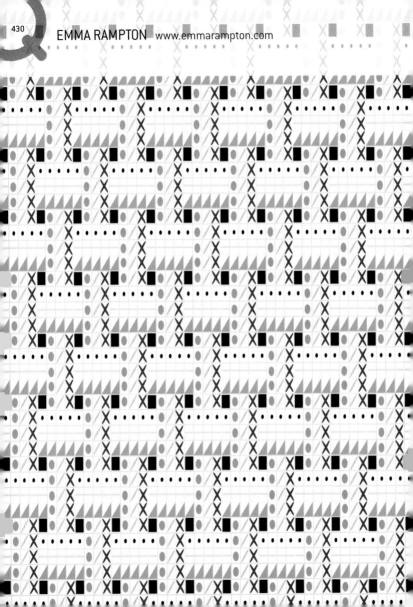

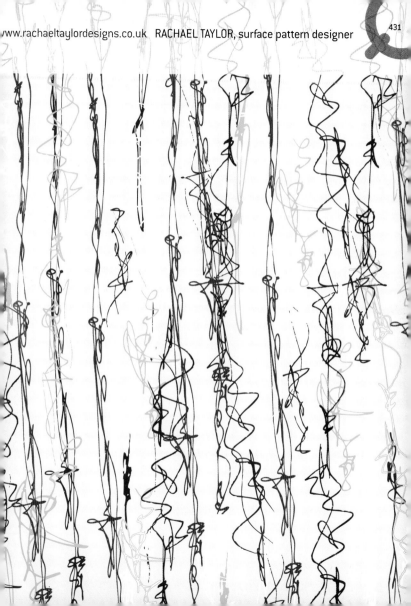

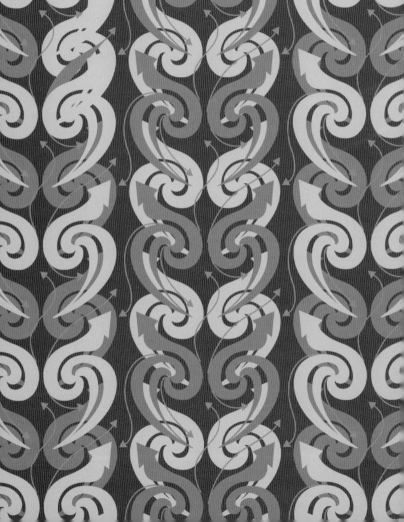

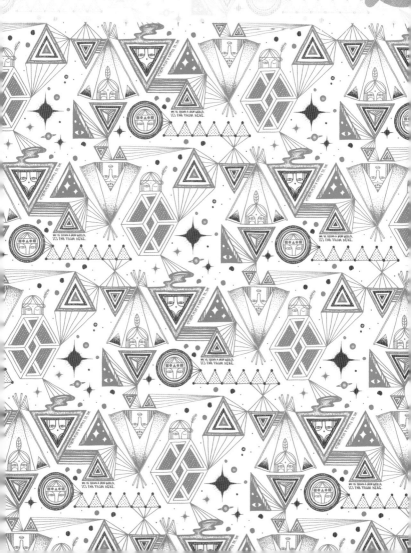

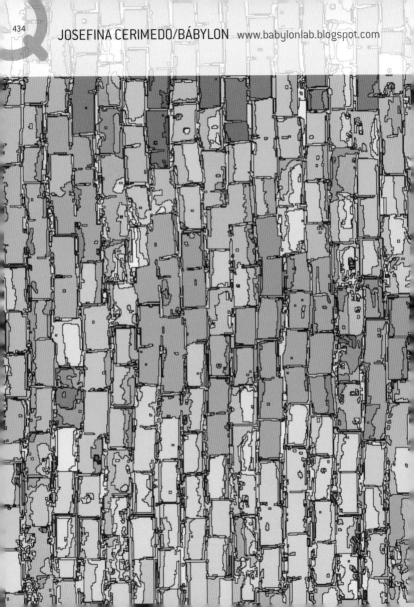

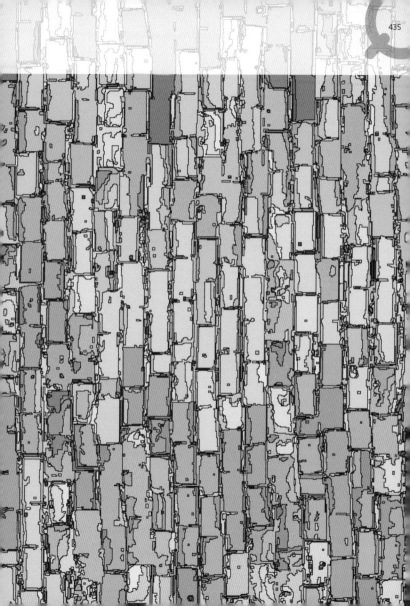

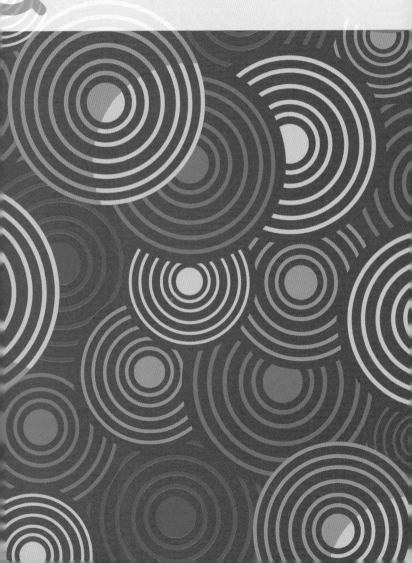

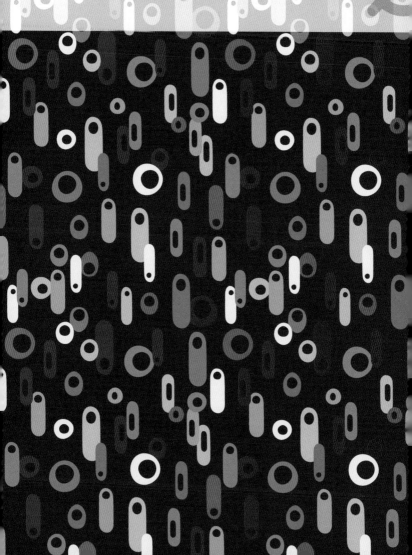

GEMMA ROBINSON gemmamarierobinson@hotmail.co.uk

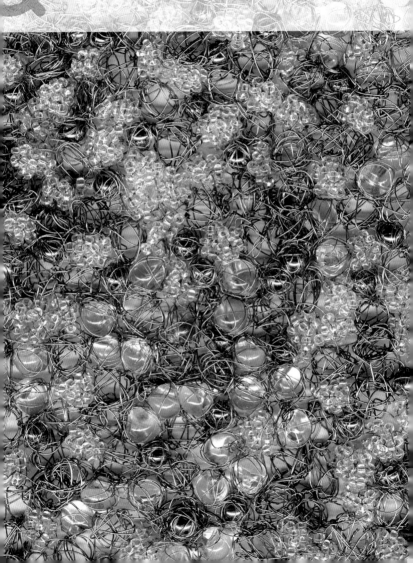

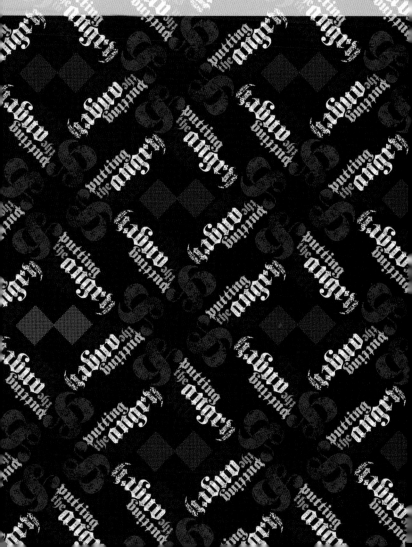

NADJA GIROD www.nadjagirod.com

MATT W. MOORE/MWM GRAPHICS mwmgraphics.com

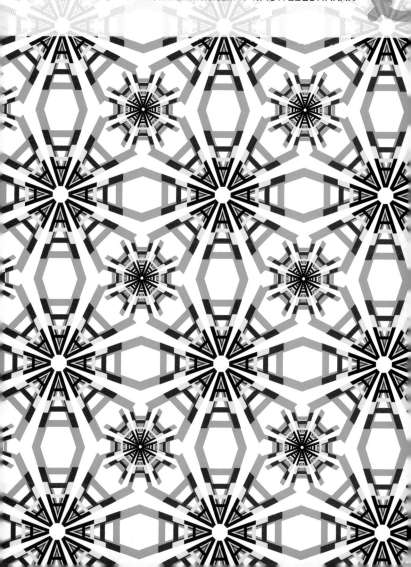

MATT W. MOORE/MWM GRAPHICS mwmgraphics.com

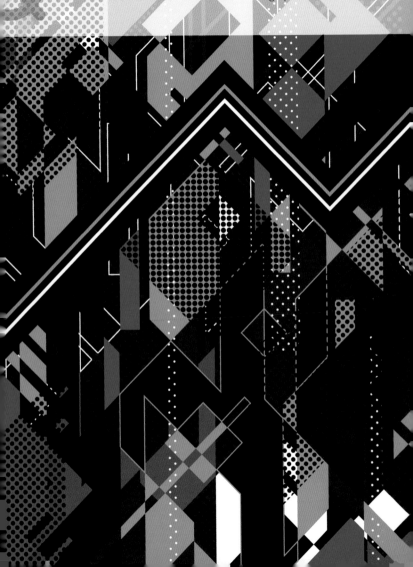

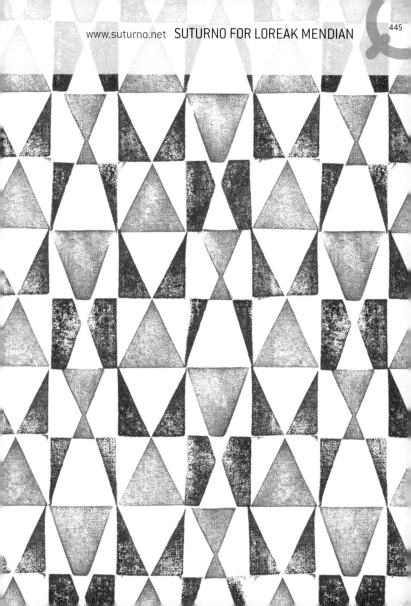

IZABELA OLDAK picasaweb.google.pl/izabela.oldak

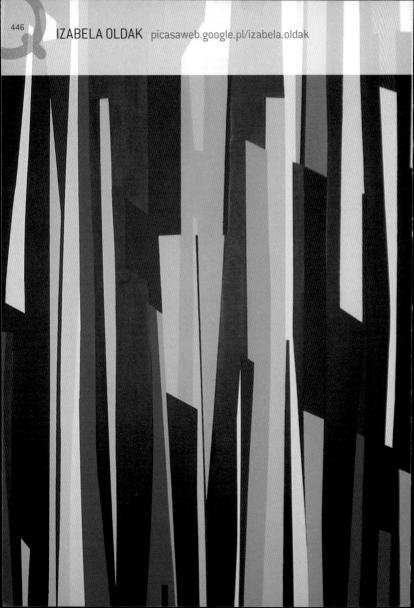

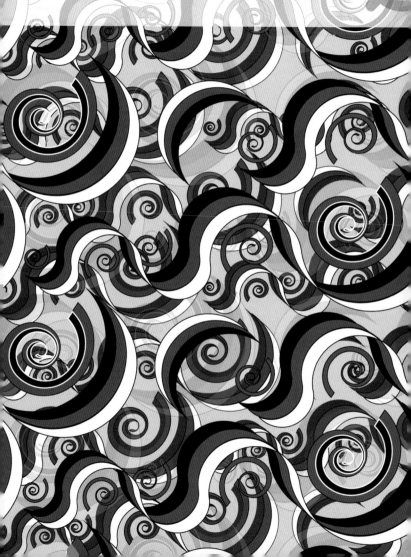

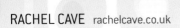

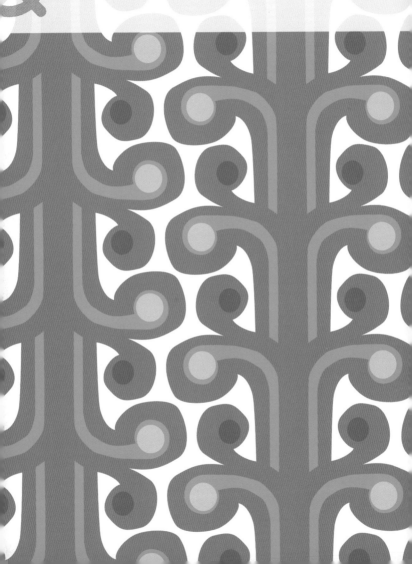

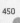

JANE MCMILLAN/MAC MILLAN www.mac-millan.com

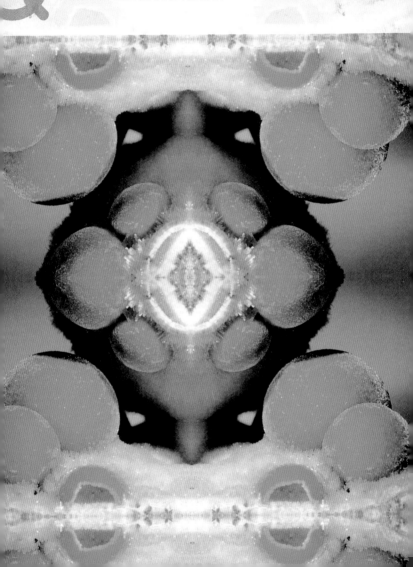

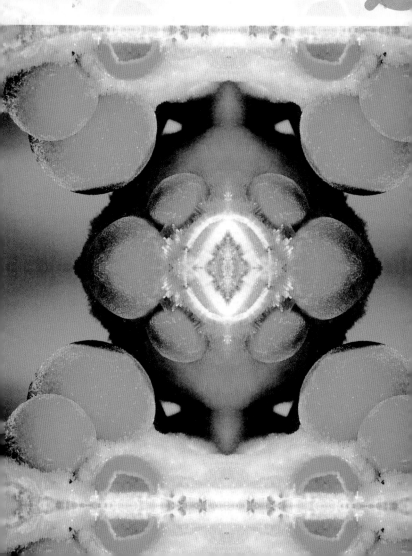

ANA MONTIEL/ALAN THE GALLANT www.alanthegallant.com

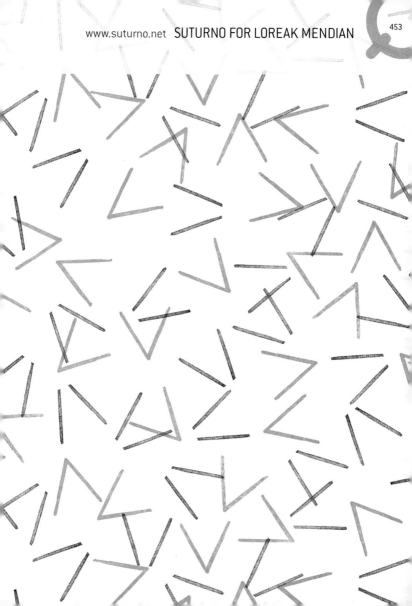

DELPHINE DOREAU/DEL4YO del4yo.squarespace.com

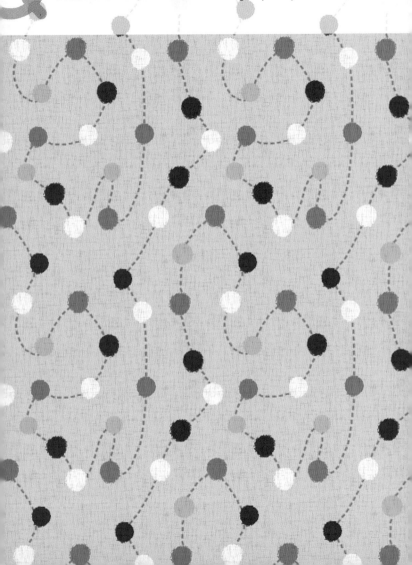

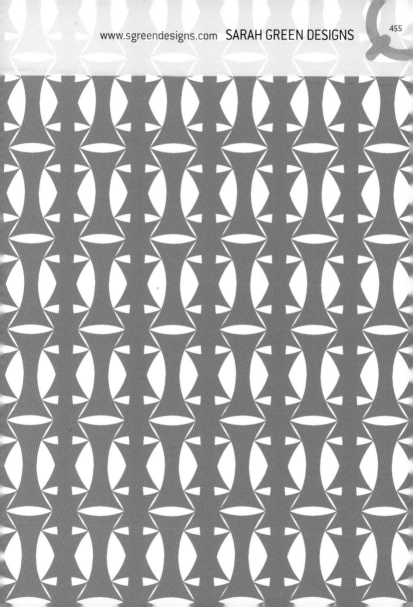

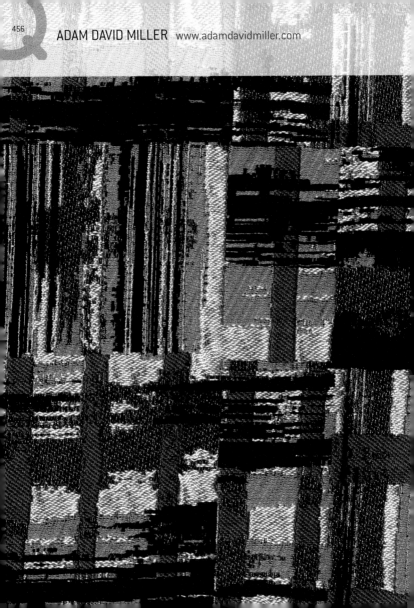

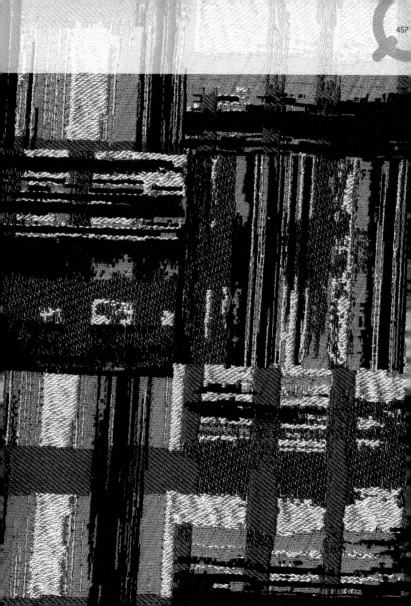

GEMMA ROBINSON gemmamarierobinson@hotmail.co.uk

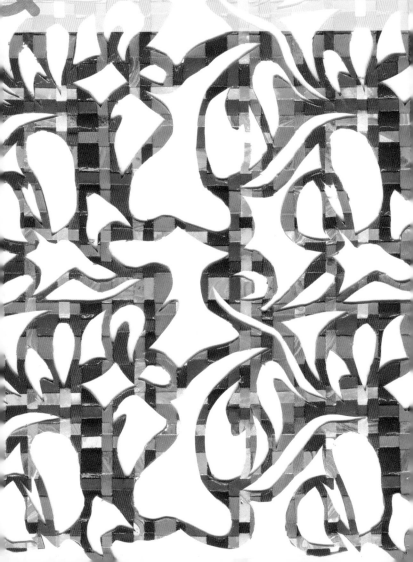

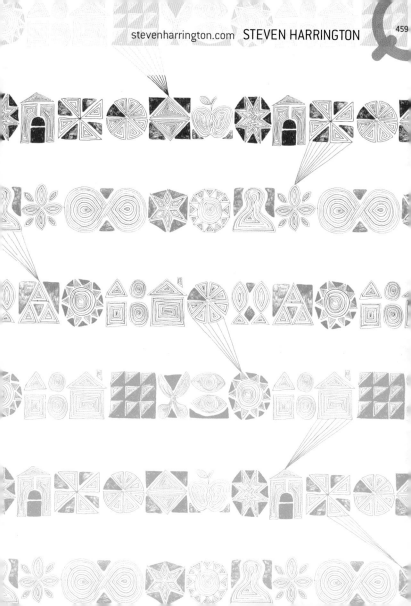

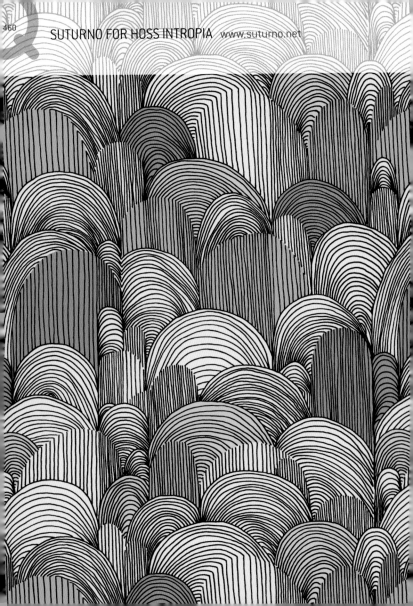

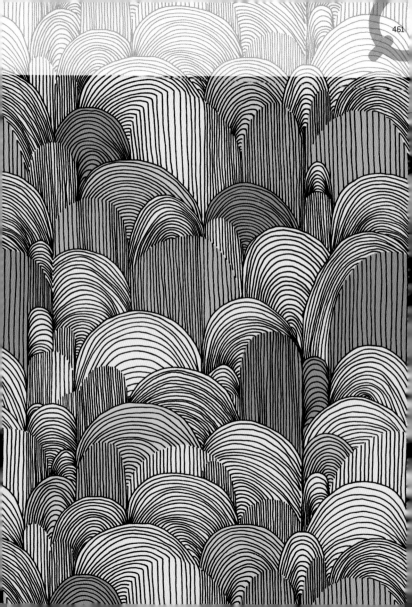

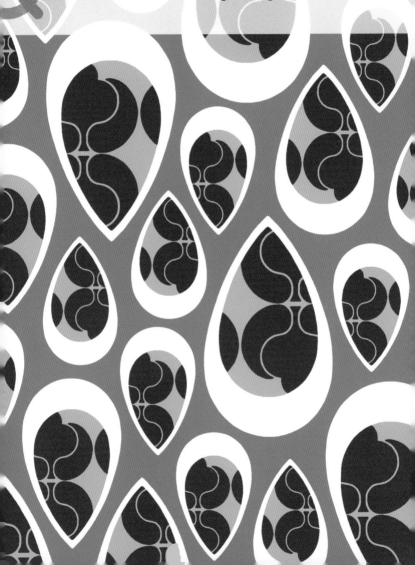

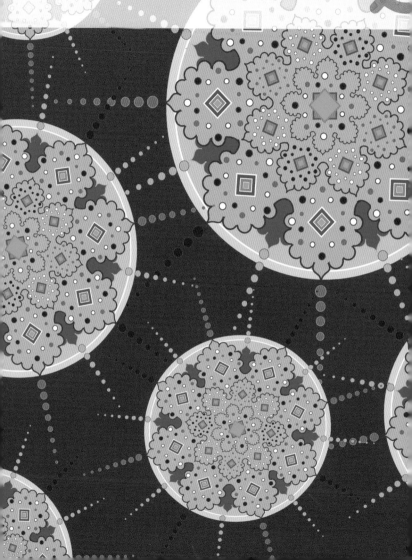

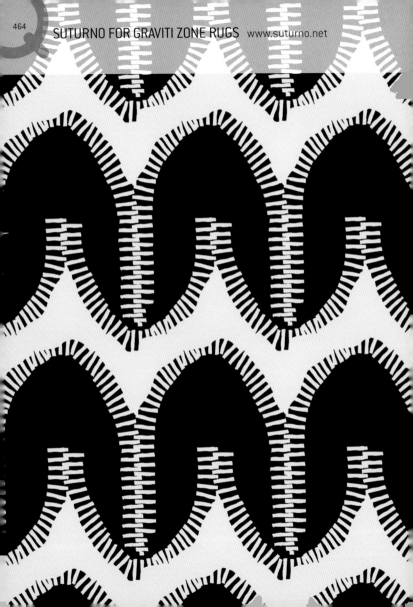

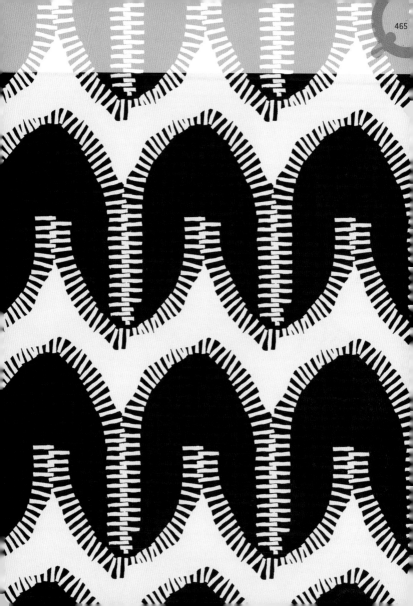

AMY+BETH DOWELL abdowell@mac.com

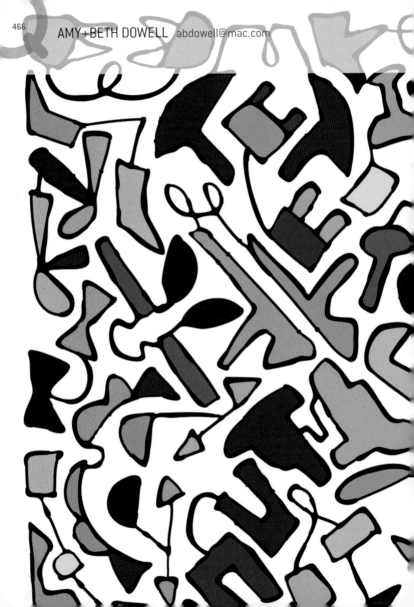

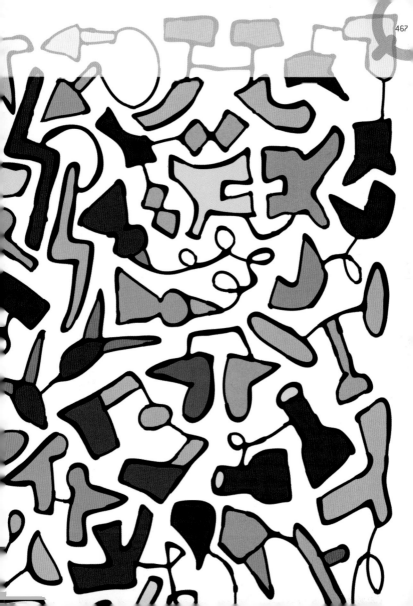

RACHAEL TAYLOR, surface pattern designer www.rachaeltaylordesigns.co.uk

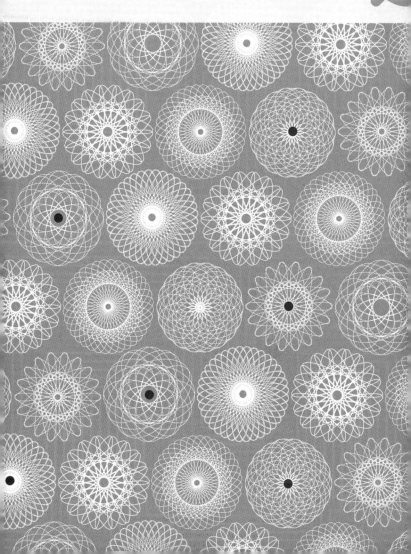

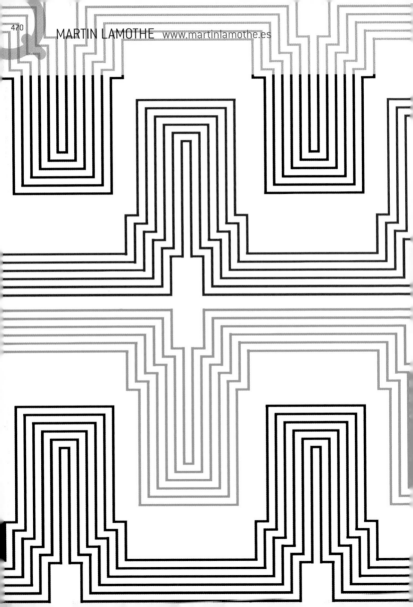

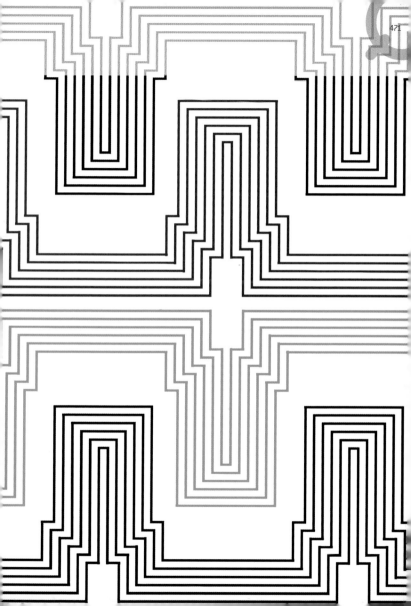

NICKY LINZEY www.nickylinzeydesign.co.uk

BAILEY SALISBURY baileysalisbury.info

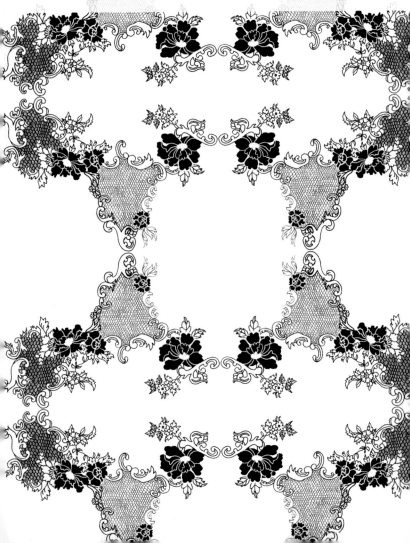

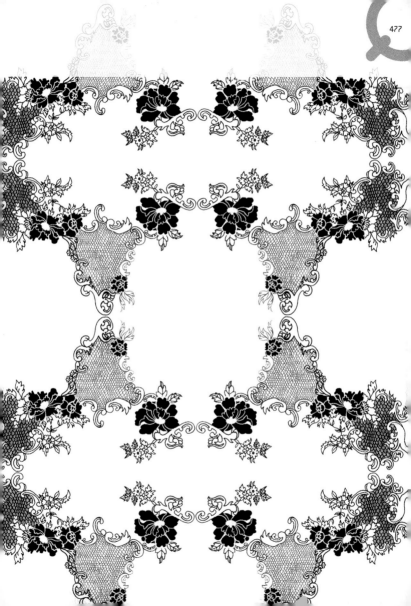

DIANA SKYLACOS dskylacos.com

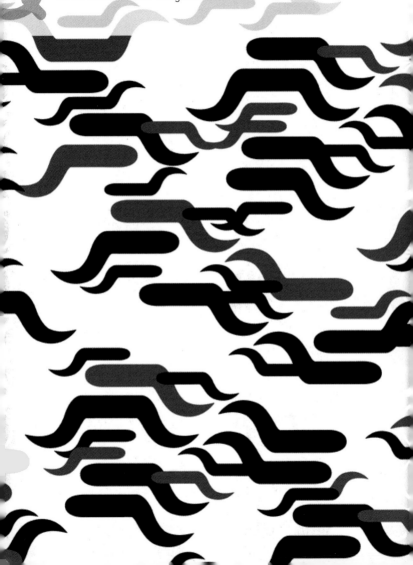

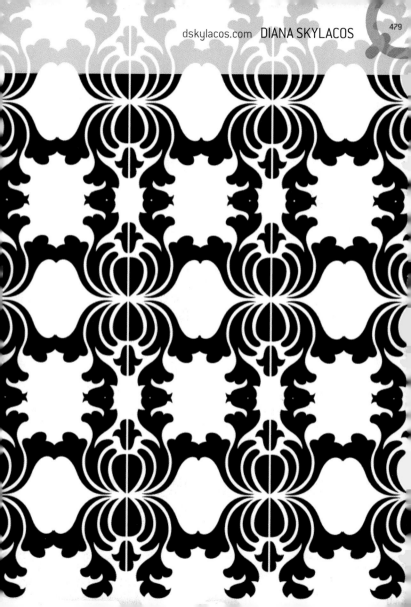